THE CRITICAL EYE

THE CRITICAL EYE

A New Approach to Art Appreciation

GUIDO BALLO

TRANSLATED BY R. H. BOOTHROYD

G. P. PUTNAM'S SONS : NEW YORK

First American Edition 1969

Originally published in Italian under the title *Occhio Critico*
Copyright© 1969 by Longanesi & C.
Translation © William Heinemann Ltd., 1969

Filmset by The European Printing Corporation Limited, Dublin, Ireland
Printed in Italy

CONTENTS

List of Illustrations

1 MICHELANGELO, The Rondanini *Pietà*

Nowadays critics no longer judge Michelangelo from the neo-classicist standpoint, and they have discovered the correct angle from which to view his works if we want to understand his style.

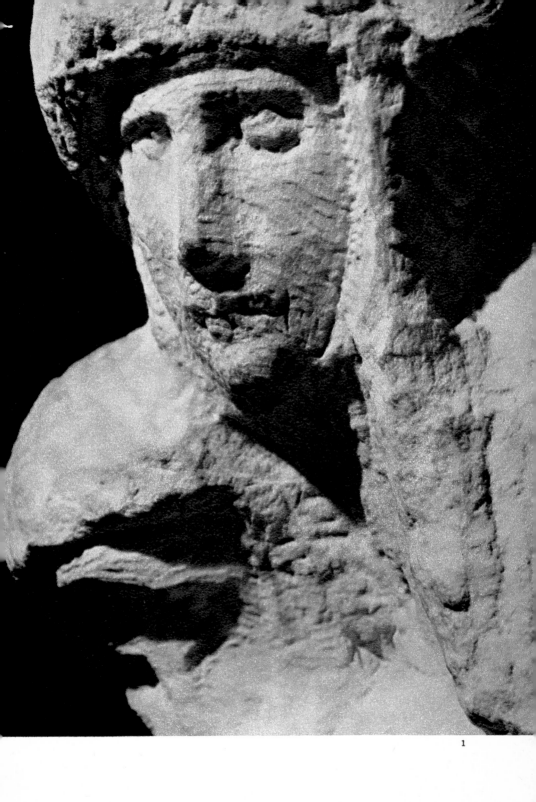

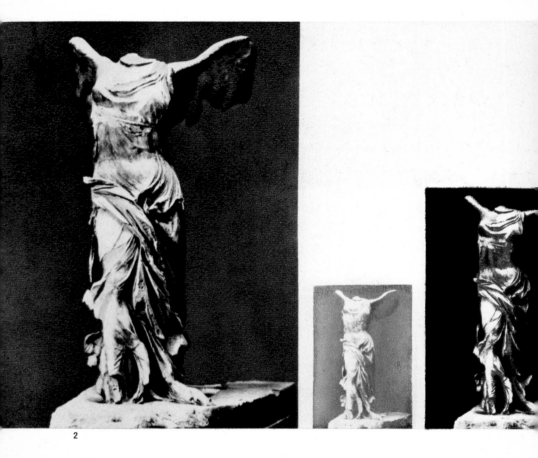

2

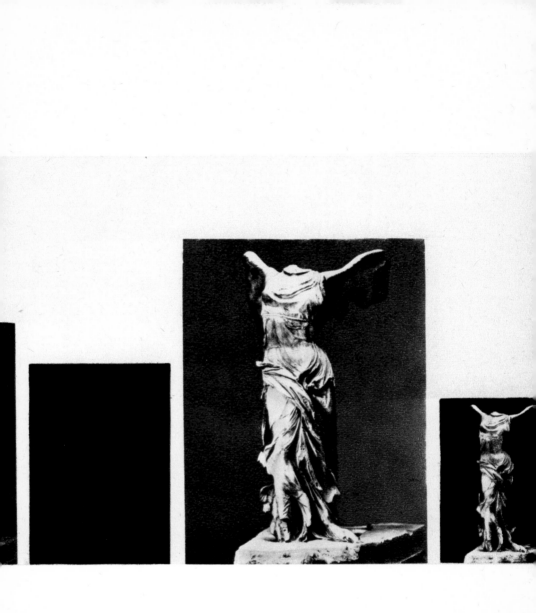

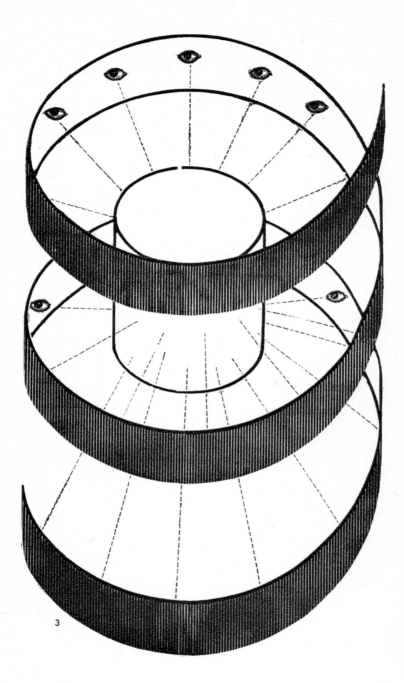

3

A Work of Art does not always Look the Same

WHEN we are standing in front of a picture, a statue or a building, we certainly think that we have a right to say whether it is beautiful or ugly, or whether it is a real work of art or not. But then comes the question, to what extent is our opinion unbiased? Are we ourselves completely impartial, or are we still the slaves of prejudice?

Of course, I am not referring to particular moods which at one moment may make us feel quite indifferent to a work of art and at another more appreciative. The same applies to poetry, music and drama. For example, when we are listening to a concert, a piece which had previously made a deep impression on us may suddenly make us more susceptible to the noises made by our neighbours or to the almost imperceptible movements of people sitting in the stalls, all of which things distract us. Obviously, in such cases our critical faculties are influenced by our mood, but the influence is only temporary.

What I want to talk about here is real criticism—the opinions we form in circumstances which can be considered normal, in the full exercise of our faculties. To what extent, then, is our judgement unbiased and not conditioned in any way by the cultural training we have received (even indirectly), by the particular angle from which we happen to be looking, by memories of other works we have seen in the past, by remarks we have overheard and accepted as rules—in short, by our own individual taste?

One day I noticed a man looking at a picture in a shop-window. He was standing quite still, as if fascinated; his eyes were shining as if he were dreaming. This induced me to take a look myself, and I saw that the picture was one of those innumerable, commonplace daubs—a landscape, with a lake, reflexions in the water, a house and so on. But the tones, the lighting and the draughtsmanship were all wrong, purely superficial (Fig. 21). Nevertheless, the man was delighted—so much so that he turned to me and could not refrain from saying: 'Isn't it wonderful?'

2 A WORK OF ART DOES NOT ALWAYS LOOK THE SAME
Works of art can change and do not always look the same, because taste changes, and with it the spectator's eyes and viewpoint. All great artists and masterpieces (e.g. the *Nike of Samothrace*, dating from the Hellenistic period and now in the Louvre, which is here shown as people of different periods saw it) are viewed with approval for a time, then with indifference, and at times they may even be despised. Art is absolute; but the public must be taught how to look at it.

3 THE SPIRAL OF AESTHETIC TASTE
When looking at a work of art, the spectators believe that they are all equal, but in reality they are standing on different planes and are not viewing it from the same point. Because they are standing on different planes, their opinions will differ; hence all the futile, interminable arguments.

On another occasion, while I was in Greece, I saw a pleasant-looking young man in the museum at Olympia who, after examining Praxiteles's Hermes (Fig. 163), said: 'Well, it leaves me cold!' He was obviously sincere, and not trying to show off, as so many dilettanti do who have no real feeling for art and just follow the latest trend, ready to change their opinions as soon as fashion changes. For him that statue by Praxiteles which for centuries has been, and still is, admired by so many people had no meaning. All the same, that young man, who, as I later found out, was himself a painter, in front of the archaic Maidens in the museum of the Acropolis in Athens, or the metopes and triglyphs dating from the sixth century B.C. at Paestum, in Greece or in Sicily, or works like the Ludovisi throne (Fig. 115 – 117) in the National Museum, Rome, would have assumed the same rapturous expression as the man who admired the daub.

These are just two cases chosen at random. Since they lacked serene and objective judgement, both men were wrong. But what does 'wrong' mean? The two works undoubtedly made an impression on them. For the first man the daub was a real work of art and he imagined that it must be the work of a great painter. For the second, Praxiteles's Hermes had no life; to his eyes it was not a work of art and did not produce the effect that real art ought always to produce.

Were these two men exceptions? I thought of that, too, but it is easy to see that many of the people we meet every day are just like them.

Moreover, to what extent are we all wrong? Are the internal rules governing a picture, a statue or any other work of art so objective and absolute that they are bound to impress everybody, at all times? And to what extent do we—as readers, spectators or listeners—allow our prejudices, our own ideas and our imagination to play a part in forming our opinions as to the quality of works of art?

The fact of the matter is that not one of us is completely objective when looking at a work of art. Accuracy of judgement is an acquired faculty and must inevitably depend to a certain extent on our angle of vision.

The man who was fascinated by that mediocre landscape was certainly not a man of outstanding artistic culture; his eye had not yet learned to distinguish 'the values' (about which I shall speak later). And his judgement was not purely intuitive, it was not unbiased. That day I was on the point of telling him that the landscape he thought so wonderful was very badly painted, that the juxtaposition of colours was all wrong, that the whole picture was—as people are fond of

4 MOVING TRIANGLE
The painter Kandinsky depicted the evolution of spiritual life in the form of a moving triangle. This simile could also be applied to the evolution of taste: most of the spectators remain at the base of the triangle, but a few pioneers reach the apex. By the time the majority have reached the point where the apex first was, the pioneers will have advanced still further. The distance between the two groups remains the same. Some people indignantly attack the innovations of modern art, because they are unable to distinguish the good from the bad.

16

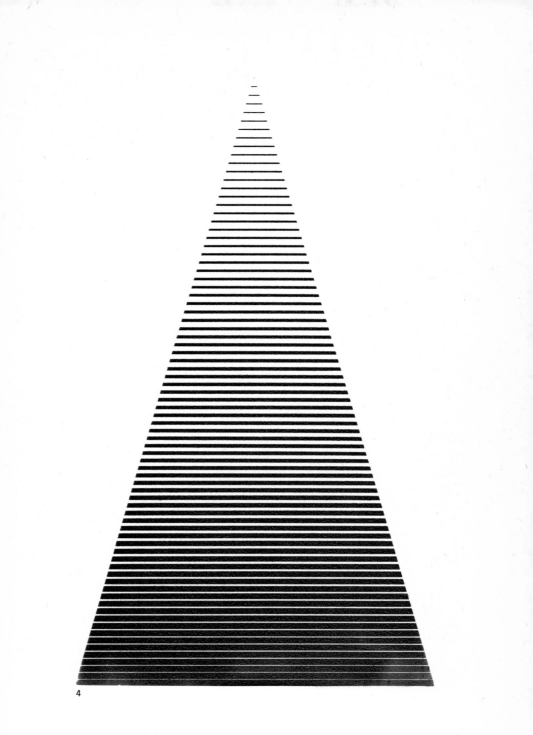

4

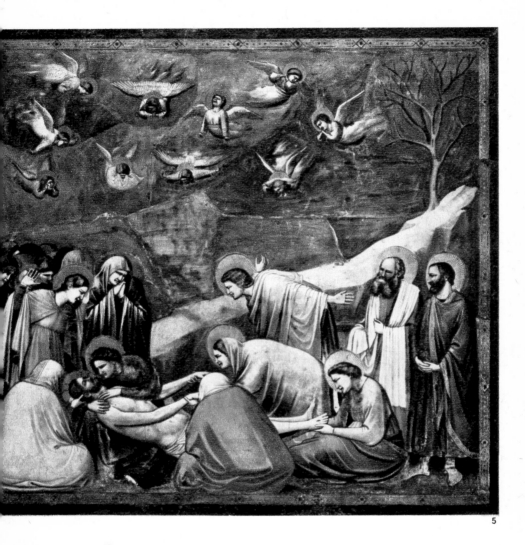

saying — 'full of gaps', because the painterly values simply did not function. But I was touched by his enthusiasm and decided to say nothing. I realized that he would want me to convince him, because he himself was convinced that the landscape was a real work of art. And in some ways he was not altogether wrong; the trouble was that he was viewing the picture from the wrong angle and had thus formed a wrong idea without being aware of it. In short, I could not have helped him to focus his eyes properly. In order to do that, I would have had to show him other pictures which would have enabled him to get some idea of the subtleties of tones. Had I done so, I should only have upset him, and in the end he would have viewed me with distrust or even with hostility. He had eyes which we can only describe as 'ordinary' — eyes that enabled him to form only a summary opinion.

With the young man who, although he was undoubtedly more cultured, could not appreciate Praxiteles, the argument might have become more heated. He was the sort of man who could not understand the values of a rhythm modulated in subtle sculptural transitions; a man who started from a different standpoint, a standpoint which might help him to understand primitive art, archaic structures and the meaning of the most recondite symbols, but which could not teach him how to appreciate form expanding atmospherically in relation to a more restless individualism. His was what we might call a 'categorical' eye, because he adopted only one viewpoint for judging the art of all periods and of every civilization. By so doing he might be able to rediscover a number of forgotten works of art, but he would ignore all those others which, in order to be understood, need to be viewed from a different angle.

It follows, therefore, that before we attempt to criticize works of art, we must first put ourselves on trial.

The really critical eye, in fact, operates on a plane quite different from that on which the 'ordinary' or 'categorical' eye functions. We can even give a symbolical form to the dialogue between the public and a work of art: it is like a spiral or a corkscrew staircase (Fig. 3). If a work of art is placed in the centre of such a corkscrew staircase, the spectators will be standing on different planes and will not be looking at it from the same angle. Although they may believe that they are equally competent to judge, their opinions will inevitably differ. Because they are standing on different planes, they cannot agree or even discuss the work. Though they are speaking about the same thing, they will express different opinions. Hence all the futile, interminable arguments.

To avoid misunderstandings, however, we must make it clear that everyone can achieve critical judgement and freedom of opinion, but this freedom will always be an acquired faculty and it cannot be acquired immediately, as we shall see later. Instinct may appear to be unbiased, but even instinct has first to free itself from a whole

5 GIOTTO, *Deposition*, 1304–1312, Padua, Scrovegni Chapel.

series of prejudices which hamper it and make it harder to discover the correct angle of vision.

Another way of symbolizing the dialogue is to liken it to a moving triangle, and this will perhaps provide a better explanation of the evolution of taste. Let us suppose that the bulk of the spectators remain at the base of the triangle (Fig. 4), while a few pioneers have managed to get as far as the apex. If the triangle were to move slowly forward, it follows that when the majority of the spectators have reached the point where the apex was before, the pioneers will have gone still further. Nevertheless, the distance between the two groups will still be the same. When the Impressionists first came to the fore in 1874, the masses were still clamouring for historical, neo-classicist or eclectic works. Nowadays we all accept Impressionism, which has become a matter of normal taste. But we do not all accept the latest innovations in art, because they have not yet become part of our everyday life and we are consequently unable to distinguish the good from the mediocre or from the definitely bad.

The moving triangle, however, provides only a partial explanation of the gap between the public as a whole and certain works of art, whether new or old. It is essential that the 'ordinary' and the 'categorical' eye should become 'critical' eyes.

This, however, involves a process of emancipation and study. We must judge the spectators and the judges before we can be in a position to judge the works themselves. Here psychology and aesthetics become fused.

Different shades of opinion can, in fact, exist, their formation being influenced by psychological as well as by aesthetical considerations, as we shall see more clearly later on. We must now consider the summary judgements pronounced by people with 'ordinary' eyes, the mistakes made by those who echo the opinions of others, categorical judgements, and, lastly, real criticism.

* * * * * *

Another myth which is now no more than a well-worn stock phrase is that a real work of art can always be appreciated by everybody, irrespective of their culture or when they lived. This is a fairy-tale, because in the course of the centuries a work of art does not always look the same — it can change. Not because it becomes corroded by the

6 TITIAN, *Simon the Cyrenian helping Jesus to carry the Cross*, detail, 1560–70, Madrid, Museo del Prado.
Titian had his own colouristic manner of drawing, depending not on lines, but on painterly vibrations; as a result his outlines do not terminate abruptly, but expand into the atmosphere with the aid of subtle graduations of the luminous effects.

7 CLAUDE MONET, *Impression — Sunrise*, 1872, Paris, Musée Marmottan,
When they first emerged, the Impressionists were derided by the public at large. Their coloured shadows seemed to be jarring and 'discordant'. Today, they have become part of normal taste, and everyone admires their works.

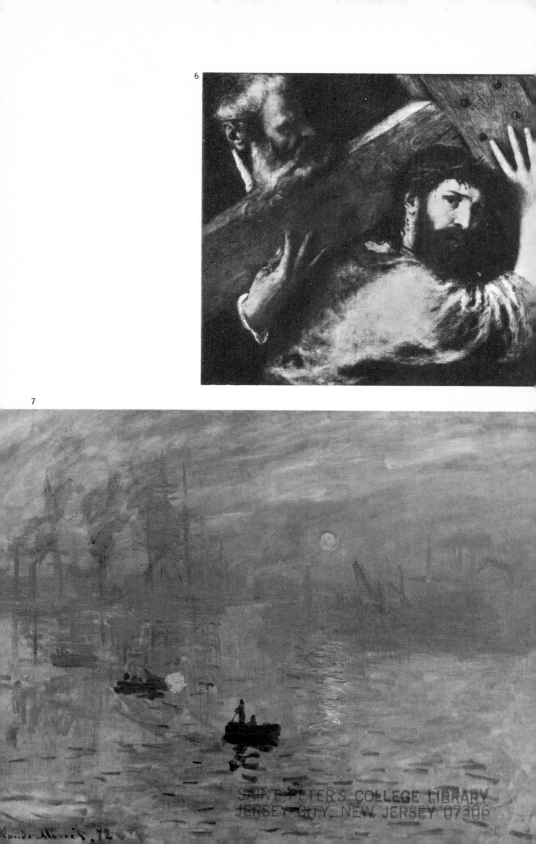

6

7

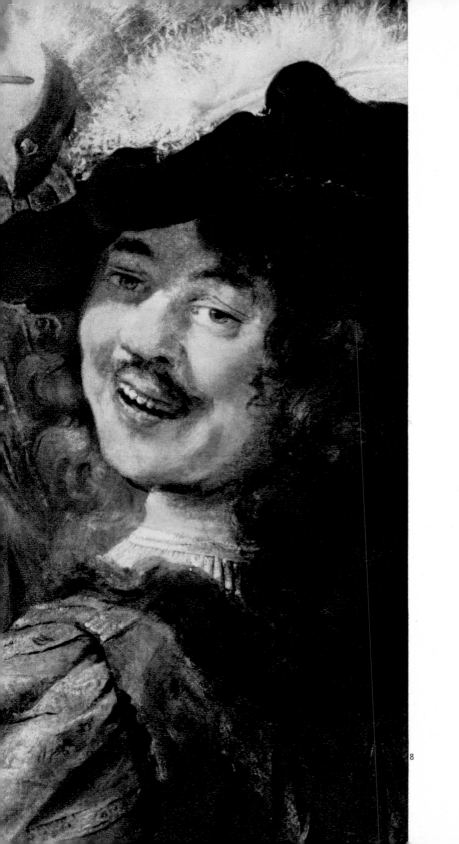

8

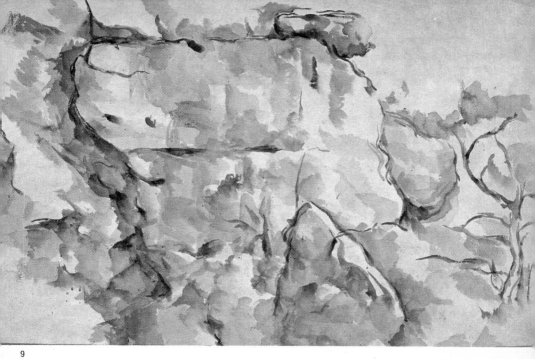

9

10

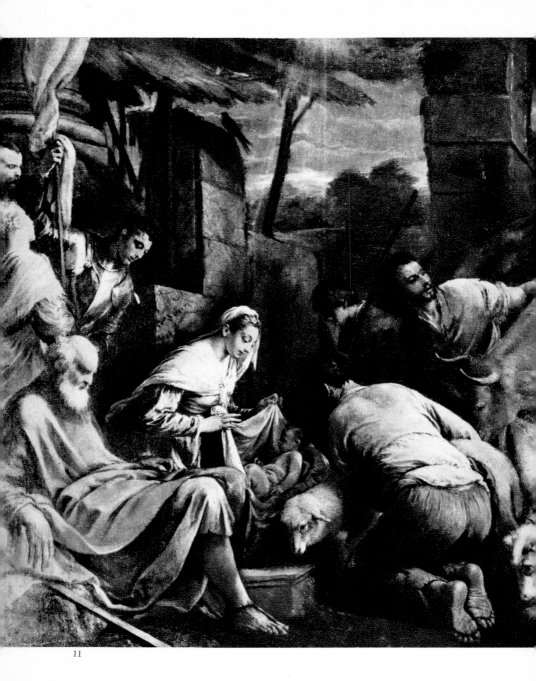

11

weight of the dust of centuries—that is not what I mean, though obviously this does help to change the appearance of the work. (From time to time I wonder what impression the Acropolis in Athens would make on us today, if it were still coloured and intact as it was in the days of Pericles; the effect would undoubtedly be different, and perhaps we should like it less than we do, since by now we have become accustomed to its subdued Impressionistic atmosphere, evocative and laden with time.) What I mean here is the continual change in the dialogue between the eye and the work. It is this dialogue that is apt to change in the course of centuries, because people look at works of art from different angles, because taste changes and so does culture.

Take any great artist or any great work of the visual art of bygone days. When we consult the documentary sources, we find that there have always been periods or cultural trends during which that artist or work has been regarded with indifference, or even despised. A few examples chosen at random will suffice to prove this.

Cimabue, Giotto, Duccio, Simone Martini, Pietro and Ambrogio Lorenzetti, Antelami, the unknown master who made the bronze doors of San Zeno in Verona, Arnolfo—in short, all the so-called 'primitives'—were ignored for centuries. Their contemporaries undoubtedly admired them (at the end of the fourteenth century Cennino Cennini wrote that Giotto '... translated the art of painting from Greek into Latin and made it modern; and his works were more perfect than those of any other of any time'), but during the sixteenth and above all the seventeenth centuries the masters of the Romanesque and Gothic periods were despised, this being largely due to the

8 REMBRANDT, *Self-portrait*, detail, c. 1634, Dresden, Pinakothek.
Rembrandt is another artist who has not always been viewed from the proper angle. The writer Baldinucci tells us that when the Florentines first saw some of his works, they found them 'most peculiar', because they could not understand the luminous shadows, the absence of outlines, and the use of subdued tones: all marks of his greatness as a painter.

9 PAUL CÉZANNE, *Rochers à Bibemus*, water-colour, 1895–1900, Milan, G. Mattioli collection.
Until a short time ago the ordinary man would never have accepted a picture like this one of Cézanne's, since he would not have understood the coloured shadows and luminous harmonies derived from the Impressionists. But today the ordinary man is no longer startled by such things. Nevertheless, if we want to understand the compositional rhythm of this water-colour, we must study the whole development of Cézanne's style. With works like these he exercised a profound influence on the evolution of art in our own times, an art which the ordinary man still refuses obstinately to accept.

10 PABLO PICASSO, *Mother and Child*, 1921.
Picasso's use of distortion invariably annoys the public at large, since they cannot discover the correct angle from which to view his various works. Others carry their admiration too far. Before giving an opinion, we must study the whole history of his style (cf. pp. 115–116).

11 JACOPO DA BASSANO, *Adoration of the Shepherds*, detail, 16th century, Bassano, Museo Civico.
Nowadays no one would dare to cast aspersions on the quality of this Venetian artist's painting, but in the course of several centuries his reputation, too, has had its ups-and-downs.

mistaken idea propagated by Vasari that art is a continuous process of evolution (whereas every period, every civilization and consequently every cultural movement has its own art, and this is not perfect at the beginning and does not become perfect with time). As a result these early masters seemed to be naive and childish, incapable of dealing with foreshortening or mastering the truths of anatomy. Thus the myth of 'primitive' painting was born—a myth which flourished and later misled the public. Behind the apparent 'primitivism' of Cimabue, Giotto, Duccio and other masters of those times were long-standing traditions and complex international cultures, ranging from Byzantine art to French, Carolingian and Ottonian influences, to inspiration drawn from miniatures produced in various countries, and to deliberate attempts to translate all these things into new forms of expression.

The men of the seventeenth century, however, could not understand these Primitives and accordingly they despised them; the plague was made an excuse for covering innumerable church walls with whitewash—walls adorned with paintings by Primitive artists, not with seventeenth-century works. Romanesque and Gothic walls were torn down and in their place Baroque altars were erected and domes adorned with fresh paintings. To the seventeenth century the Primitives seemed lifeless and static because in them men sought in vain for foreshortening, rhetorical emphasis, spatial breadth and stupendous images.

The neo-classicist art historians went even further: thanks to the myth so dear to Winckelmann and generally accepted, Greek art was held to be the only possible form of art, and the Primitives failed to attract the interest of anybody. It was not until the days of Wackenroder and the first Romantics that people began to revise their ideas and to adopt an attitude which today is generally accepted. Wilhelm Wackenroder was a humble German friar who died in 1797 when he was only twenty-five, but it was he who first sought for feeling and inner meaning in art, and together with Novalis, the Schlegels and other Romantics he provided in his writing a new conception of the primitive art of all periods and all cultures: 'Had your soul budded thousands of miles away, in the East or on Indian soil, when you gazed on the queer little idols with their innumerable arms you would have felt that a mysterious spirit, unknown to our senses, was inspiring you; and this spirit would bring them to life before your eyes, and you would feel only indifference when confronted with the Medici Venus. Artistic feeling is a solitary and immutable ray of light which,

12 *Annunciation*, 12th century, bronze doors of San Zeno, Verona.

13 Chartres Cathedral, 12th–13th centuries, detail.
Today Gothic cathedrals and Romanesque sculpture are universally admired, but it was not until the Romantic period that their real merits were perceived. Before that they were often despised as being the work of naïve, primitive craftsmen, this being particularly the case during the neo-classicist and Baroque periods.

26

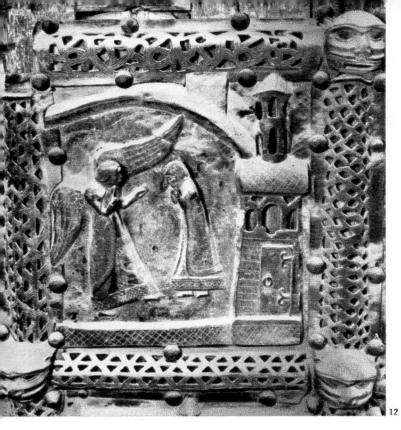

12

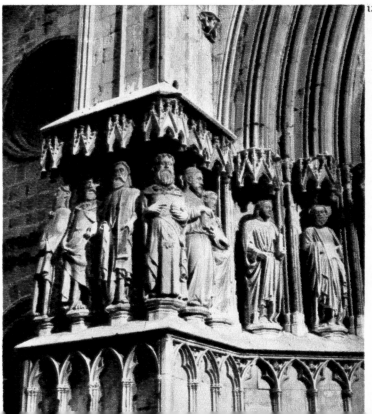

13

14

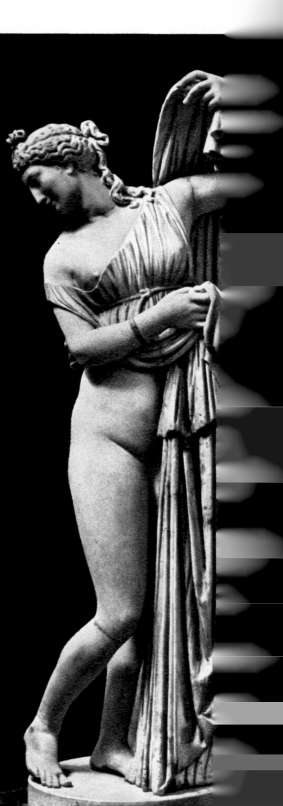

15

as is passes through the polyhedric crystal of our sensibility, breaks and is reflected in a thousand different colours.'

Take another artist, this time from that very seventeenth century which was so hard on the mediaeval masters. Who today would venture to dispute the greatness of Borromini or the brilliant architecture of the church of Sant'Ivo alla Sapienza in Rome (Fig. 83)? But to the eyes of the neo-classicists, who theoretically demanded strict adherence to geometrical proportions, his work was incomprehensible. Accordingly we find Francesco Milizia, who disliked Baroque, condemning Borromini's capriciousness and imagination and all the liberties he took: 'Borromini carried capriciousness to the point of delirium. He distorted all the forms, mutilated cornices, turned volutes upsidedown, cut off angles, made architraves and mouldings undulate, and was lavish in his use of cartouches, coils, corbels, zigzags and trifles of every sort. Borromini's is a topsy-turvy architecture. It isn't architecture at all; it is just a medley issuing from the brain of a crazy carpenter... He deliberately tried to make himself unique by breaking all the rules... He flaunted his singularity even in architecture.'

According to the architect Milizia, Borromini in architecture and Bernini in sculpture were 'plagues that have afflicted taste', 'plagues that have infected a great number of artists'.

Milizia's words show that the neo-classicist viewpoint and the ensuing controversy, which was eagerly followed by ever larger sectors of public opinion, made it impossible for people to understand the positive qualities of Baroque art, which we of today view from a different angle that has enabled us to revise our judgement. And what for Milizia was Borromini's worst defect—'he flaunted his singularity even in architecture'—is now deemed to be a fundamental merit. Today we might even say that Milizia's ideas are 'topsy-turvy criticism', since although he perceived the factors distinguishing Borromini's style, his angle of vision was such that to him they seemed to be defects and vices—'plagues that have afflicted taste'.

In short the vicissitudes of fame, combined with changes in public taste, affect all artists, even the most famous. In the course of centuries the parabola of the esteem in which they are held by the public is distorted, because the angle of vision changes, and consequently the dialogue between the work itself and the spectator's eye. The history of art ought to be completely rewritten—as a history not of

14 *The Hera of Samos*, 6th century B.C., Paris, Louvre.

15 *Callipygian Venus*, 1st century B.C., Naples, Museo Nazionale.

On seeing the *Hera of Samos*, an archaic statue of the 6th century B.C., and the Hellenistic *Callipygian Venus*, the general public generally prefers the latter, because it is more sensual and pleasing to the eye. But the *Hera of Samos*, unlike the *Venus*, is not a complacent work; on the contrary it is austerely circumscribed by its linear rhythm and is very expressive. The *Venus*, however, a work of the Hellenistic school of Rhodes and Asia, has also been adversely criticized, especially in more recent times. Before formulating an opinion we must study the whole history of style and of the periods during which the works were produced, since our judgement should not be based on whether we like a work or not.

the works themselves, but of the reactions of the public during the various centuries, thus showing how the evolution of taste and new points of view can alter our estimate of one and the same work.

To take another example, visitors to the 1951 exhibition in Milan said of Caravaggio (Fig. 33): 'Here at last we have a great painter, beyond all possibility of doubt.' But in the days when people were conditioned by other ideas what they wanted to see in a picture was 'decorum', 'gracefulness', 'nobility', 'sublime inventiveness', and similar things, and consequently Caravaggio had no success. 'Undoubtedly Caravaggio helped painting to make a step forward, because he appeared at a time when naturalism had not yet become a vogue and figures were still drawn conventionally, in order to satisfy a certain feeling for beauty rather than a demand for accuracy. Caravaggio deprived colour of all its prettiness and vanity, introducing more vigorous tones which had real flesh and blood, and reminding painters that it was their duty to imitate... Nevertheless, he lacked many — including the best — qualities, because he had neither imagination, nor decorum, nor skill in drawing, nor any real knowledge of painting whatsoever, since, once the model was removed from his sight, his hand and his mind were impotent.' By writing these words Giovanni Bellori, the archaeologist and art biographer, showed that he appreciated the novel qualities in Caravaggio's works, but was too much under the influence of the Carracci school and consequently mistook for defects what are in reality the Lombard painter's most genuine merits. And the opinion of Francesco Albani, the painter who helped Bellori write his biographies, as quoted by the poet and painter Carlo Malvasia, was even more severe. He thought that Caravaggio's manner was 'the precipice and total ruin of the most serene and noble virtue of painting'. Obviously, to Albani, whose pictures have a drawingroom elegance. Caravaggio's violence and ability to depict nature were bound to seem 'ruinous'.

It is equally obvious that Caravaggio could not possibly appeal to neo-classicists, who attached even greater importance to academic rules. For Anton Mengs the very word 'naturalistic' was a condemnation. But modern painters, from Géricault to Courbet, Manet and the disciples of Impressionism, have, together with the critics, changed

16 The Willendorf *Venus*, Early Stone Age, Vienna, Naturhistorisches Museum.
Real primitivism is not to everyone's taste; people are inclined to find such works distorted and crude, because they do not understand their expressiveness and are always looking for beauty of the neo-classicist type.

17 RAPHAEL, *Pope Leo X with Cardinals Giulio de' Medici and Luigi de' Rossi*, detail, *c.* 1518–19, Florence, Uffizi.
The reputation of Raphael, which at one time seemed to be above all discussion, has also suffered occasional setbacks. Even Berenson seemed to be echoing the words of Raphael's adversaries when he wrote: 'If we measure him by the standards we apply to artists like Pollaiuolo and Degas, we must consign him to the limbo of golden mediocrity.' More recently, however, other writers, after a close study of Raphael's style, have revised their opinions.

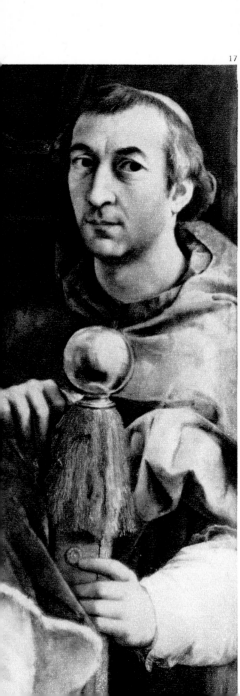

17

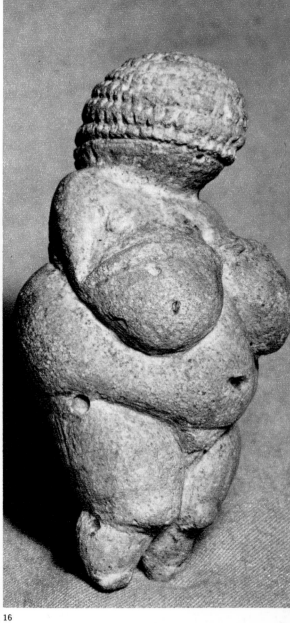

16

public taste and made it easier for people to look at Caravaggio from the proper angle and appreciate his painterly and expressive values.

Here is another example. Who today would dare to cast aspersions on the art of Rembrandt, one of the greatest artists of all time? And yet, in the course of the centuries this Dutch master has not always been appreciated and understood (Fig. 8).

Towards the end of the seventeenth century, as Lionello Venturi has pointed out, Filippo Baldinucci was well aware that he was writing a chronicle rather than a history of art, and he consequently confined himself to quoting the opinions of his contemporaries. It is interesting to hear what Florentine artists thought when a painting by Rembrandt reached Florence. Evidently they were quite unable to understand why this artist should be so famous, for to them he seemed 'most peculiar, since his manner dispenses with outlines of any sort, neither the inner nor the outer contours being clearly shown, everything being done with the aid of wild strokes or stressed by an abundance of dark patches, without any deep shadows'.

What they appreciated far more than Rembrandt's paintings were his etchings, one reason being that they had already seen other engravings characterized by painterly draughtsmanship and consequently tending more towards linearism, and also because in this field local tradition was less strict than in that of painting. Nevertheless, this is yet another example of incomprehension, due to a different angle of vision.

When we turn to what people said about the works of Titian (Fig. 6) we find some astonishing statements. Today no one would think of denying that he was a great artist, but the fact remains that he was not always appreciated or viewed from the correct angle. In Giotto's case the myth has persisted that he knew nothing of foreshortening and could not reproduce the effects of perspective, and as regards Titian we continually hear the stock phrase that he did not know how to draw. Accustomed as they were to a tradition of sculptural draughtsmanship — the development of which could be traced from Giotto to Michelangelo — and a predilection for sturdy, dynamic forms which did not dissolve into the atmosphere, the Tuscans, including Vasari, had helped to propagate this myth of Titian's inability to draw, and they were not the only ones, for even in Venice similar statements were made. Titian 'did some things in a way that could not be bettered, but in others his drawing might have been better,' Tintoretto once remarked. Paolo Pino, a disciple of Gian Girolamo Savoldo, the Lombard painter, asserts that he had seen 'miraculous landscapes by Titian, far better than those of the Flemings', and

18 Pablo Picasso, *The Fall of Phaëton*, Illustration for Ovid's *Metamorphoses*, 1931.
Here again, if we want to understand this drawing, we must study the whole evolution of Picasso's style, from his 'blue' period in the early years of the present century, when he used thin outlines, down to this Cubist phase, when he broke up the subject while still retaining a certain classicism. Although it is linearistic, this drawing reveals the influence of Cubist intersections and reversals.

Giovanni Lomazzo, the writer and painter, that it was 'impossible to expect more from a human hand or art'; but for Charles du Fresnoy, the French painter and poet, 'he was not so perfect in his figures, and when it came to draperies he was inclined to be trivial'.

Antonio Zanetti, a seventeenth-century writer, after noting with regret that Titian 'paid no attention' to 'the accurate study of muscles, and did not always attempt to give ideal beauty to his outlines', went on to say that 'if the vicissitudes of his career had enabled him to acquire a more thorough knowledge of drawing, he might have become the greatest painter in the world'. Such statements show that the myth of Titian's inability to draw persisted for a very long time. Conversely, in the works of Michelangelo other people looked in vain for the colouring of the Venetian school—colour-schemes which in his case did not come into question because of the solidity of his sculptural forms—and still others expected Titian to draw like a Tuscan, ignoring the fact that the values of his tones submerge the atmosphere, blur the outlines and make incisive drawing impossible. When based on such standpoints, appreciation of both these artists is bound to be completely wrong. Writing in neo-classicist times, Anton Mengs went even further when he said that he could not number Titian among the great draughtsmen and felt bound to relegate him to the category of ordinary painters, 'far inferior to the old masters, though if he had really made up his mind to study drawing, he would have been successful, for his eye was sufficiently keen to enable him to copy Nature'.

Eventually, when the influence of positivism began to make itself felt, Titian's later works, painted with a broad, inner expressiveness, seemed to be distortions and attempts were made to attribute this fact to the cataract which afflicted the painter's eyes in his old age, and nobody appreciated the harmony of his luminous and profoundly poetical tones.

While on the subject of nineteenth-century positivism, we must mention that attempts have been made to explain the distortions we find in El Greco's works—a neo-Byzantine feature, accentuated by his contacts with the Mannerists during his sojourn in Venice—as being due to astigmatism, since their unearthly intensity, filled with inner life, was not understood and was even held to be a defect. To-day we all admire El Greco's works because, in addition to the critical studies of his works, Expressionism, of which he was a forerunner, has made it possible for everyone to view them from the correct angle, and consequently his distortions and strident harmonies are now seen as the outcome of an inner urge, the aim of which was not

19 *The Escort of Theodora* (below), with (above) details, 6th-century mosaic, Ravenna, San Vitale.
People are too often inclined to express unfavourable opinions on the Ravenna mosaics, because of the alleged lack of perspective, the fact that the personages seem to be crowded together, lookng straight to the front. Even the merits of these works—rhythm, colouring, the handling of the composition—seem like defects to those who do not know how to look at them with critical eyes (*cf.* the description on p. 109).

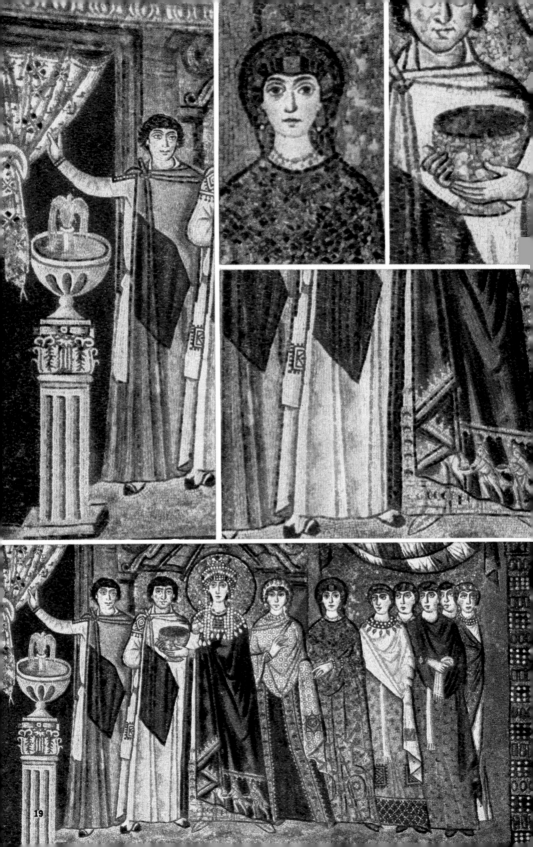

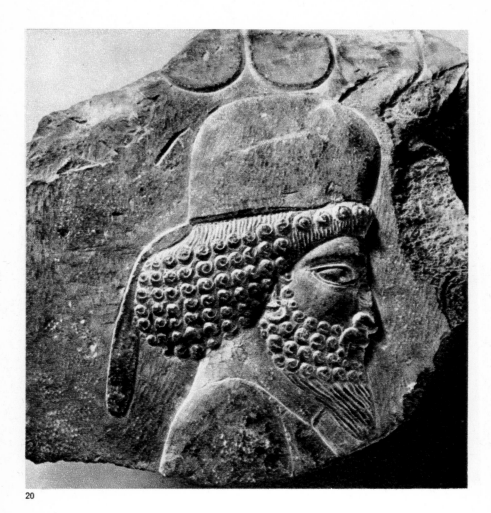

20

beauty as a thing to contemplate, but the direct rendering of expression. On the other hand, it was El Greco himself (Fig. 214) who, according to the Spanish painter Francisco Pacheco del Rio, once said that Michelangelo 'was a good man, but did not know how to paint'. Here again, it is clear that the eye of the Cretan painter could not penetrate beneath the surface of Michelangelo's plastic values, because El Greco's standpoint was essentially that of a colourist, not of a Florentine draughtsman. The absolutism of El Greco's art, which aimed at achieving effects by harmonizing discordant colours—in some ways a revival of remote Byzantine traditions—made it impossible for his angle of vision to coincide with Michelangelo's. (At all events as far as his critical intention was concerned, for although he did not realize it El Greco was himself influenced by Michelangelo, through the Mannerists.)

After these examples, we might mention Piero della Francesca, who was not fully appreciated until the twentieth century; Jacopo da Bassano; Masaccio, who for centuries was consigned to oblivion; the Byzantine artists, who were accused of being unable to render perspective (because it never occurred to anyone that their painting, being all on the surface, was based on a different conception of reality); the Impressionists—from Monet to Cézanne—who for years were derided and have only recently aroused the interest of a wider public; the tribal art of Negro peoples, and lastly, even Raphael and Leonardo, who in their own time were popular, but have often been misunderstood and subjected to unfavourable criticism.

As regards Leonardo, for whom it is difficult to find the most suitable angle of vision, incomprehension, even if mingled with superficial praise, was inevitable. 'This painter,' Antoine d'Argenville wrote in the eighteenth century, summarizing opinions which in those days were tending to become general, 'expresses all the minutiae of Nature—the hairs on the skin, beards, the hair of the head, herbs, flowers etc. This almost servile meticulousness in reproducing Nature might have been eliminated if he had studied antique statues, but he never did. His colouring is not of the best, and his flesh-colours are a trifle grey...'

Such examples could be supplemented by many others taken from every stage in the history of art and taste. Works of art are subject to change in the course of the centuries simply because taste and culture—and consequently the angle from which they are viewed— have been continually changing from ancient times down to our own days.

20 *Head of a Persian Warrior*, 5th–6th century B.C., Paris, Louvre.
This remarkable relief with its stringent rhythm is incomprehensible if we look at it from the wrong angle; most people would be inclined to say that the sculptor made a bad job of the foreshortening of the eye. They do not see that the symbolical values are here of greater importance than any imitation of Nature, and that the rhythm thus has an abstract spatiality, and, moreover, that the whole head is so expressively rendered that it seems to be alive.

We must, however, pause for a moment to consider the reputation of Michelangelo, one of the most popular artists who have ever lived. In his case, too, the dialogue with public opinion has had its ups-and-downs, especially at moments when opposition to Baroque was at its height. 'In all his works of sculpture and painting,' the neo-classicist Milizia tells us, 'Michelangelo makes a great show of his knowledge of anatomy, to such an extent that he would seem to have been working solely in the interests of anatomy. But unfortunately he never really mastered it or applied it properly... He mistook what is only a means for the end; he studied anatomy closely, and was right to do so; he made anatomy the ultimate aim of his art, and in this he was wrong; and worse still, he did not know how to use it. As a result, he was rugged, hard, eccentric, too intense, petty, coarse, and—even more noticeably—manneristic, since his figures always have the same style and the same character, so that when we have seen one, we have seen the lot.'

From statements like these it is clear that Milizia, instead of trying to formulate a critical judgement, was merely expressing his aversion to Michelangelo's style, because in Milizia's day the trend was towards rigid, academic beauty. This was obviously not the right way to approach the whole of Michelangelo's art, down to his last, astonishing work—the Rondanini *Pietà* (Fig. 1).

But at this point, in order to show that changing one's angle of vision does not imply putting a vulgar daub on the same plane as a painting by Giorgione or Piero, or that art has no objective values, we must define the limits and degrees of judgement, the difference between the 'ordinary' and the 'critical' eye.

21 Commonplace landscape.
The man with 'ordinary' eyes readily accepts works like this commonplace view of a lake; he is pleased by the resemblance to Nature, which in reality is due to an elementary use of perspective, and does not worry about the colours, which in this case are coarse.

22 The ordinary man's likes and dislikes.
The ordinary man readily accepts works which are lifelike and rejects those which cannot be comprehended at a first glance. His judgement may seem to be impartial, but in reality is influenced, not by quality, but by quantity, as well as by the stock phrases which he has heard other people repeat ever since his childhood.

21

The 'Ordinary' Eye, or Summary Judgement

I OFTEN think of my chance meeting with that man who was so fascinated by that wretched landscape depicting a lake. He was a representative of the public at large — a man with an 'ordinary' eye.

It is impossible to argue with people who have 'ordinary' eyes, because their criticisms are never unbiased; they start from a definite standpoint, and only later, when they have managed to develop their aesthetic culture and improve their taste, will they be ready to admit that they were wrong. But they don't know that yet; they are still convinced that they are right, that their way of thinking is the only one, and that those who do not share their opinions are not in a position to argue with them.

The judgements of people of this sort are dogmatic and they still take all the stock phrases literally. They never pause to think of spiritual values, but are impressed by technical skill. For them the only thing that matters is the subject (and in fact their first question is invariably: 'What does this represent?'), and they take not the slightest interest in the way in which this subject is transformed into a concrete image.

Their judgements are influenced by hearsay, by the traditions of the preceding hundred years. Without being aware of it, they are always behind the times. They accept only those things which have become the current fashion.

The vast majority of people have reached only this first stage. It seemingly never even occurs to them that other points of view may exist. Their sincerity, however, is always relative, since their ideas are not based on any real cultural training and they have never studied works of art. In fact, they have seen only very few works and these they have examined only superficially. Nevertheless, in each one of us, from the moment we begin to take note of our surroundings, a certain taste is formed, which will subsequently appear to us to be wrong as soon as we have got beyond the first stage.

However superficial this first taste may be, we feel it entitles us to criticize works of art, to discern certain qualities in them, and we are inclined to argue if we see that these qualities are not there, if — for example, in modern works of art — we find that it is difficult to say what the picture represents, or note the absence of beauty as conceived by the neo-classicists, of lifelikeness, sugary and pathetic effects, or technical skill.

23 Commonplace ornament.
 Similar objects are to be found 'ornamenting' the houses of people who have no taste, but fondly imagine that such things are beautiful.

24 Strip cartoon.
 Like the oleographs of former days, modern strip cartoons play a rôle in the aesthetic education of people with ordinary eyes.

The formation of this early kind of taste is influenced by the things we see around us, which become our teachers without our knowing it. They may range from the products of craftsmen to mass-produced articles; from trivial knick-knacks to picture-postcards, commonplace images of saints, Christmas cards and strip cartoons; from the appalling statues to be seen in cemeteries to advertisements and the ugly monuments in our public squares. All these things, to which no critic attaches any importance, have a fundamental influence on the formation of taste, a greater influence than real works of art, which are comparatively rare and which few people ever see or study — or if they do see them, do so without knowing how to look at them. Quantity, when it becomes omnipresent, has an overwhelming influence on the subconscious. But it does not enable us to appreciate the values of rhythm, of proportion, of genuine expression and style.

In the early stages our judgements are largely influenced by stock phrases which we accept as precepts; such as 'Art should confine itself to the imitation of Nature', 'beauty must always be ideal beauty', 'anyone who wants to become an artist must first of all study anatomy', or, 'artists must be good at perspective'. These are phrases which the ordinary man hears repeated as if they were dogmas and which even during his schooldays result in his acquiring an inferiority complex just because he finds that he cannot foreshorten figures or master perspective, or express ideal beauty; and that is why he dislikes all art which to him seems to be childish, for example the works of Klee (who in reality was one of the greatest and most complex painters), and does not admire mosaics like *The Cortège of Justinian* or *The Escort of Theodora* in the church of San Vitale at Ravenna. Even Giotto does not altogether satisfy the man with an 'ordinary' eye, because Giotto's treatment of space seems to have no perspective depth.

To the ordinary man the Primitives were men who had not yet learned to express themselves properly, in a beautiful and at the same time skilful way, because they lived before the days when art became 'sublime' and then began to decline, since when no one has managed to produce real works of art. For the ordinary man this myth of the evolution of art is an indisputable truth.

And that is why so many people are ready to declare that art, if it is real art, can always be easily understood by everyone. Consequently, they think that they are just as capable of forming an opinion as any critic.

25 GUSTAVE COURBET, *The Funeral at Ornans*.
The ordinary man likes Courbet's paintings because they are lucidly realistic. But a thorough understanding of his art is another matter, because he did not merely imitate Nature. This painting has an unusual expressiveness, due to the alternation of beats and pauses, the use of grey tones and the fact that many things are left unsaid.

26 Cheap reproduction of Michelangelo's *Pietà*.
Comparatively few people have ever seen the original of this *Pietà* in St Peter's, Rome. The popularity of the work is due to the existence of thousands of cheap reproductions.

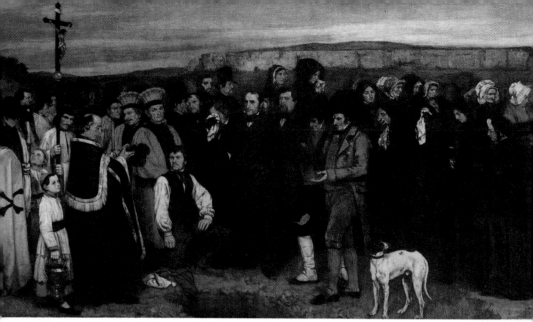

25

26

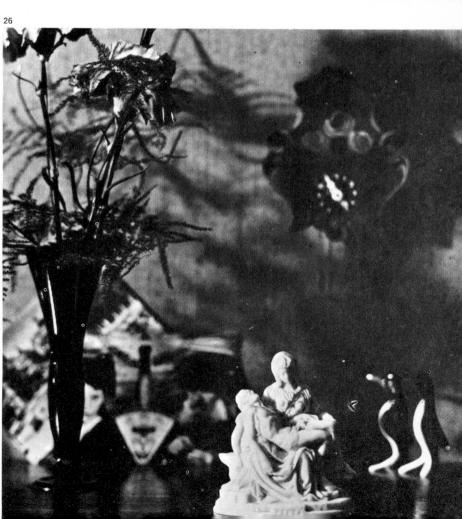

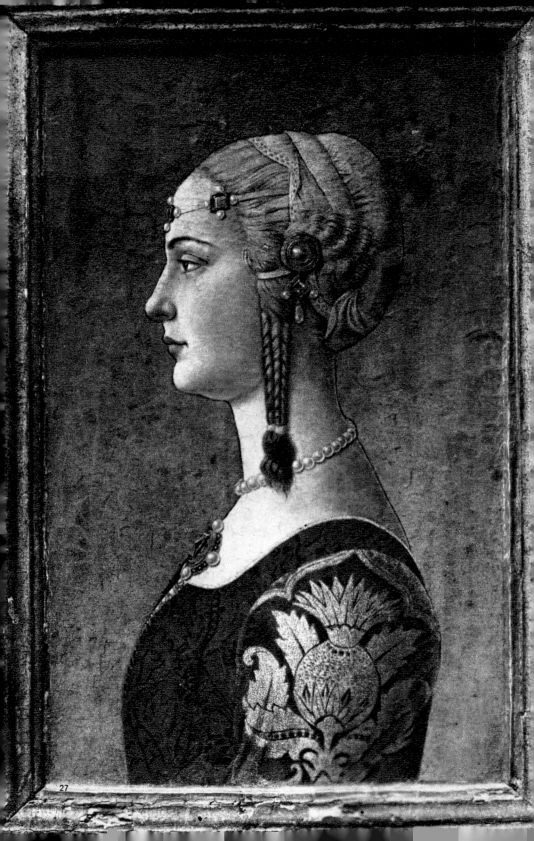

27

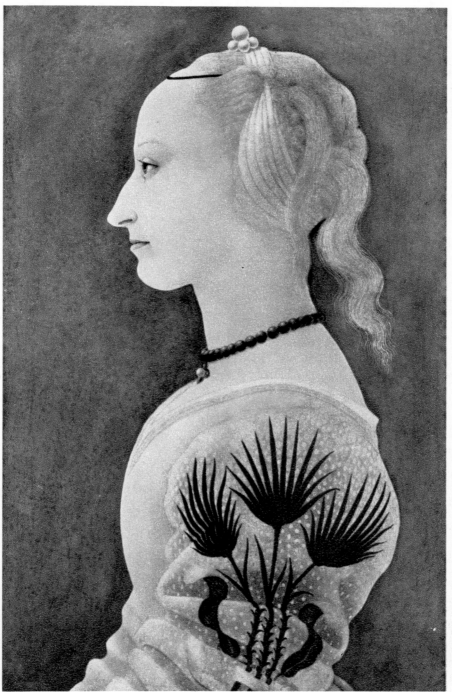

28

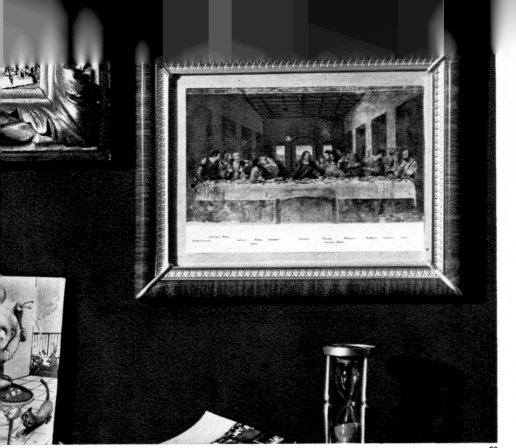

29

30

31

In reality, for people with 'ordinary' eyes copies of paintings or statues have the same value as the originals. They may even admire forgers more than they admire the actual creators. Such people believe that 'you have to be a good artist if you want to produce a good forgery', and here once again we find that inferiority complex of the ordinary man which leads him to admire any degree of skill that he himself is incapable of achieving.

The ordinary man's distrust of critics is also due to his conviction that, to judge works of art, sensitivity, imagination, intuition and feeling are needed, and that he himself possesses these qualities in abundance. To a certain extent, he does possess them, since he is inclined to be emotional and sentimental. But he is unwilling to admit that art can be understood only by those who know how to focus their eyes properly, which implies, among other things, that they must have a thorough knowledge of the circumstances in which a particular work of art was produced. This in its turn involves making a certain effort to grasp the essential premisses of each form of artistic culture; in other words, we must not expect to find in Giotto or in Egyptian painting things which are only to be found in the works of Raphael or Ingres, or in artists of the fourteenth-century Sienese school.

There is an explanation for all these misunderstandings. In the mind of a spectator who is trying to form an opinion, the aesthetic emotions evoked by a popular song, by doggerel verse or by a wretched daub, are initially as intense and as pure as those experienced by better-trained minds when they are considering real works of art. Consequently, the man with an 'ordinary' eye cannot understand

27 Faked portrait of a woman.
The ordinary man sometimes admires fakes more than he does the originals, and he is fond of saying that 'you can't even fake a picture without knowing something about art'.

28 ALESSIO BALDOVINETTI, *Portrait of a Lady*, 15th century, London, National Gallery.

29 Oleographic reproduction of LEONARDO DA VINCI's *Last Supper*.
Like Michelangelo's *Pietà* and *Moses*, Raphael's *Madonna of the Chair*, and some of Titian's paintings, Leonardo's *Last Supper* is well known to the ordinary man because of the existence of thousands of reproductions.

30 RAFFAELLO SORBI, *Dante's first meeting with Beatrice*, 1903.
Romantic painters of the late nineteenth century had a predilection for subjects taken from mediaeval history, especially for love-scenes. Such pictures appealed to popular taste and the ordinary man of today still admires them.

31 A typical contemporary advertisement.
Although we may not be aware of it, the numerous placards we see on walls exert an influence on our unconscious and they help to form the ordinary man's taste. Really beautiful advertisements are rarely seen; most of them are mediocre productions or even vulgar. Nevertheless, quantity has hidden powers of persuasion, even when, as in this case, the poster is deliberately commonplace, in the hope that it will appeal to wider circles of the public.

(except in very special cases) that a more thorough critical knowledge of the subject is needed. He is in perfect good faith when he believes that his own opinion is the right one.

And in fact, when he first comes into contact with works of art his opinions are at least coherent. He judges everything from one angle, and misunderstands values without realizing it. In this first phase the catharsis—i.e. the process of aesthetic purification, which has been held to be the indirect purpose of great art—undoubtedly exists. Once he has reached the first stage in criticism, a man listening to a popular song is moved and his passions are purified; he thinks that the song is wonderful. But if he had to listen to the works of Bach, Stravinsky or Hindemith, which cannot be described as 'catchy', he would think that they were artificial and boring. In this latter case his soul does not appreciate the poetical effects and the catharsis does not take place.

* * *

Having reached this point, we can start our examination of the early stages in the formation of taste characteristic of the various civilizations and periods, which are inter-related because they all sprang from a basic demand for direct communication. To make our exposition clearer, however, we will first make a brief study of the factors which have contributed to the formation of the ordinary man's taste in the culture of our own times.

Nowadays there is much confusion and conflict between the various means of communication. The ordinary man therefore assumes a defensive attitude, bewildered and overawed as he is by the mass of conflicting ideas, controversies and exhibitions, from which he is virtually excluded. There are critics who do not—and do not want to—understand each other's ideas (one of them will say that a work is a masterpiece, another that it is rubbish; so which of them are we to believe?); there are descriptions couched in difficult terms which only initiates can understand; innumerable exhibitions are organized, some of them on a big scale, and in many of these we find works exhibited which are in violent contrast with one another. Where are we to begin if we want to understand? And then again, why should we try to understand? As soon as we have mastered one thing or one trend, it becomes old-fashioned and is replaced by others which in turn will soon be out-of-date. What is the point of this mad rush to demolish things? It merely creates still more confusion. Some people are still proclaiming from the housetops that art ought to be nothing more than imitation of Nature, while others maintain that it

32 GEORGES BRAQUE, *Violin*, collage, 1913, Philadelphia, Museum of Art.
The ordinary man definitely dislikes a picture of this kind, because to him it seems to be flat, without relief, unlifelike and too intellectual. He knows nothing about the influence of Cubism, which has induced this refined French painter to express the rhythm of the composition in a harmony of lines and colours on modulated surfaces, combined with a rigorous treatment of space and the use of subdued tones.

50

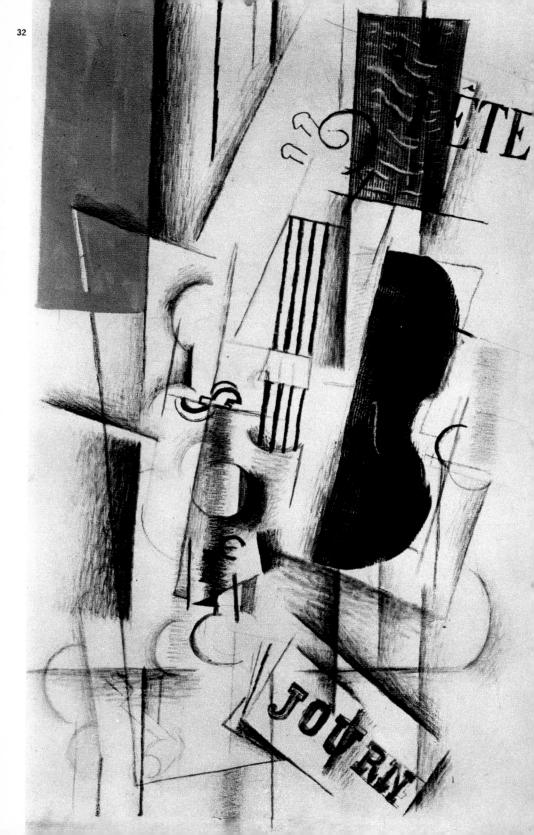

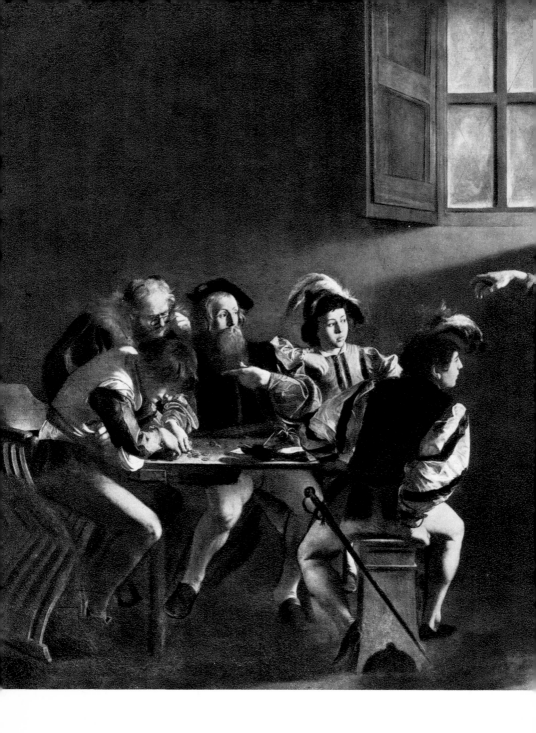

33

34

35

36

should never imitate or try to represent anything; others again say that everything is a dream, but that life has its problems which are not dreams; others seem to be convinced that art is a kind of dustbin; they draw a few lines at random and proclaim that this is authentic, great art; or they depict intestines and entrails, produce pictures which are not painted at all, but consist of objects standing out in relief — puppets, cushions or bits of metal. What is there in all this that can really be called art? Picasso, for example, sometimes paints in the manner of the Old Masters — pictures in which everything is beautiful and neat and easy to understand; but in the same exhibition we may find another picture by him in which a woman looks like a bull and has two noses, while her knees are where her breasts would normally be and her shoulders where we would expect to see her feet. Why should we even try to understand things of this sort? 'I can't make head or tail of it, it's just a leg-pull.'

When in this state of mind, the ordinary man — in other words, the public at large — refuses even to try to understand and takes refuge in the more comprehensible past. As a guide he takes certain fundamental characteristics which he feels will never let him down: a kind of beauty resembling that of cinema-stars, since sex-appeal is always pleasing: a subject that can be easily identified — an imitation of Nature or at all events something vaguely resembling Nature; and then he looks for a knowledge of anatomy, foreshortening and perspective, and above all technical skill, embellished, if possible, with a little sentiment — all these being things which can be achieved only by 'real' artists, and not by inmates of mental hospitals. If the artist's name is well known, so much the better; and better still if he is one of those Old Masters who never let you down and whom everyone admires. 'The beautiful is always beautiful.' 'Everyone can understand real art.' 'You don't need to be an expert to understand that.'

Nowadays the ordinary man accepts Impressionism, because he knows that people expect him to accept it; but in the early stages of

33 CARAVAGGIO, *The Calling of Matthew, c.* 1595, Rome, church of San Luigi dei Francesi.
The ordinary man appreciates this Lombard painter's naturalism and his lighting effects, but, as usual, he is interested only in the illustrative elements. In reality, Caravaggio uses the narrative elements to heighten the visual effect of the whole.

34 Front page of a popular weekly.
Illustrations like this one, from the front page of the *Domenica del Corriere*, reveal a certain ingenuity in the creation of a picture which will strike the imagination of a large number of readers by appealing to the taste of the ordinary man.

35 RAOUL DUFY, *Orchestra*, detail, 1936, pen drawing.

36 *Race-course scene*, faked Dufy.
When he sees these two pictures the ordinary man finds that the fake is more comprehensible and less formidable. The genuine Dufy seems to him to be just a scrawl, with no perspective, no proportion and no beauty. Nevertheless, since both are works of modern art which 'distorts reality', the ordinary man dislikes both the fake and the genuine work. In reality the latter has a subtly modulated, flowing rhythm; it is poetical and makes expressive use of symbols and spaces.

the formation of his taste, he interprets the word Impressionism in the broader sense, including all works in which the brushwork fuses with the lighting effects. For the ordinary man the Florentine *macchiaioli*, the Lombard *scapigliati* school and the Post-Impressionists are on exactly the same plane as the original French Impressionists; but he makes no attempt to distinguish the names, of which he has only a vague recollection. He knows the names of some of these artists because he has heard stories (mostly apocryphal) about their Bohemian way of life, and if he looks at their pictures with half-closed eyes he is delighted if he manages to identify the subject-matter, the story behind them.

He admires Canova and the other neo-classicists, the Venetian painter Francesco Hayez and the rest of the Romantic school, but their names mean little to him. His eclectic taste is not based on a sound knowledge of their works; if it were, he might manage to distinguish copies from originals and mere technical skill would no longer impress him. He might also perceive that in the works of the best artists of the nineteenth and other centuries the actual way in which a subject is treated is of prime importance, and consequently his eye, helped by the clarity of the subject-matter, would then go on to consider the functions of colour, chiaroscuro, light, tones and lines — in other words, those factors which, although they are not the ultimate aim of art, help us to understand the figurative language.

But the ordinary man's taste develops on a much broader and more direct basis, on the fact that he has seen works which have become universally popular, imitations of them and the works of would-be disciples, bad copies, reproductions in the form of ornaments, picture-postcards, strip cartoons and advertisements. What counts in the first stage of the formation of taste is not quality, but quantity; with the result that in the end quality is ignored, or perceived only by those few who have truly critical eyes.

Today certain facile and mistaken ideas, repeated in the form of stock phrases, also contribute to the formation of the first stage of taste. These are based on the degree of lifelikeness or on a misinterpretation of Romanticism. For example, the notion that art must always be an imitation of Nature and sentimental effect, especially as regards the psychological pose of the figures, an effect which is necessary in order to achieve 'spirituality', or that artists must always

37 Maurice Utrillo, *House of the Composer Berlioz*, 20th century, Paris, Musée d'Art Moderne.

38 Picture-postcard.
 The ordinary man finds that there is little difference between the picture-postcard and Utrillo's painting, and in fact, up to a few years ago, he would have been inclined to give the preference to the postcard on account of its shallow sentimentality and he would have described the Utrillo as 'childish'. In reality, Utrillo's painting shows that he was a real artist, since he knows how to use tones and with the aid of colours evokes a lyrical state of mind.

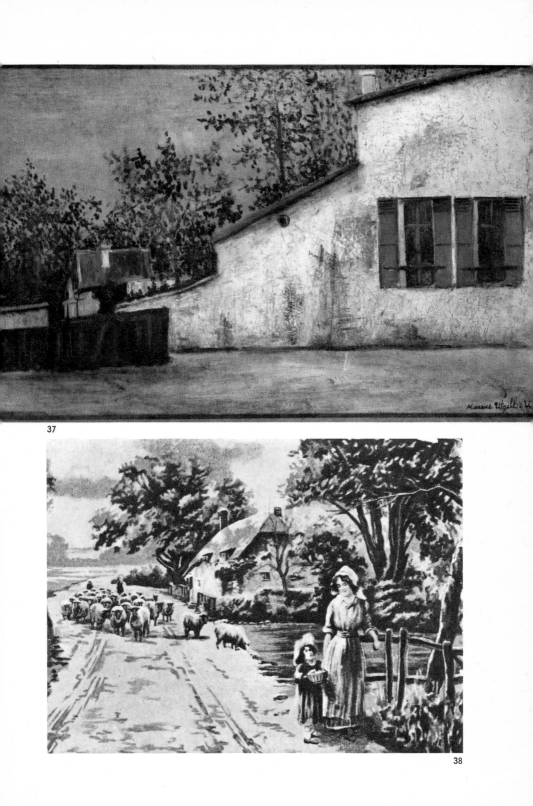

37

38

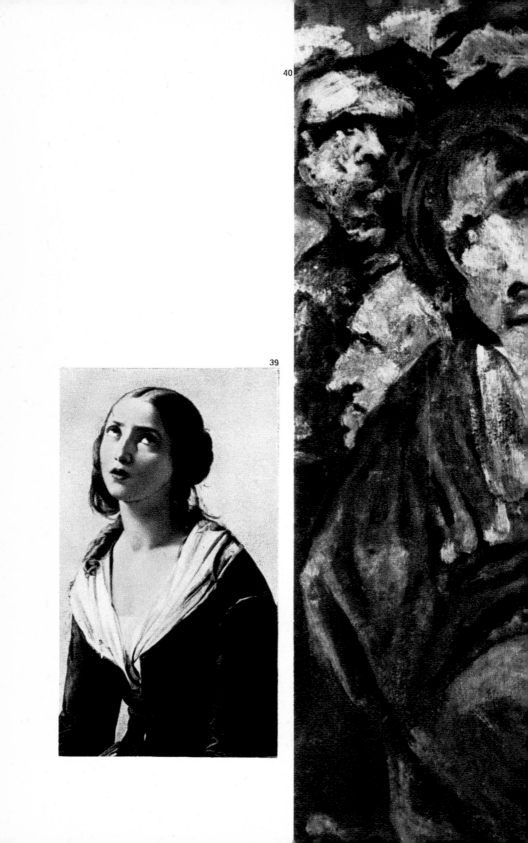

39

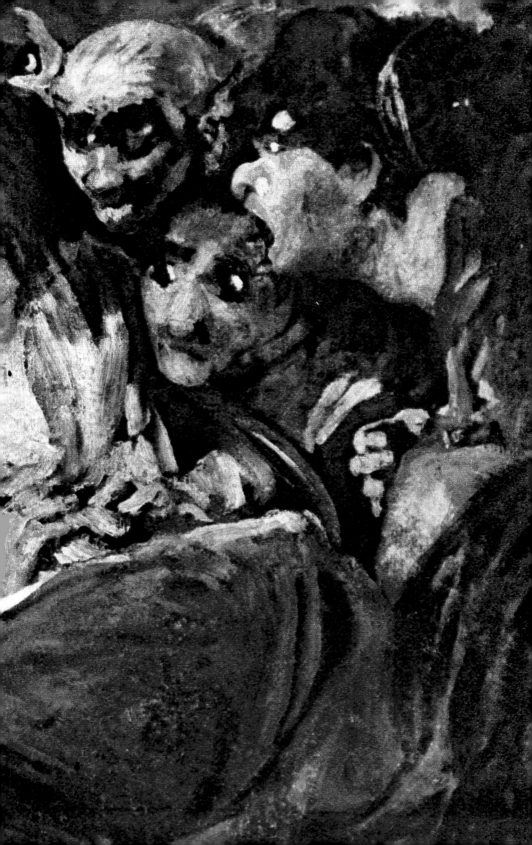

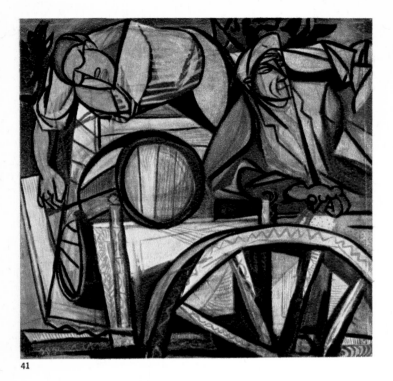

41

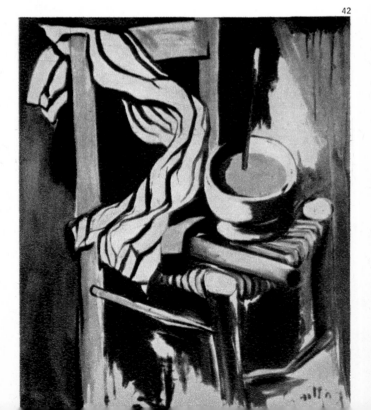

42

be 'very skilful' and, because they are skilful, are a superior race of beings. (In the following chapter the reader will find a whole string of stock phrases which the ordinary man still goes on repeating today as if they were new discoveries.)

The problems of rhythm, proportion, restraint and expressive deformation are not, as I have already pointed out, for the ordinary man; to him votive offerings and ingenuous paintings seem to be inferior art, simply because they do not appear to require any skill. When he hears the names of Leonardo, Raphael and Michelangelo, he feels that he is on firm ground; but of course, what impresses him is the external aspect or resemblance to reality, and he makes no attempt to understand the difficult problems of spatial composition, rhythm and proportion. Faked Raphaels, Pollaiuolos and Titians are for him on the same plane as authentic works, and he is reluctant to accept distortions which are not found in reality or are just mental abstractions. At the most, when he does not know what a picture is meant to represent, he will admit that it has a 'decorative value', though when he uses this term, what he really means is that it is an inferior work.

For the ordinary man, the abstract, non-representational works of Klee, Kandinsky, Miró and other artists are aberrations created by lunatics. He may accept Picasso in his more realistic, neo-classicist phase, but as for his other works full of distortions, the ordinary man thinks that they are not sincere, 'because Picasso can draw and paint perfectly well when he wants to'. Anything grandiose appeals to the eye of the ordinary man; in the past he rejected rational architecture, because to him it seemed to be nothing more than a pile of boxes, but today he admires skyscrapers, even if they are built of prefabricated sections, because they are imposing.

39 GIUSEPPE MOLTENI, *Despair*, detail, 19th century, Milan, Brera.
The ordinary man is attracted and moved by nineteenth-century pictures of this sort, showing a pathetic figure with upturned eyes, and in this case the effect is made even more mawkish by the sentimental idealization – a legacy of Romanticism.

40 FRANCISCO GOYA, *Witches' Coven*, detail, 1820–23, Madrid, Prado, formerly in the 'Quinta del Sordo'.
The ordinary man is impressed by the famous name of Goya. But what he likes best of all is the sensual beauty of the *Maja desnuda*. The distortions and gloomy colours in this painting, which is one of Goya's most expressive works, seem to the ordinary man to be due to the fact that the artist's mind was deranged. The ordinary man, however, is afraid to say that he does not like it, because Goya was a 'great' artist.

41 RENATO GUTTUSO, *Carters at night*, 1947, Brescia, A. Cavellini collection.

42 *Still life with chair*, forgery.
The ordinary man is unable to distinguish fakes from genuine works and will probably like this *Still life with chair* better than the *Carters at night*, simply because it is more true to life and therefore easier to understand. In actual fact, the *Carters at night* reveals the influence of Picasso's type of Cubism, whereas the *Still life with chair* is only an ordinary fake, in which the colours and heavy draughtsmanship show that it cannot be by Guttuso.

61

Men with 'ordinary' eyes can belong to any class. They can be found among the lower middle class or among the affluent bourgeoisie, among workmen, office workers and the professional classes (lawyers, doctors, academics, engineers), among writers and even among the originators of aesthetic theories or philosophers who discover something new, but who nevertheless, when it comes to matters of taste, remain slaves of their old prejudices. Obviously, the vaster their knowledge, the more readily will they reject stock phrases, but too often their visual taste is still conditioned by the fact that they are unable to change their viewpoints and achieve a critical detachment based on historical facts. We must not forget that even Benedetto Croce, who with his *Estetica* gave a new trend to Italian culture in our own times, when it came to visual art went so far as to maintain that the works of Cézanne, which today are universally accepted, were simply aberrations. In this respect Croce's eye was not even 'categorical'; it was just 'ordinary', still faithful to the naturalism of the old masters of the Neapolitan school.

43 PAUL KLEE, *Portrait of a Lady*, 1924, Venice, P. Guggenheim collection.
The ordinary man takes an even greater dislike to the art of Klee, which to him seems childish and clumsy. Since he knows nothing of the life and works of this great modern painter, he cannot see that Klee was a very gifted artist, who, in order to achieve a more poetical simplification, reduced his means of expression to the bare essentials.

44 *Removal of the remains of St Mark*, 13th-century mosaic, Venice, St Mark's.
To the ordinary man there seems to be something wrong about this Romanesque mosaic revealing Byzantine influences, and he thinks that the deformations are due to inability to deal with perspective and copy reality. He does not see that this mosaic is based on a particular conception of space, with carefully modulated surface rhythms which heighten the harmonious effect of the colours.

45 and 48 Decorative sculpture from the last years of the nineteenth century, Rome.
Nineteenth-century monuments, the tombstones to be seen in cemeteries and decorations like those shown here, dating from the reign of King Umberto (an *Allegory* on a house in Via del Tritone and a tasteful *Window* in the Palazzetto a San Lorenzo) are typical of the taste of that period—an anecdotical realism which, however, does not preclude the insertion of allegories and a sentimentality which is almost always rhetorical and redeems itself only if we consider it with a dose of irony.

46 GIAMBATTISTA TIEPOLO, *Aeneas presenting Ascanius to Dido*, 1757, fresco in the Villa Valmarana, Vicenza.
Tiepolo is admired by the ordinary man because of the melodramatic touches which make some of his works more pleasing to the eye than the sincere, harsh manner which this Venetian master often adopts, for example in the cycles of paintings in Udine. In short, the ordinary man occasionally admires really great artists, but for the wrong reasons; in this case, the illustrative character of the work, its pathos, eloquence and lifelikeness, the idealization of beauty, the splendour, sensuality and theatrical effects.

47 FILIPPO PALIZZI, *Little Donkey*, 19th century, Rome, Galleria d'Arte Moderna.
Works like this delight the ordinary man on account of their meticulous adherence to reality, which poses no problems and can therefore be understood at once. The ordinary man remarks with satisfaction that 'you could almost count the hairs on that donkey's hide'.

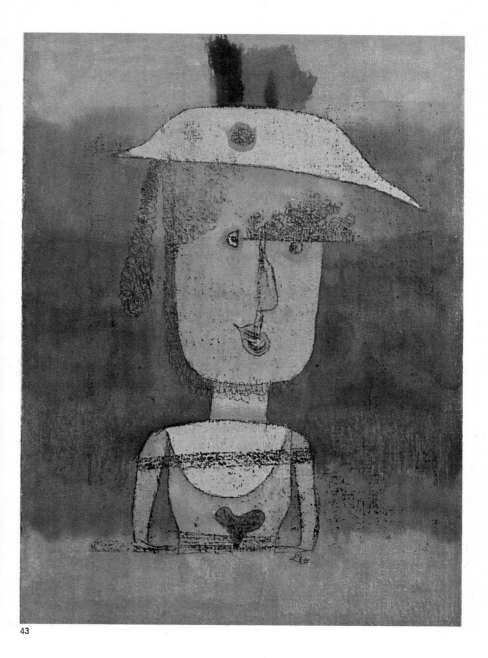

43

MARC

ALEXAN
DRIA

THEODO
R.PBR

STA/R
CIVS
MON

S

CARNIB: ABSCONSV·L

RVSTIC

RVSTIĆ

TRIBVN.

...VNT FVGIVNTQ. RETRORSV.

STAVRCLVS THEODOR.
MON̄ PBR

TRIBVN RVSTIĆ

...NZIK.NZIK.

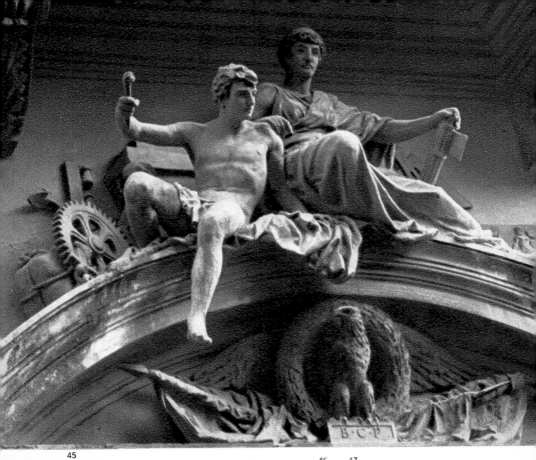

45

46 47

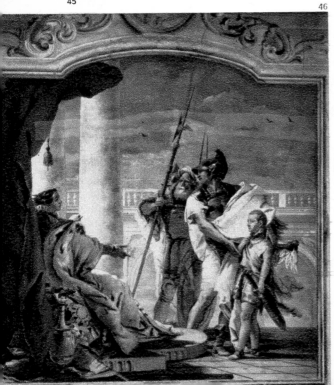

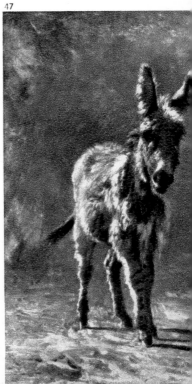

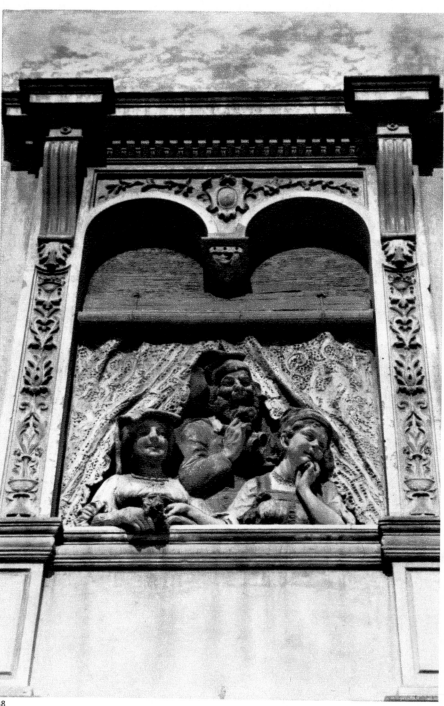

48

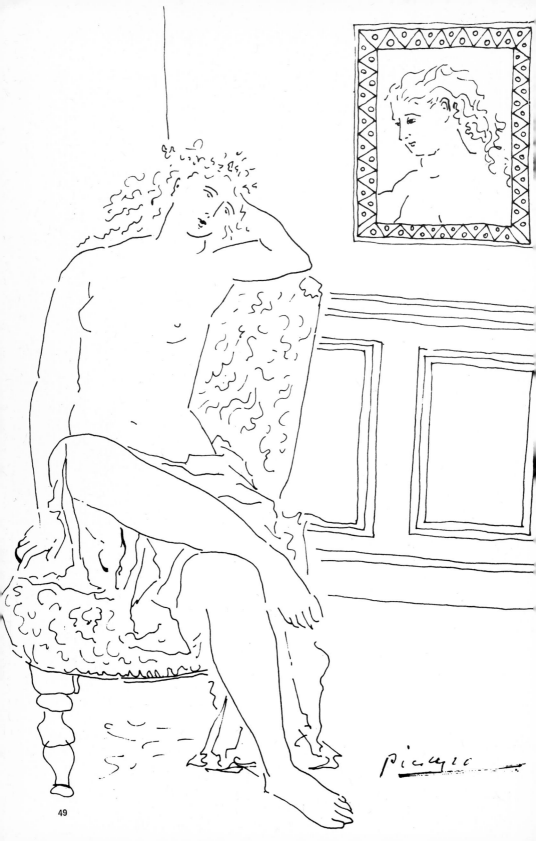

49

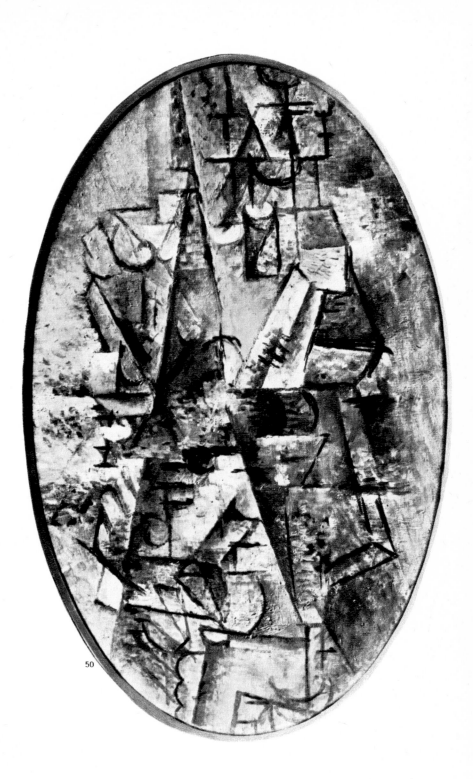

50

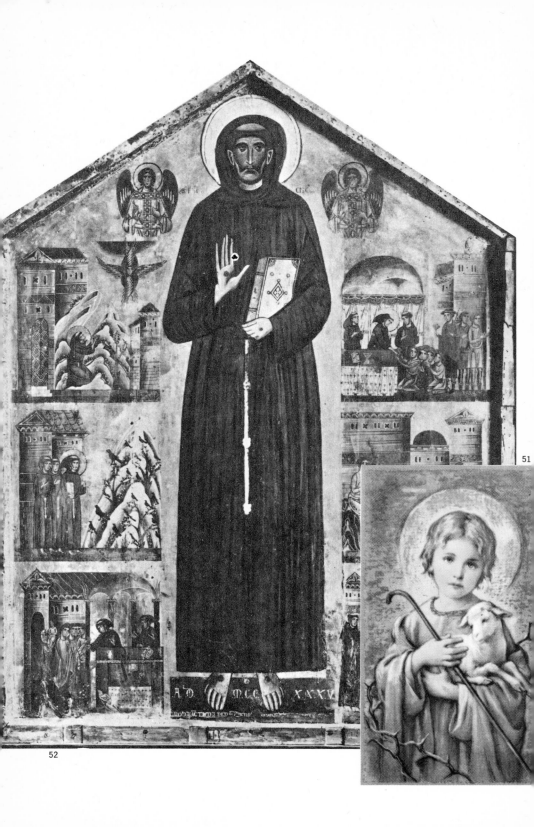

51

52

Stock Phrases from the Vocabulary of an Ordinary Man

BELOW we give a selection of stock phrases which the ordinary man is fond of repeating in an aggressive and polemical way, as if they were sensational discoveries and absolute novelties.

'The beautiful is always beautiful.'
'Everyone can understand real art.'
'You can't even fake a picture without knowing something about art.'
'A thing isn't beautiful just because it's beautiful, but because we like it.'
'The drawing's quite good.'
'Of course I know nothing about art, but I know what I like.'
'I could do better than that myself.'
'It all depends on one's eyes.'
'Anybody can understand Raphael.'
'How wonderfully pathetic!'
'Don't these people know how to paint portraits?'
'It may be beautiful, but what on earth does it mean? What does it represent?'
'That navel is much too high up.'
'Art is wonderful!'
'So that's what they call a Venus!'
'They ought to try drawing a real hand. As for the feet, they never get them right.'
'Even your children could do better than that!'
'They're just trying to pull our legs.'

49 Female nude, forgery.

50 PABLO PICASSO, *Homme à la mandoline*, 1911, Milan, G. Mattioli collection.
 Such works as this are categorically rejected by the ordinary man, who thinks that they are too intellectual and is annoyed because he has a feeling that the artist is pulling his leg. He fails to notice the rhythmical coherence of the syncopated segments, the harmony of the handling of space and of the austere brownish colouring. The ordinary man finds the female nude far more attractive, though the draughtsmanship is all wrong.

51 Ordinary greetings-card.

52 BONAVENTURA BERLINGHIERI, *St. Francis with episodes from his life*, detail, 1235, Pescia, church of San Francesco.
 The ordinary man will hardly think that Berlinghieri's picture is beautiful, and is more likely to believe that this 13th-century artist painted in this way because he did not know how to paint any better, since he believes in the evolution of art, which for him is a question of skill. And he is almost certain to prefer the commonplace, pathetic and mawkish greetings-card.

'Art with a capital A.'

'In those days painters really knew how to paint!'

'The anatomy's all wrong!'

'Those were the days! A nose was a nose then, and an eye was an eye.'

'He can make love to Picasso's Venus if he wants to. I'd sooner have Titian's any day.'

'There's no such thing as art these days.'

'Provided a thing's beautiful, anyone can understand it.'

'They say that things like that are beautiful just because they want to show off.'

'I'll tell you what I'd do to the man who painted that woman. I'd make him marry her.'

'Nowadays people don't have time to paint like they used to.'

'Modigliani is the man who always paints people with long necks.'

'The only beautiful thing about that picture is the frame.'

'Come and look at it from over here; you'll see how the eyes follow you.'

'In those days painters had patrons who looked after them; nowadays they have a hard job to make both ends meet.'

'You can't even see which way up it ought to be.'

'Leonardo was a universal genius.'

'This sort of painting is all the rage now, but just wait a few years and you'll see...'

'How expressive the eyes are!'

'This is a practical joke'.

'Raphael was the painter of sublime beauty.'

'There's no getting away from it; Hitler was a bad man, but he was quite right when he burned all those horrors they called works of art.'

'You're quite right; that sort of art is "degenerate".'

'Just look, that picture speaks; you can almost hear the words.'

'Art that doesn't touch people's hearts isn't art at all.'

'That looks just like real flesh.'

'When artists were as poor as church mice, it gave them inspiration and taught them how to paint.'

'Caravaggio was the painter who was dogged by fate.'

'Art means ideal beauty.'

'Art ought to be just imitation of Nature.'

'Just look at that rose; you can almost see the dew on it.

'That isn't a woman's nose, it's a bull's.'

'If art doesn't try to be sublime, it just isn't art.'

'To judge by that man's complexion, he's got jaundice.'

'The eyes are very expressive.'

'People shouldn't dabble in art just for their own sakes.'

'At that rate we're all painters.'

'It's absolutely lifelike.'

'It might be a photograph!'

'When an artist's a genius, he doesn't need any teachers.'

'The function of art ought to be the education of the masses.'

'Van Gogh, the mad painter.'

'Real art is religious art, that's a safe bet.'

'Art is simply the representation of things that exist and that we can touch.'

'It looks just like a picture-postcard.'

'When Michelangelo had finished his Moses, it looked so lifelike that he threw down his chisel in front of it and shouted: "Why don't you talk?"'

'As for those critics, they're just people who couldn't hold down any other job.'

'In this picture there just isn't any perspective.'

'I can't think why they call that a portrait of a "woman"!'

'The colours are all right, but the figures are as stiff as ramrods and treading on one another's heels.'

'You can almost count the eyelashes. That's what I call art.'

'I won't let you go until you tell me what this horrible thing is supposed to mean.'

'Here the pupil has done better than his teacher.'

'As for those art-dealers, I leave them to you. All they think about is making money.'

'After all, there are so many beautiful old works that you can't expect these people to tell us anything new.'

'Some of the pictures you see nowadays really make your hair stand on end.'

'All right, I agree; but if the painter had been born later, he'd have known more about perspective and foreshortening.'

'The things my child used to scribble when he was four were far better than that.'

'If art stops imitating Nature, it won't survive for long.'

'Nature is the artist's only teacher.'

'Seeing that you can buy beautiful clean bottles in any shop, why do these people paint only broken old ones?'

'Art ought to improve our minds, not make us worse than we are already.'

'Art means gracefulness.'

'Just wanting to produce a work of art won't get you far; there's always something miraculous about it.'

'They used to call this place a temple of art, but now it's nothing but a freak-show.'

'Modern painters have no souls.'

'Fancy taking all that trouble just to produce a thing like that.'

'It's all bluff!'

'No one has the courage to say so.'

'The man who did that was cunning and just speculating on the result.'

'Don't talk to me about those critics, they love using difficult words so as to make it more difficult for us to understand.'

'They try to impress us by being abnormal.'

73

'They call this picture *Flowers*, but I can see nothing but leaves.'
'Is that supposed to be a saint?'
'Believe me, I like lovely pictures, especially landscapes, but only when they're really good; I've no use for still-lifes.'
'That isn't art, it's just silly.'
'That's worse than the way monkeys behave. Really!'
'Titian was the sublime painter of sensual beauty.'
'Art ought at least to be lifelike.'
'Well, what else do you expect? After all, we're living in a period of transition.'

53 Nineteenth-century print.
 During the last century, prints showing horses were very popular with the general public, especially if they were lifelike or even 'a trifle idealized'. 'The horse is a noble animal and *so* decorative.'

74

What the Ordinary Man sees in Museums and what he says about the Works he sees

WHAT are the reactions of the ordinary man when he visits museums, and what does he say when he looks at the pictures, statues or frescoes exhibited there? All of us, at one time or another, have heard some member of a group who, as soon as he sees, say, a portrait, exclaims: 'I say, that's just like my cousin!'

When the party is in charge of a guide (and I know this from experience), the visitors with 'ordinary' eyes will listen attentively and take an interest in what the guide says; but if they have no guide, it all depends on how the individual members of the party are feeling, and the usual stock phrases and commonplaces are repeated as if they were novelties. The opinions are influenced by whether the artist is famous or not, and by the psychological mood of the individual who expresses these opinions to his companions.

I have listened to all kinds of comments in galleries and other places where works of art are exhibited – at the Brera or the Poldi Pezzoli Museum in Milan, at the Galleria Borghese or the Vatican Galleries in Rome; in the Baptistery at Castiglione Olona, at the Pitti Gallery or the Uffizi in Florence; in the National Gallery, London, in the Louvre or the Prado, at the Metropolitan or the Museum of Modern Art in New York. And exactly the same comments are made when people are looking at reproductions of famous works.

The taste of people with 'ordinary' eyes is influenced by ideas and names, and they repeat what they have heard other people say or their own impressions after one hasty glance. Naturally, they are impressed by skill. Leonardo's *Gioconda* astonishes them because it is famous; they admire Caravaggio's foreshortening or those interiors painted by the Dutch seventeenth-century school, 'where you feel you could actually touch the things'. But when they come across Piero della Francesca's *Virgin with Angels, Saints and the kneeling Duke Federico* in the Brera at Milan, they are apt to remark that 'to judge by the Child's face it's got jaundice' (I have heard this said several times, especially by doctors); and in front of *The Escort of Theodora* in the church of San Vitale they will keep on saying that it is 'wonderful', but that 'the figures are treading on one another's heels because the painter could not cope with foreshortening'. In the Baptistery at Castiglione Olone they will say that the water in the river, as painted by Masolino, looks like 'a wicker basket'. On the other hand, people with 'ordinary' eyes are quick to assume a defensive attitude and defend their own ideas and their own good faith with stubbornness against all those who do not happen to share their opinions.

54 GUIDO RENI, *Cleopatra*, *c.* 1642, Florence, Galleria Pitti.

On seeing this picture many people—especially ladies—are apt to comment on how fat Cleopatra is, how tiny the asp and how horrible it must be to hold a snake in one's hands, and they then go on to talk about Antony who 'died for love of her'. They never even notice the delicate art of this painting, which is a harbinger of Poussin's neo-classicism.

55 ANTONIO CANOVA, *Pauline Bonaparte or 'The Conquering Venus'*, detail, 1808, Rome, Museo di Villa Borghese.

This sculpture, in which the typically neo-classical continuous lines produce a rather frigid effect heightened by an adulatory idealization of beauty, gives rise to comments which are generally of a psychological kind mingled with moral disapproval; people remember that Pauline used asses' milk instead of water in her bath, that she had numerous lovers and was very capricious, all because she was Napoleon's sister. 'In those days portraits used to make people look more beautiful than they really were.'

56 MASOLINO DI PANICALE, *The Baptism of Christ*, detail, *c.* 1435, Castiglione Olona, Baptistery.

Few people are capable of appreciating the style of this very delicate fifteenth-century painter; those who go to see his frescoes in the Baptistery remark that 'the perspective is all wrong' and that 'the water looks like a wicker basket', or that 'Masolino didn't know how to make a scene dramatic'. If we want to understand the merits of this artist, who has not yet met with the recognition he deserves, we must consider his style against the background of late 'international' Gothic art and the early years of the Tuscan Renaissance; and we must never, as so many people do, compare him with Masaccio, who was of a very different temperament.

57 *Portrait of Margherita Gonzaga*, Florence, Uffizi.

This portrait by an unknown artist interests lady visitors, who often start by counting the pearls and discussing the coiffure, which they compare with the more comfortable modern style, but they never pay any attention to the style of the painting itself. The general public is often attracted by things which have nothing to do with art.

58 LEONARDO DA VINCI, *La Gioconda*, *c.* 1503, Paris, Louvre.

This is perhaps the most popular picture in the world, and yet it is one of the most difficult to understand, on account of the hidden rhythm in the pyramidal construction, with a kind of helicoidal movement inside the figure shown in three-quarter length, which gives animation to the half-lights with their *sfumato* transitions, so that landscape and figure are merged into one without any sharply defined contours. It is thus a work which combines Renaissance restraint with a lively potential movement. What the ordinary man admires above all are 'the eyes which seem to be looking in every direction', a phenomenon discernible in many portraits which any artist can easily produce. And the ordinary man is also impressed by the technical skill and above all by Leonardo's reputation as a great artist.

59 ANTONIO POLLAIUOLO, *Portrait of a Lady*, 15th century, Milan, Museo Poldi Pezzoli.

What impresses the public in this carefully modulated, linearistic fifteenth-century portrait is the refined elegance and beauty of the sitter, and also her coiffure and the necklace, which 'looks so real'. We may also hear unfavourable comments about the upper lip 'protruding above the lower'. It is undoubtedly true that the public appreciates the rhythm of this picture, but their attention is invariably distracted by trivial details: 'Just look how he has painted the hairs one by one. That needs patience! And as for the muslin, it's as delicate as a spider's web!'

60 FRANCESCO HAYEZ, *The Kiss*, 1859, Milan, Brera.

In front of this typical example of early Romantic painting, people inevitably start talking about 'the genuine sentiment of those days', 'so different from what we find in modern films', and they are impressed by the 'shininess of the silk' which 'no modern artist could paint so well'.

76

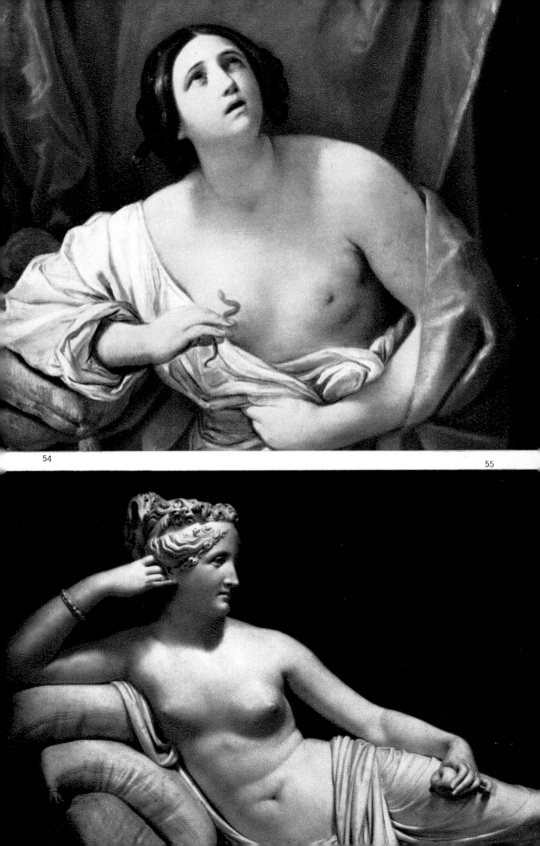

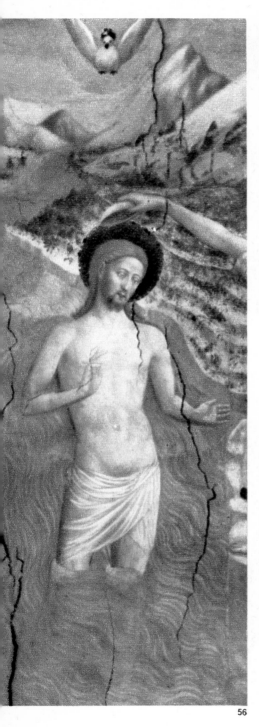

57

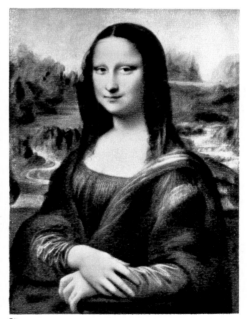

58

56

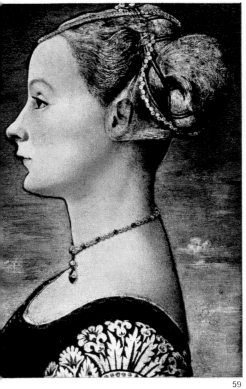

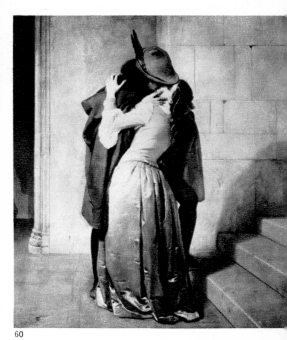

59 60

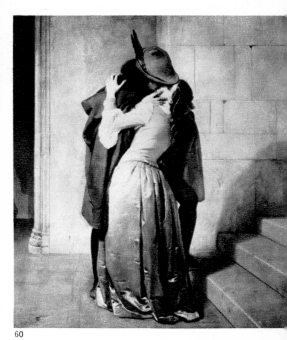

61

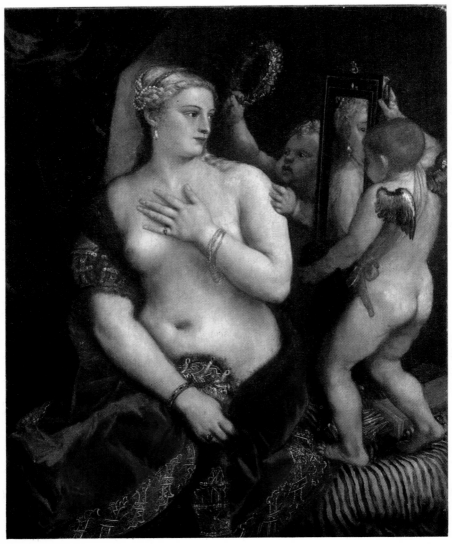

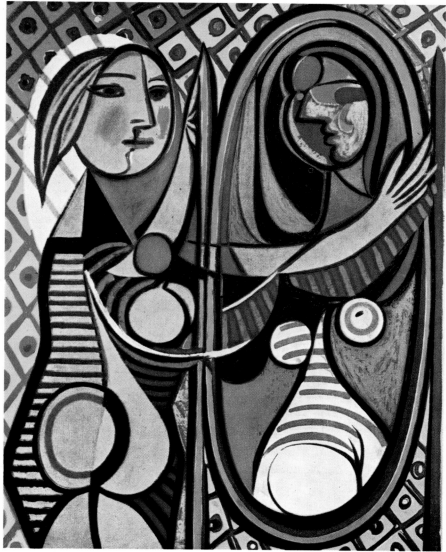

63

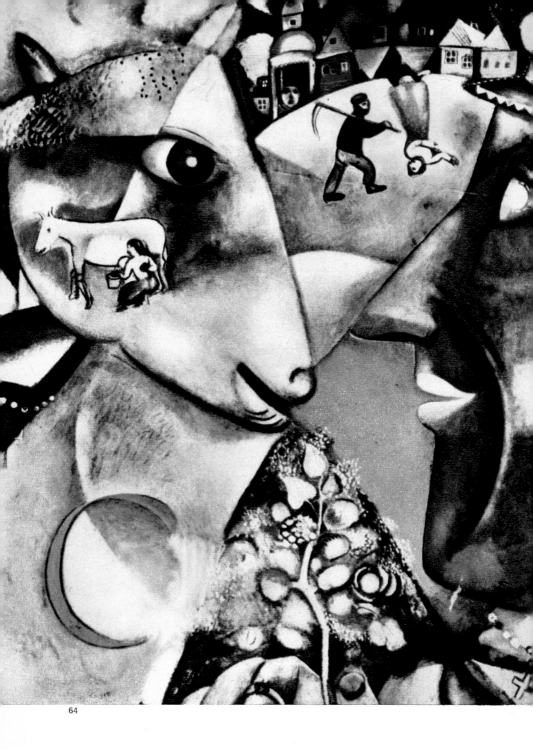

The Mistakes made by Hearsay-Mongers

IN MODERN society we find another type of person—a type that in reality has always existed—who is always prepared to express an opinion on matters of art and always ready to accept the newest and most revolutionary notions. The opinions of such people, however, though apparently spontaneous, have no firm foundations; they are just hearsay-mongers, whose only wish is to be 'with it'. Without any real knowledge, and consequently without any cultural basis, they are quick to express rash and mistaken opinions, which they are ready to change the moment a new trend makes its appearance, whereupon they will promptly express opinions which are the contrary of those they had previously held.

People of this kind suffer from a social inferiority complex and try to assert themselves by making an impression; they try to mask their own uncertainty by pretending that they understand all the newest and most startling ideas. They have all the characteristics of snobs, but only on the surface; a more or less subtle kind of exhibitionism gives them confidence even when they are wrong. They are, in short, the sort of people who have nothing but contempt for the ordinary man (who on the contrary at least has some ideas of his own, even if these may be wrong); when they find themselves in a room full of

61 CANALETTO, *View of the Grand Canal*, detail, 18th century, Milan, Brera.
 What impresses the public in this view of the Grand Canal is the 'skilful' perspective, the transparency of the water and the naturalness of the lighting effects, though these are all things that can be found in the works of minor artists who painted similar views. In Canaletto's works there are other things besides perspective—tonal values and an almost metaphysical atmosphere, timeless and surpassing Nature herself. But the ordinary man admires only the artist's skill in imitating Nature: 'That water's extraordinary! You can almost feel it!'

62 TITIAN, *Venus and the Mirror*, 1555, Washington, National Gallery, Mellon Collection.

63 PABLO PICASSO, *Girl before the Mirror*, 1932, New York, Museum of Modern Art.
 The ordinary man accepts Titian's *Venus and the Mirror* without any reservations because it conforms with his ideal of feminine beauty and is warm and sensual; but he is horrified by Picasso's *Girl before the Mirror*. He does not realize that Titian's painting conforms with sixteenth-century ideas (and is not, as it might seem to be, timeless); and that the reflexion of Picasso's woman as seen in the looking-glass solves problems of rhythm and painting which are characteristic of another age—our own.

64 MARC CHAGALL, *I and the Village*, 1911, New York, Museum of Modern Art.
 Numerous reproductions of this work exist and when the ordinary man sees them he waxes indignant: 'They're just making fun of us'; 'It's a leg-pull'; 'They can't think of anything better because all they want to do is to impress us'. In reality, the influence of Cubism and Symbolism gives a dreamlike air to this picture; it represents a state of mind and reminds us of the artist's longing for the Russian village where he spent his childhood. And the whole painting is based on limpid harmonious colours and rhythmical lines and spaces, which produce striking effects.

other people, they will talk of the latest trends as if they themselves had helped to launch them. They are fond of using technical terms when talking about certain matters and, by doing so, they make it impossible for others to contradict them; they will talk, for example, about pop art, about 'op', mech or cynetic art, of programmation in art, new methods of representation, automatism and alienation, of electronic and gravitational music, of unusual films which very few people really understand. And if anyone raises an objection, their reply will invariably be: 'Oh, but that's old-fashioned.' And the next time you meet them, they will say exactly the opposite, adding: 'That's what I've always said.'

A few penetrating questions (which, however, he will skilfully parry while continuing to treat you *de haut en bas*) will be all that is needed to show that the art snob has only a smattering of culture, for he never reads or studies seriously, because he has no real wish to understand; all he wants is to make a good impression and to cut a good figure. Generally speaking, people of this type come from the *petite bourgeoisie*; their inferiority complexes are due to the hardships they suffered when they were young and surrounded by tasteless things, and always longing for worldly success. But in reality they are incapable of any deep feeling; they are just mimics who can never see below the surface of anything.

In short, the mistaken opinions of such hearsay-mongers are not based on any clear point of view, or on the assimilation of taste, for they are shallow, changeable people who judge only by appearances, and they are also exhibitionists. Their contempt for the ordinary man, who is at least coherent, conceals a vacuum.

There is no point in arguing with people holding opinions of this sort. It would be futile even to start.

65 Pictures that people with 'categorical' eyes admire.

People with 'categorical' eyes have very definite tastes. On occasions they may be perfectly right, but they invariably start from one angle even when they are judging works of different civilizations and different periods. They lack the historical knowledge which we must have before we can express an opinion.

66

67

The Categorical Eye

In ADDITION to the more common types of ordinary men and hearsay-mongers we have another, easily identifiable type — categorical people who never hesitate, who are always ready to answer yes or no to any question, and for whom a work of art is either great or worthless. Here we have to do, not with psychological types suffering from complexes (though some of them may have such complexes in the concrete sense), but with truculent observers who invariably start from the same point of view, irrespective of whether they are discussing works produced by different civilizations or dating from different periods. Their taste is clearly defined and sometimes quite good, but their critical judgement has no historical foundations, and for this reason they take a categorical view of every work of art, regardless of the circumstances and culture that gave birth to it. They can be polemical to the point of exaggeration; they deny that anything can be a work of art if it does not conform with their own ideas; but on the other hand they may occasionally draw attention to certain works of art or throw a new light on others which have long been forgotten. Many of the people of this type are themselves artists, which means that they invariably start from a given point — that of their own art — and either in self-defence, or else because they are really convinced that they are absolutely right, they refuse to admit any other standpoint, and consequently reject all other trends except their own.

I have already had occasion to mention the negative, sometimes even violent opinions expressed by Francesco Albani when referring to the works of Caravaggio; and it is easy to understand how, since he started from the concept of a refined, 'precious' art, suitable for the drawing-rooms of fashionable people, Albani was bound to be repelled by Caravaggio's paintings and was thus unable to appreciate his vigorous naturalism. We need only compare one of Albani's own paintings, for example the *Dancing Putti* now in the Milan Brera (Fig. 66), which is certainly rather mannered, but nevertheless an accomplished, cultured work, with certain details in the works of Caravaggio, such as the feet and buttocks in the *Crucifixion of St Peter*, the feet of the kneeling man in the *Madonna of the*

66 Francesco Albani, *Dancing Putti*, 17th century, Milan, Brera.

67 Caravaggio, *Sacrifice of Isaac*, detail, 1590–91, Florence, Uffizi.

Albani, whose *Dancing Putti* is a typical example of his own style, thought that Caravaggio was a good painter when he simply imitated Nature, but that he tended to 'concentrate on the shape of objects, and not on movement, which proceeds from the mind and can be rendered only by those who have mastered drawing. His feeble brain, incapable of planning the composition in advance, thought only of silly things like melons and cucumbers, which can easily be rendered and appeal only to men of little judgement...'

Pilgrims or a detail from his *Sacrifice of Isaac* (Fig. 67), which are rendered with a 'vulgar' naturalness and prominence. Here we have two conflicting worlds, like two irreconcilable social classes. And it is also obvious that Caravaggio in his turn would have despised the works of Albani, simply because their points of view did not coincide.

Another example of aesthetic incompatibility is Michelangelo's remark about Flemish painting as quoted by the Portuguese Francisco de Hollanda in his treatise entitled *De la Pintura Antiga*, in which he tells us of his conversations with Michelangelo. Although Francisco de Hollanda is not always reliable, it is quite probable that Michelangelo actually was of the opinion which he quotes. Michelangelo loved broad, monumental syntheses, as can be clearly seen from his drawings (Fig. 68), paintings and sculptures, and even in his architecture, which conveys a sensation of movement thanks to the contrasts between the masses of chiaroscuro. This liking for synthesis made it impossible for him to admire the attention to detail seen in certain Flemish paintings, and in particular the tendency to give equal prominence to the figures, plants and background details in a scene. 'The attempt to execute perfectly so many things, each of which is in itself great and difficult, results in none of them being executed perfectly'—that is what Michelangelo is supposed to have said. In short, he was incapable of grasping the subtle atmospheric effects, thanks to which every detail plays its own part, with an expressiveness which may seem to be naturalistic, but is often allusive, thus creating a hidden rhythm giving animation to the whole. Michelangelo's starting-point was a rugged monumentality that was all essence, and this made it impossible for him to appreciate the works of Flemish painters.

Again, how could Medardo Rosso, at a moment when, with the zeal of an Impressionist, he was experimenting with the breaking-up of light into strokes, have appreciated the stark, hermetic, rigorous forms of the ancient Egyptians (Fig. 71)? It is easy to understand why this great Impressionist sculptor rejected all those monumental, sculptural figures, constructed with an architectonic austerity. In his own sculptures (Fig. 70) he tried to render the fleeting moment, the expressive mobility of being, by means of bold and rapid strokes, his chief aim being to lead the spectator to see the carved image from one point of view only, thus making it as similar as possible to a painting (though he did give us a new definition of plasticity, based on moving

68 MICHELANGELO, Studies for figures, 16th century, Paris, Louvre.

69 HANS MEMLING, *The Seven Days of the Virgin*, 15th century, Munich.
 We have another example of categorical judgement in the words which, according to Francisco de Hollanda, Michelangelo used when speaking of Flemish painting: 'The attempt to execute perfectly so many things, each of which is in itself great and difficult, results in none of them being executed perfectly.' But he failed to realize that the Flemish painters were symbolists rather than realists.

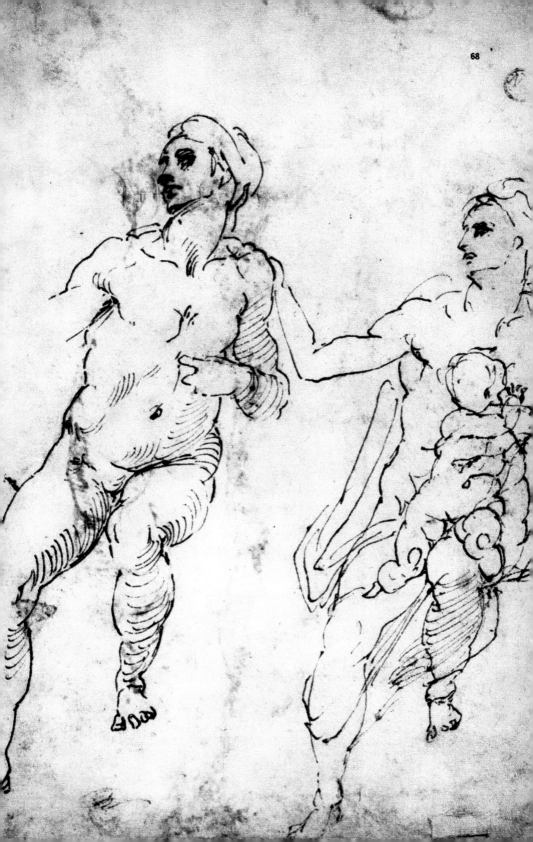

69

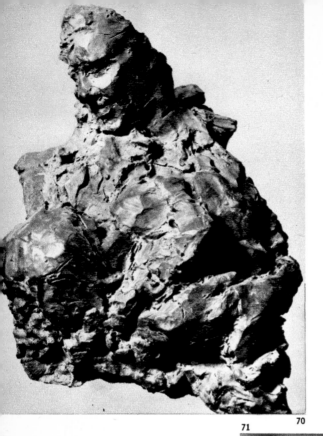

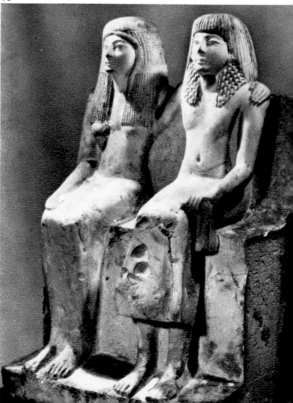

71 70

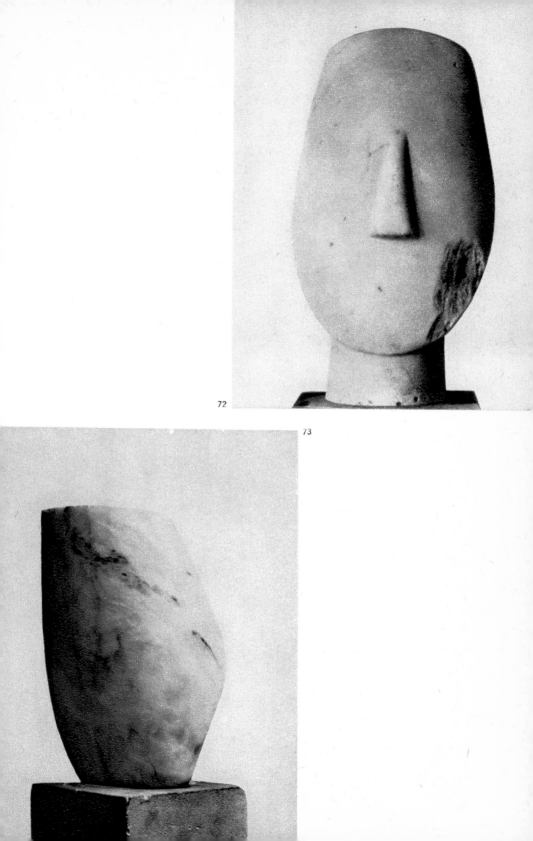

72

73

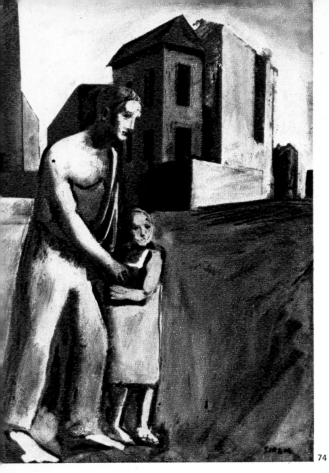

74

75

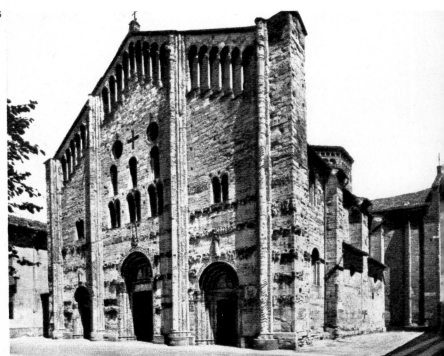

light and strokes). It was thus only natural that Medardo Rosso should reject the kind of sculpture round which one can walk—a carefully constructed, monumental form. His was the viewpoint of the categorical eye, not of the critical eye; for him sculpture was an act of faith, necessary in order to express his own particular language.

Another well-known controversy was the one between Giorgio De Chirico and all the modern followers of Impressionism—Cézanne, Modigliani and the other painters of our own century, whom De Chirico described as 'incompetent'. But he in his turn was accused by others of poetical incompetence, despite the fact that he used to sign his works '*pictor optimus*' (especially those executed after about 1930). De Chirico drew his inspiration, not from the Impressionist school, but from the Symbolist followers of the Swiss painter Arnold Böcklin, all of whom influenced him—careful finishing with a thin wash of colour in the antique manner. Earlier on, De Chirico had approved only the painters of the fifteenth century, rejecting the whole of the seventeenth century *en bloc*, and he used to make such categorical statements in 1919 in the review *Valori Plastici*, explaining his basic idea of a 'metaphysical aesthetics', at a time when he was still immersed in the atmosphere of his *Piazze d'Italia* and *Lay Figures*, which undoubtedly reveal a 'metaphysical' trend derived mainly from fifteenth-century painting, but transposed into a key of 'magic realism' (to quote Massimo Bontempelli). Later he sang the praises of seventeenth-century painting, the only school he considered worth studying after his conversion to a spectacular kind of Baroque. Obviously these controversies had no real critical foundations, but they do help us to explain the painter's occasionally categorical ideas.

70 MEDARDO ROSSO, *Maternity*, 1889, Rome, Galleria d'Arte Moderna.

71 *Funerary statues of a married couple*, New Kingdom, *c.* 1100 B.C., Turin, Museo Egizio.
 Medardo Rosso disliked the monumental, hermetic forms, with their architectonic austerity, so dear to the ancient Egyptians. In sculptures like this *Maternity* Rosso tried to render the fleeting moment, the expressive mobility of life, by means of bold and rapid strokes, his aim being to lead the spectator to see the carved image from one point of view only, thus making it as similar as possible to a painting.

72 Cycladic sculpture from Amorgos, *c.* 2000 B.C., Athens, Archaeological Museum.

73 CONSTANTIN BRANCUSI, *Torso of a Girl*, 1918, Sèvres, Private collection.
 Brancusi's compact, modulated sculptures, as exemplified by this *Torso of a Girl*, awakened interest in Cycladic civilization, which he interpreted in a new way.

74 MARIO SIRONI, *Townscape with figures*, 1932, Milan, G. Mattioli collection.

75 Church of San Michele Maggiore, Pavia, 11th–12th centuries.
 Sironi followed the 'twentieth-century' trend and with his categorical ideas he revised the existing interpretation of the expressive values of the Romanesque façades carved by anonymous masters. He has also written about his own methods, explaining the relationship between the unadorned sculptural lines of works like his *Townscapes* and the lucid expressiveness of Romanesque basilicas like San Michele Maggiore in Pavia, where the sculptures form an integral part of the architecture.

Let us now turn to the neo-classicists, for whom nothing existed outside Greek art, which—incidentally—they knew only from late copies, since they had never seen the originals. The categorical declarations of Winckelmann, Mengs and Milizia left no room for the relationship between art and the milieu in which it developed, and their statements were consequently not critical, but dogmatic, since they ignored the historical element in art. Winckelmann himself, however, did at least help to arouse interest in the Antique, which Nordics like him regarded with an exotic stupor, and to make people realize its value to our own age. Certain remarks of his on the continuity of line, on Greek beauty and restraint, threw a new light on Hellenic civilization, while other penetrating observations are to be found in the history of art which he wrote. But the neo-classicists, simply because they started from one rigid viewpoint, were obviously unable to understand mediaeval and modern art.

The contemporary squabbles between the supporters of abstract art and those of representational painting make no sense, because they are too generic. To condemn all compositions which are not representational, or conversely, all those that are not abstract, is a fundamental error, typical of the categorical eye. Such observations are merely generic opinions about individual works.

We must always remember that in the works of the abstract artists of the present day—just as with the representational painters of the past—there are innumerable variations on the same theme. Thus we may find geometrical abstraction side by side with images that appear to be non-representational, but are in fact dialogues with the reality of Nature, which, however, is reconstructed from memory and is therefore a state of mind, set in a background which is no longer naturalistic. Thus they seem to be abstract and non-representational, but their origins are representational. Take, for example, Mondrian's tree series (Figs. 191–194) and many of the works of Klee (Fig. 198). Then there is abstract painting executed with detachment of mind, without any profound participation of the emotions (here too Mondrian provides an example with the painting shown in Fig. 195). And there is also abstract painting based on total participation, as if dragged up out of the unconscious, for example the first, so-called musical compositions of Kandinsky (Fig. 199) or the more recent, non-formal works of Pollock (Fig. 205).

76 PAUL GAUGUIN, *The Yellow Christ*, 1889, Buffalo, Albright Art Gallery.

77 Sepik art, painted plaques from Eastern New Guinea, Basle, Museum für Völkerkunde.

Gauguin discovered the charms of primitive painting. His dislike for European civilization and his own synthetic symbolistic works, with their broad surfaces and stimulating colours, awakened a new interest in the art of remote peoples and primitive tribes. This had been first discovered by the Romantics, but Gauguin was the first to point out its real value. Naturally, his opinions were categorical and did not admit of any discussion.

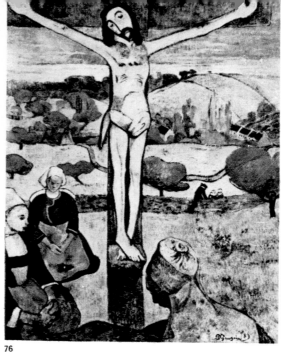

76

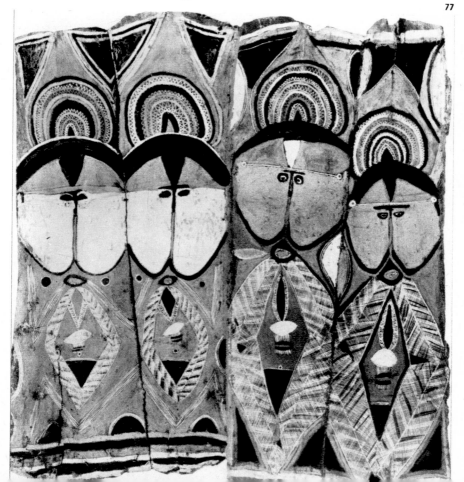

77

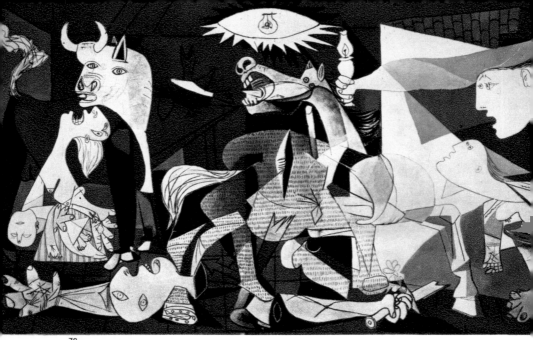

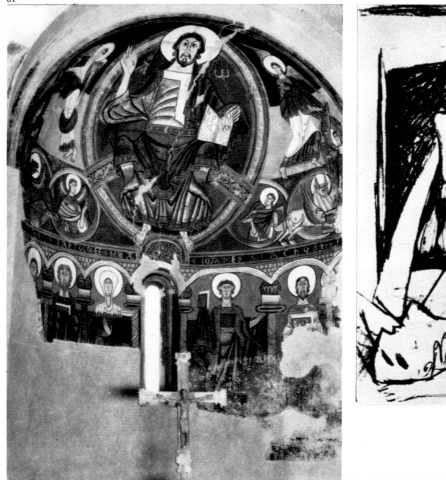

79
80

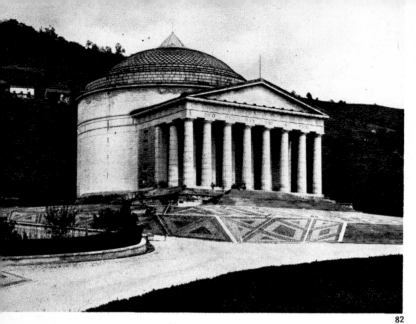

82

83

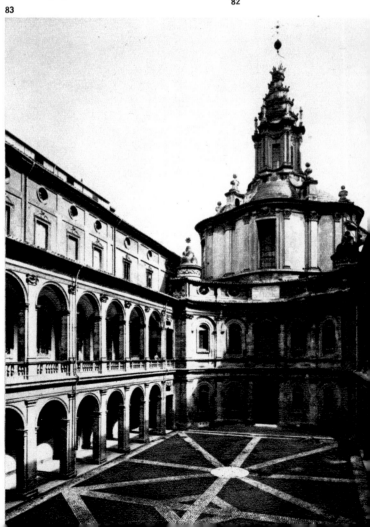

Conversely, even among representational painters there are some who are more intellectual and more aloof, while there are others who distort their images to a greater degree in order to achieve expressiveness—Piero della Francesca in the fifteenth century (Fig. 86) and Seurat at the end of the nineteenth (Fig. 85), who, although they are representational artists, are, on account of their geometrical accuracy, different from Masaccio as exemplified by his face of *Eve* (Fig. 219), which is distorted in the interests of expression, or from Nolde (Fig. 217), who distorts everything under the impulse of his desire for expression.

We must also point out that certain representational artists are closer, as regards temperament and conception of reality, to some of the abstract artists (for example, there is a kinship between Piero della Francesca and Mondrian) than they are to other representationalists (e.g. Piero della Francesca and Nolde are at opposite poles), and that conversely certain abstractionists are at loggerheads among themselves. And the same might be said of certain representationalists, the reason being that the prime factor is the individual temperament, whether hot or cold, emotional or intellectual, sensitive or aloof.

If, then, we attempt to judge a trend without taking into account the cultural milieu, the artist's actual personality and the historical circumstances in which the work was produced—without, that is to say, focusing our eyes properly on each occasion and, if necessary, changing our angle of vision—then we are making a mistake which will render us incompetent to judge the historical factor in art and its concreteness.

Obviously, if two people start from different or opposite points of view, each of them categorical, there can be no dialogue between

78 PABLO PICASSO, *Guernica*, 1937, New York, Museum of Modern Art.

79–80 PABLO PICASSO, Preliminary drawings for *Guernica*, 1937.

81 MASTER OF TAHULL, *Pantocrator*, 12th century, Barcelona, Museum of Catalan Art.
 With his famous *Guernica* Picasso threw fresh light on the Catalan painting of the Romanesque period. He revived an ancient tradition of his native country and brought it up to date. It should be noted, among other things, that in order to heighten the expressiveness of his symbols he transformed the first naturalistic elements, as seen in these two preliminary drawings which have been chosen from among many other studies, into a synthesis reduced to bare essentials. The connexion with Catalan art is thus only an indirect one, for Picasso had no wish to imitate it. He regarded it merely as a stimulating old tradition, of which he gave a new interpretation.

82 A. CANOVA and A. SELVA, The 'Temple' at Possagno, 19th century.

83 FRANCESCO BORROMINI, Sant'Ivo alla Sapienza, Rome 1642.
 What to Milizia's categorical eye was Borromini's worst defect—'he flaunted his singularity even in architecture'—is now deemed to be a fundamental merit, as can be seen in the original architecture of Sant'Ivo alla Sapienza, where the contrasting shadows and lights in the architecture produce fantastic effects.

them. Hence the interminable, futile arguments, among which we must also include the bad criticism we read in newspapers and art reviews. Such things confuse the public, who are puzzled and unable to distinguish the good from the bad.

But quite apart from the question of abstract and representational art, all those who try to reduce art to the programmes of certain trends and consequently take as their basis the various 'poetics', or in other words try to lay down the rules that art must follow, are really making exactly the same mistake in method. This, in reality, is just another form of categorical judgement. When Courbet, attacking certain sentimental tendencies among the Romantics, said that art must always reproduce 'the reality that exists', that we can see and touch, he was making a useful, in fact essential, comment on his own art. Nevertheless, he was starting from his own viewpoint, which he wanted to transform into a 'poetic' of his own ideas, instead of a guide to the understanding of the art of all times—the symbolism of the earlier periods, of primitive and oriental civilizations, as well as that of decadent cultures, would thus be classified as not being art at all. Courbet, being a great painter, achieved more than he set out to do, and in works like *The Funeral at Ornans* (Fig. 25) he expresses a great deal, including things that he does not actually say or depict; in fact he becomes a new kind of 'Primitive', a new, modernized Giotto with a predilection for broad syntheses.

For that matter the most gifted artists have always been absolutists and absorbed in their own particular vision of the world. The trouble starts when some of their minor followers, or certain ignoramuses, presumptuously adopt a categorical standpoint, taking everything literally and obstinately defending their own preconceptions. The controversies between abstractionists and representationalists, between the admirers of Wagner and followers of Verdi, between disciples of Romanticism and the neo-classicists, between the fanatical advocates of Venetian colouring or Tuscan draughtsmanship, between the opponents of formalism and the 'geometricians', and between innumerable other representatives of conflicting opinions, all degenerate into meaningless squabbles, because the participants start from different angles of vision and their arguments inevitably become too generic. And the upshot is that each of them sticks to his own opinion.

Nevertheless, although the man with a categorical eye, provided he is a genuine creator, may cast doubts on the value of certain real works of art, he may also manage to throw new light on the products of forgotten cultures or works which are alien to the prevailing taste. This was the case with Brancusi, who reawakened interest in Cycladic sculpture (Fig. 72), while in Dresden, from 1905 on, the Expressionists drew attention to the works of the German painter Grünewald. And the same can be said of Sironi, who admired the carvings by anonymous artists that we see on the façades of Romanesque churches (Fig. 74); of Carrà, who after his early futurist

phase returned to Giotto: of Picasso, who in some of his works reminds us of early Catalan painting (Fig. 81); of Derain, the discoverer of Negro art; of Gauguin, who made a close study of primitive art (Fig. 77); and of Seurat, who was the first to draw attention to the austerity of Piero della Francesca.

In short, provided he has talent, a 'categorical' artist can make his own contribution to the renewal of taste and to changing our ways of thinking; and it is precisely for this reason that he has to be polemical and partial, and has to have faith in something. He has neither the time nor the ability to be objective and serenely critical. He admits only one angle of vision or standpoint, and for him everything that does not conform with his own views is negative. The things which he does accept, however, acquire a new and unsuspected value.

Unfortunately, however, it is usually the minor and presumptuous followers who have 'categorical' eyes, people who are incapable of formulating ideas of their own; to do which one must have a sound knowledge of the individual artists, their works and the background against which they developed.

The Critical Eye

How, then, can we train our eyes to be critical? What is the best system? And if there are any rules which will enable us to enter into a really critical dialogue with works of the visual arts, what are these rules?

There is no beaten track, nor are there any hard and fast rules. The dialogue is inevitably a complicated matter, requiring intuition, the elimination of all preconceptions, and proper focusing of our eyes, so that they can find the correct angle of vision. It also requires historical knowledge of the milieu and culture in which the artist developed and produced his works, and we must also train our eyes to appreciate painterly and plastic visualization and the concreteness of rhythm — these being the so-called 'values', in other words the means of achieving expression, such as line, colour, tone, timbre, masses, light and surfaces — and if necessary, we must also master the concepts of dimensions and proportion, or even of the contamination of art by life. This, as can be seen, is not an easy task, despite the fact that everyone can at least try to accomplish it; and in reality it all boils down to perceptiveness of vision. But in order to achieve this perceptiveness, we need preliminary training and direct, instructive experience.

To start with, let us consider intuition. Every one of us possesses, to a greater or lesser degree, this irrational faculty which enables us to jump to the top of a staircase without climbing up the intervening steps. But in the preceding chapters we have seen that we must first free ourselves from a whole series of preconceptions that hamper our efforts. All the preconceptions which I have mentioned in the preceding chapters when discussing the ordinary man, the hearsay-monger and the categorical eye, normally tend to over-shadow intuition, which can become freer only when we have divested ourselves of the preconceptions derived from our surroundings, to which we have been directly or indirectly subjected ever since childhood and which inevitably influence our freedom of thought.

Then there is another thing. What exactly do we mean when we talk about focusing our eyes properly and changing our angle of vision? How are we to do this? And where are we to start?

84 What the critical eye sees.
A man with critical eyes knows how to change his angle of vision so as to be able to view a work of art properly, and provided we know something about these things, he studies the various trends, the historical, cultural and social conditions at the time when the work was created and in relation to the career of the artist and the civilization he reflects.

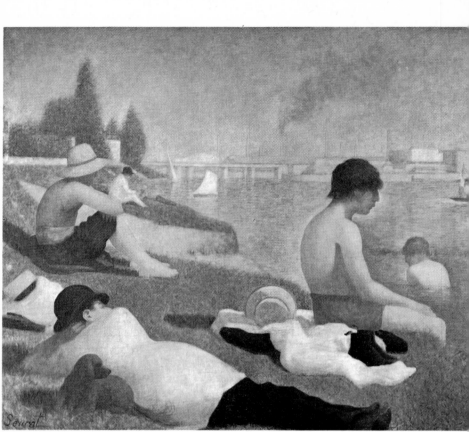

85

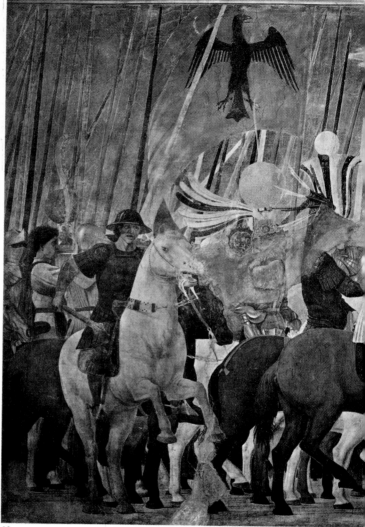

86

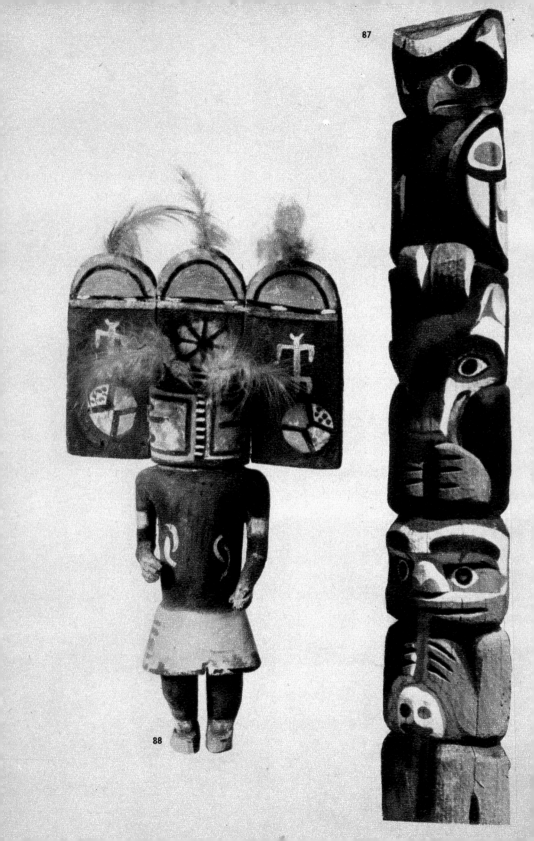

87

88

Let us take a few examples. If we look at a mosaic such as *The Escort of Theodora* (Fig. 19) or *The Cortége of Justinian* (Fig. 125) in the church of San Vitale in Ravenna, and in them try to find spatial depth in the perspective, or a treatment of light and shadow resembling what we find in Nature, in other words if we consider them from the point of view of nineteenth-century *Verismo*, we shall think that a lot of things are all wrong. In reality these are two of the greatest works of art of all time, but we must not view them from the standpoint of *Verismo* or find fault with the perspective. We must adjust our angle of vision to that of the sixth century, when Byzantine influence was strong in Ravenna and the conception of space was not tri-dimensional (height, width and depth), but only bi-dimensional (height and width), since space was felt to be a symbol and, although it could be seen only on the surface, it suggested infinity, which the colouring helped the spectator to imagine without any need actually to represent it. In Byzantine works the gold ground is flat, and although there is no perspective, we realize intuitively that there is an infinity beyond the limits of our earthly experience.

The first thing we have to do, therefore, is to set the mosaic within the framework of the cultural milieu at the time when the work was executed and compare it with others dating from the same period (for example the *Cortège of the Virgins* in Sant' Apollinare Nuovo (Fig. 166) or the ceiling mosaic in the apse of Sant' Apollinare in Classe, both of which date from the sixth century), noting the search for rhythm, which is achieved by harmonizing the colour-values with the essential outlines of the modulated surfaces. In *The Escort of Theodora* the austerity of the composition and the refinement of Late Roman art, remind us of the oriental spirit of the Byzantine Court and the grave solemnity of its leading figures. In order to render all this, the artist, whose name we do not know, did not need to know anything about the problems of perspective, or to worry about *Verismo*; he had a different

85 GEORGES SEURAT, *Bathers*, 1883–4, London. National Gallery.

86 PIERO DELLA FRANCESCA, *Battle of Ponte Milvio*, detail, *c.* 1452–66, Arezzo, church of San Francesco.
Seurat's restraint reawakened interest in Piero della Francesca, who for a long time had been neglected.

87 Totem-pole from British Columbia.

88 Kachin figure from South-West Arizona, recent Pueblo period, Copenhagen, National Museum.
To consider art as being nothing but beauty is an error which can result in serious critical mistakes. The artists of native tribes and the older Primitives considered expressiveness as forming part of life—something lying between magic, religion and primordial psychic collectivism.

conception of space and life, and a different sensibility. Thus, if we make no attempt to understand his angle of vision, we are making a great mistake which makes it impossible for us to formulate any critical judgement, since this can only be based on overall knowledge, not merely on casual impressions regarding the charm and lifelikeness of the work.

Take another example (Fig. 7). When the first Impressionist exhibition was held in 1874 on the premises of the photographer Nadar in Paris, it aroused bitter opposition on the part of the public. All the paintings shown were judged from an angle of vision which made it impossible to understand their value, and people saw in them only a hotchpotch of discordant colours, the reason being that they were accustomed to the gradual transitions of chiaroscuro, and not to coloured shadows or the relationships between complementary colours. Consequently, all these paintings seemed to be out of tune, repellent, jumbled together like colours on a palette. Nowadays even the general public knows that Impressionist paintings should be 'looked at with half-closed eyes' — a somewhat ingenuous and generic phrase which does, however, at least imply that we must not expect to find colours or chiaroscuro with intermediate zones of greys, but a diffuse atmosphere created by means of rapid strokes of the brush. The Impressionist painters, from Monet to Sisley, Renoir and the others of the first phase, made no attempt to isolate the elements in their compositions (figures, objects, landscapes), but tried to reproduce atmospheric movement. Consequently they carried the green of the plants over into the red clothing of the figures, while they made the red of the figures penetrate into the green, because the movement is entirely atmospherical and every line, every edge is made to expand and blend with the others, just as light does. The result of this is a pictorial fabric rich in colours, the aim of which is to render the luminous mobility of a scene — gardens, reflexions in the water, skies, rivers and trees, avenues, people walking, crowded cafés and theatres. The light becomes pure, the colours are pleasingly harmonized and the shadows coloured. Obviously the process of deformation becomes more and more evident; but nowadays people are no longer disturbed when they see Impressionist paintings and they no longer consider them from the standpoint of the neo-classicists, who were continually seeking for ideal beauty (which is just not to be found in these pictures), or from that of the Realists, who demanded a meticulous analysis and strict adherence to the truth in the representation of a subject.

Let us now glance at the *Deposition* (Fig. 5) which Giotto painted on a wall of the Scrovegni chapel in Padua. From what angle ought we to view this work?

To judge it critically we have to try to understand the whole of Giotto's art and his personality, and give him his proper place in the development of art, and this involves making a thorough study of his works. When we look at this fresco, we must remember that

110

it was the culminating point of a whole cycle and we must note how expressiveness is achieved by making use of all the means of visualization (to which I shall return later) and all the possibilities of composition and rhythm. In the years 1304–1312, Florence, where Giotto lived, though torn by internal dissensions, was definitely making progress; new buildings were being erected and new enterprises launched; the economic situation was favourable for trade, the activities of artisans and, indirectly, the arts. Amidst all this fervid activity there was a renewal of culture.

Some years earlier, Cimabue had made people realize that Byzantine tradition no longer adequately represented the aspirations of the times, and that mankind, after a crisis that had lasted for centuries and had been accompanied by an economic depression, was at last beginning to acquire a new consciousness of its ability to dominate the world. Human life became the new motive, and this laid the foundations of Humanism, which was a prelude to the Renaissance. And at the same time the conception of space likewise underwent a change; instead of being bi-dimensional, the symbol of an infinite beyond human understanding, it became part of everyday experience. Instead of flat surfaces (which, however, had enabled the artists of former times to produce masterpieces based on a different conception), a need was felt to emphasize volumes and masses, to render the substance of things. In his *Maestà* now in the Uffizi, Cimabue gave the Prophets beneath the throne under the lower arches a sculptural prominence reminiscent of Romanesque sculpture. Giotto went even further; he abandoned the last traces of symbolical graphic art (*cf.* Figs. 156 and 157, especially the detail from Coppo di Marcovaldo's *Madonna with the Child and Angels*) and modelled his forms with the vigour of a draughtsman; instead of gold, he used sky-blue for his grounds (which, however, still had uniform surface tones, since they still reflected the influence of gold grounds), sometimes enlivening them with clouds and angels; and above all he gave his figures movement and placed them in a three-dimensional setting which had sufficient depth to make his compositions stand out like high reliefs, thus enabling him to concentrate the gestures and movements in a very synthetic manner.

After his first experiments in the Franciscan cycle at Assisi (Fig. 168), his style, which had already achieved a high level, became even more synthetic in the Scrovegni chapel frescoes, where the scenes from the lives of the Virgin and Jesus Christ have a cadenced rhythm which does not stop at the edge of each compartment. One of the culminating moments is the *Deposition*, in which the masses of the figures are expressively stressed and become part of the rocky landscape, while the diagonal of the compositions makes all the figures, and even the natural features, converge on the figure of the dead Christ, so that they seem like the members of a choir. The rhythmical draughtsmanship—in harmony with the colours which are never overdone but serve to heighten the effect of relief—no longer reminds us of

the piecemeal schemes to be seen in Byzantine paintings; it is sweepingly modelled, with contrasts which make the whole composition come to life. As well as being a painter, Giotto was an architect and a sculptor, and his character remained that of a man from the country (a peasant, in the best sense of the term), who was keenly aware of man's struggle against Nature. His imagination was vigorous and something quite new.

If after this we turn to a statue of the Greek archaic school, the so-called *Hera of Samos* (Fig. 14) now in the Louvre, how are we to adjust our angle of vision? Archaic art is too often deemed to be 'stiff' and 'lacking movement', as if the artists of those days did not know how to express movement. Such generic and false statements are due to the fact that those who make them start from the naturalistic standpoint, which maintained that art was imitation of Nature, and consequently they prefer painters and sculptors whose chief aim was versimilitude; for example, works of the Hellenistic period like the *Callipygian Venus* (Fig. 15), in which the effect produced by the flesh is striking, or the *Gaul killing himself* (Fig. 162), skilfully executed as regards lifelikeness, but very superficial and without any real inner rhythm. The statue of *Hera*, which today is headless, dates from a period during which artists confined space as if within a column; the goddess is, in fact, conceived as a column and is austerely aloof; she is an abstract, absolute symbol, based on linear rhythm, which Ionic artists also utilized in architecture. The upward thrust of the column (we must also look at it from the back), the modulations of the linear folds, the delicate modelling of the arm resting on the bosom, make this statue rhythmically austere, and it is one of the most striking works produced by the Greek archaic school at a time when artists, instead of imitating Nature, were trying to produce an effect of symbolic force. Consequently, if we want to appreciate the secret inner rhythm of this statue, we must consider it as an example of a refined symbolical art.

Let us now take an example from the Italian Quattrocento. What are we to think of *The Baptism of Christ* (Fig. 56) in the baptistery at Castiglione Olona? What is the best angle from which to view it? Masolino was a very gifted, lyrical painter active during the early years of the Italian Renaissance, but unfortunately for him there has always been a tendency to compare his works with Masaccio's. If we judge his works by the same standards that we apply to those of Masaccio, then Masolino is definitely the loser. But when we turn to the sources (original statements by contemporaries and others that have been handed down), we find that the temperaments of these two artists were completely different, not to say conflicting. Masaccio, who died in 1428 when he was only twenty-seven, was an emotional painter and consequently put more of himself into his works and showed a preference for a well-defined, plastic amplitude. From his *Crucifixion* in the polyptych which he painted for the church of the Carmine at Pisa (now in the Capodimonte Museum, Naples),

112

in which the vivid red of the Magdalen (seen from behind) makes a poignant appeal, down to his *Expulsion of Adam and Eve from the Garden of Eden* (Fig. 219), in which the expressive deformation is heightened by the vigour of the figures, the other frescoes in the Brancacci chapel and the *Trinity* in Santa Maria Novella, Masaccio invariably displayed a lively and fertile imagination, which enabled him to feel all the dramatic significance of human life represented with a sculptural vigour, to such an extent that he is closer to Giotto than he is to Masolino, who was actually his teacher. Conversely, Masolino himself was influenced by Masaccio, and when he tried to paint in the latter's manner, he became a painter of the second rank. In reality his temperament was quite different, for he was an elegiac who loved subtle fables and lyricism; the cultural world in which he was most at home was that of late 'international' Gothic, sometimes described as 'courtly' Gothic, though he was prepared to accept the spatial innovations of the Florentine school, despite his predilection for soft colours and a modulated linearism. Not for him the tragedy of man's struggle against Nature; what he loved to do was to digress.

The *Temptation of Adam and Eve*, when we compare it with Masaccio's *Expulsion of Adam and Eve from the Garden of Eden* in the Brancacci chapel, is in fact a subtle fable, in which, however, the linear rhythm is modulated with a sober gracefulness. Obviously, quite apart from the difference of subject, it is futile to compare this with the expressive impulsiveness of Masaccio since, if we do so, it will seem lifeless, whereas it is in reality extremely vivacious, though in a different way. Masolino's language can be seen to be coherent if we examine the series of scenes from the life of St Catherine in the church of San Clemente in Rome, and the frescoes in the collegiate church and the baptistery at Castiglione Olona. When viewed from this angle, *The Baptism of Christ* (Fig. 56) stands out as one of the liveliest compositions produced in the early years of the fifteenth century; the river flowing towards the spectator, with its winding lines forming a pictorial tapestry made up of beautiful greens, the figure of Christ, which is almost at the intersection of the diagonals next to the more incisive figure of the Baptist, the girls in pink, the everyday scene of the bathers on the right, and above all the sky, the unusual colours of the sloping mountains and the spatial background which, though not in strict perspective, gives an impression of distance—all these things, which remind us of Gothic art because of their tendency to dissolve on the surface—thus giving the effect of a tapestry—together with the cadenced rhythm, the imaginativeness, the austere beauty and the originality of the various portions, combine to endow this composition with very delicate poetical accents, realized by purely visual means.

Now we turn to a very different work—El Greco's *Apocalypse* (Fig. 214). For far too long Domenico Theotokopulos, called El Greco, has been accused of using 'wrong' and therefore jarring colours, while some people, simply because they cannot understand him, have claimed that he was 'mad'. In reality, between 1567 and 1570

113

he studied under Titian in Venice, and for this reason people apply the same standards to him as they do to the whole Venetian school of colourists which started in Giambellino's workshop and was developed by Giorgione and Titian. As regards colouring, El Greco certainly does seem to be rather harsh; owing to his juxtapositions of certain metallic and strident tones his backgrounds seem to have no aerial perspective. But the real explanation is quite different. El Greco was an 'atonal' painter, and if we want to understand him well, that is to say to find the correct angle from which to view his works, we must go back to his training, which was Byzantine, not Venetian. He came from the island of Crete, where he spent his early years, an island that was a busy centre of artistic activity, influenced about the middle of the sixteenth century by Venetian art. It was a world for which naturalistic ideas — and consequently a naturalistic treatment of space — had no appeal. In particular, the painters of icons still used schemes and symbols in a way which accentuated a typically anti-tonal range of colours. This explains why Cretan painters (of whom quite a number were living in Venice in El Greco's time) were naturally attracted by Mannerism, because the Mannerists (in Venice the influence of Parmigianino was particularly strong) did not believe that the fundamental aim of art was imitation. Their so-called 'distortions' gave to their compositions a rhythm which, with their exquisite intellectual taste, they were able to turn into a coherent style, without any need to resort to models. For that matter the whole of Byzantine art was already pervaded by Mannerism.

Viewed from this angle, the atonal discords in El Greco's works — even in those which he painted in Spain — can be easily explained. Often he deliberately made his colours clash, as they do in certain mosaics deriving from Byzantine art, thus achieving effects which are harbingers of modern Expressionism and remind us of the deformations introduced by the Italian Mannerists. Hence too the elongated figures, the accentuation of certain details, the bright colours, the compositional schemes defying all the rules of proportion or beauty, in order to give a version of 'truth' which is not just superficial, but a kind of 'inner harmony'. El Greco was in Spain during the heyday of the Inquisition, which found in him an artist able to provide new, imaginative renderings of the conflict between sin and conscience, between the promise of eternal life and the sensuality of this world. Consequently, it is wrong to consider him from the same angle as we do Titian, who never attempted to portray these conflicts.

And now we have to ask ourselves from what angle we have to view the works of Picasso, who changes his style so off-handedly, with the result that each of his pictures differs from the others. Studying Picasso is like looking into a prism of shifting mirrors. Everything seems to be fleeting and inconstant, because the angles of vision are continually changing in the most provoking manner, almost as if he were a conjurer. And yet, for anyone who really wants to, it is not really so difficult to find the correct angle of vision neces-

114

sary if we wish to understand each individual work. Nowadays, in fact, the standpoint most commonly adopted by non-initiates is that art ought to be imitation of reality; in other words, a mirror (if we may use this simile once again) is fixed on a wall at a given distance from the spectator's eye, like the ordinary mirrors we use every day. Picasso, however, does not start from the idea that art is an imitation of life; in his case the mirrors move and multiply, or may even break, and consequently the image changes. Our social world never comes to a full stop, though crises and clashes may shake it to its very foundations. The theory of relativity has made it possible to discover innumerable points of view, and anti-naturalistic imagination has replaced the contemplation of a more stable Nature. Moreover, artists are now aware that no single tradition can offer more than one possible angle of vision; there are numerous traditions conflicting with one another and these have produced different trends in works of art. The historical method favoured by our own century teaches us that every civilization, every period, has an art 'of its own', which will change in conformity with the changes in the social structure, in customs and in the evolution of life.

Consequently, the artists of today are conscious of the fact that in addition to Greek, Pompeian and Hellenistic traditions, there also exist Cycladic traditions and Negro traditions, which do not follow the myth of beauty, but that of a more direct expression full of symbols and cadenced rhythms. Then there are other traditions: oriental, resulting in an art which has no resemblance to truth because the works are based on a different conception of space and time; pre-Columbian, Romanesque, Byzantine and numerous other traditions all speaking different languages. When Picasso arrived in Paris from Spain at the beginning of this century, the discussions aroused by these encounters with different cultures and civilizations were still being eagerly carried on. About 1905 Negro art, in particular, attracted the attention of Derain, Matisse, Picasso and other avant-garde painters and sculptors, all of whom were astonished at what they found in it. In the series of studies for his *Demoiselles d'Avignon* (1906–1907) Picasso reveals the influence of the harsh expressiveness and syncopated rhythms to be found in African carvings.

Obviously, after all these encounters, the idea that art ought to imitate Nature could not be more than one among many points of view. The style of modern forms of expression takes this as a starting point and produces variations on the theme.

Accordingly, in Picasso's *oeuvre*, after his 'blue' and 'rose' periods, which were more acceptable to the public at large because the subjects could still be easily identified (though even in such works of his we find a subtle linearism and colour-schemes derived from Symbolism, which make the atmsophere seem to be suspended timelessly), we have a trend towards Cubism, of which *Homme à la mandoline* (Fig. 50) painted in 1911 is a good example. Here the chief thing is the rhythm of the composition; the subject (a man with a

musical instrument) becomes a mere pretext and can hardly be identified by the naked eye; it is distorted by the numerous triangular 'schemes' and one might say that it had been 'taken to pieces' and then put together again in a new spatial setting in which the most prominent factor is a pure, dissonant musicality. Yet the picture has an undeniable harmony with its soft greys and browns, and also thanks to the conciseness of the rhythm. In short, Picasso dismantles the original model and, instead of just standing in front of it, looks at it from different angles, after which he reconstructs its essence and creates a new synthesis in a spatial setting which is no longer naturalistic, but abstract. Even in this picture, however, it is not difficult to discover in the exaltation of the rhythm (inspired more by Negro sculpture than by Cézanne) a conception of reality which has a coherence of its own, and we can see this more easily if we consider it as something entirely new instead of comparing it with the original model. Here, too, the painter invents forms in the most light-hearted way; but there is always emotion and energy, combined, however, in this case with austerity. What he shows us is not so much a man with a mandolin, but rather a dissonant musicality.

In another work, *Mother and Child* (Fig. 10), painted in 1921, Picasso, who by that time had already produced a number of pictures tending towards Cubism, seems to be returning to the methods hallowed by classical tradition. In the meantime he had visited Pompeii and Rome and had seen with new eyes the linear draughtsmanship of Ingres, who by origin was a neo-classicist. But is this conception of maternity naturalistic and really traditional? Here, too, Picasso invents new forms, broad and monumental, but with a realism which is not derived directly from Nature (from the naturalistic viewpoint coherent distortions are defects). After his encounter with classical antiquity, Cubist influence is transformed into interest in the structure of volumes, as can be seen in this monumental symbol of maternity.

Other pictures by Picasso, and above all some of his drawings, which have a neo-classical linearism, are, with their varying rhythms, examples of this phase of maximum relaxation. But for Picasso this was only one of many viewpoints and it did not, except as regards verisimilitude, conflict with Cubism, since in Cubism we also find a clarity of construction which in reality is classical. In the *Girl before the Mirror* (Fig. 63) dating from 1932 he returns more decidedly to the Cubist point of view; the surface and lines, in a setting which is reversed, and the striking colours, serve to render 'the act of looking in a mirror', while the rhythm, broken by ovoid forms and angles, distorts the apparent verisimilitude, but at the same time turns this dialogue between a girl and a mirror into a non-representational integration.

On the other hand, in Titian's *Venus and the Mirror* (Fig. 62) we find an ideal of beauty that is typical of the Renaissance, a tonal painting that must be viewed from a different angle. People with 'ordinary' eyes like it because the general effect is pleasing, but in reality, if we

want to understand Titian thoroughly, we must have some knowledge of the values of tones and of atmospherically modulated rhythm. In any case Titian represents a stage of the Italian Renaissance, which is still universally admired because of its harmonious, well-proportioned and sensual beauty, but this is not (as the ordinary man is inclined to think) the only way in which pictures ought to be painted, but simply one of the many ways which Titian, since he was a truly great painter, raised to the level of real art. But when we consider it from the proper angle, Picasso's *Girl before the Mirror* is also a great work of art, and closer to the transitory, changing ideas of our own time.

In his *Guernica* (Fig. 78), dating from 1937, Picasso carries his Cubist notions a step further and achieves more dramatic effects; all the violence of an attack on innocent people (women and children, people who love peace) during the Spanish civil war is portrayed in this work showing the havoc wrought by an air raid on a village. The scene, based exclusively on draughtsmanship and the values of greys, is expressively tense—symbols, deformations and juxtapositions lend a terrifying rhythm to this portrayal of a brutal massacre of the innocents. When we compare the finished work with the artist's preliminary sketches (Figs. 79–80), in which the bull and other figures are still naturalistic, it is easy to see that the final version is more synthetic and above all better compressed. Picasso's process of continuous deformation is used to achieve a more direct and peremptory rendering of expression, which is here like a message, while the last traces of naturalism have disappeared. But if we cannot discover the right angle from which to view it, the whole work is incomprehensible.

To take another example, even when we are looking at primitive carvings (Figs. 16, 220), we must first find the best angle from which to view them, and this we can only do if we know something of the history of the milieu in which the work was produced and if we are capable of judging the means of expression, which in such cases are marked by rough transitions and violent accentuations, far removed from the notion of beauty as a thing to be contemplated or that of geometrical proportions. The vitality of the whole work, its directness, take us back to the prevailing terror of ancient times, when magic and the desire for expression tended to assume an aggressive mask, traces of which can also be found in modern Expressionism.

* * * *

Obviously, there are countless other works which do not comply with any standards of art and the next question is; how are we to judge such works? Does knowledge of the historical background eventually lead us to appreciate everything, including things which cannot really be classified as works of art?

That this is a fallacy becomes clear when we turn our attention to forgeries (Fig. 27). The ordinary man cannot distinguish a forgery from a genuine work, but anyone who is acquainted with the history of an epoch and knows the values of rhythm and space which governed the works produced by different civilizations and individual artists, is aware that genuine works exist and that these are better than forgeries. His eye will quickly grasp the fact that the manner characterizing the faked portrait of a woman shown in Fig. 27 is not that of the fifteenth century and he will detect a treatment of chiaroscuro and naturalistic analyses which are typical of the nineteenth. The truth is that every forger, even when he is doing his best to imitate a certain period, reveals certain characteristics of his own times. For example, the faked Modigliani shown in Fig. 174 is not in accordance with Modigliani's methods; it is heavy and has no rhythm. Generally speaking, forgers, provided they are skilful, can imitate the material content of a painting; they can copy motives and excerpts from other works by the same artist, but they cannot imitate the rhythm, which is always the life and breath of a painting and is barely perceptible. Anyone who knows how space was treated during a certain period or by individual artists (that is what a knowledge of history gives us) and has a keen eye accustomed to noting the rhythm of concrete methods of representation, is unlikely to be taken in by a forgery or by a work which is not by the artist to whom it is attributed.

But quite apart from forgeries, what are we to think of works which are generally deemed to be mediocre or at all events not real works of art?

Let us look, for example, at Domenico Morelli's *The Iconoclasts* (Fig. 167), at the *Gaul killing himself* (Fig. 162), at the anonymous landscape daub mentioned earlier (Fig. 21), and at Cesare Maccari's *King Victor Emmanuel receiving the Plebiscite of the People of Rome* (Fig. 100).

In the *Gaul killing himself*, by an anonymous Hellenistic sculptor of the school of Lysippus, who, however, had a far more vigorous imagination, we can admire the accuracy of the anatomy, the eloquent gesture, the lifelikeness and the technical skill; but the fact remains that this is a rhetorical work, superficial, and without any real hidden rhythm. And yet we know that it was produced during a highly individualistic period, which had a feeling for free movement and the movement of forms in light. Here it is historical knowledge that shows us the best angle from which to appreciate the relationship between light and shade in movement and an expressiveness already pervaded by individualism; and consequently our judgement will be negative, because complacent ability has got the better of expression and the rhythm is false because it is all on the surface. In fact, it is just a garrulous work, little more than a striking portrayal of an incident. From the same Hellenistic period we have the *Battle of Giants* from the Pergamon altar (Fig. 182) which, despite its broader spatial setting, is far more vivacious as regards the rhythmical relationship of light

118

and shadows in movement, and among other merits it has a special value on account of the architectural setting, the personages being shown, in high relief, on a flight of steps, almost as if they were living people walking up them, which gives them a novel effect of dynamic movement. In the details, too, we can detect the influence of Scopas as regards the contrasts between the masses; of Praxiteles himself in certain transitions which enable the sculptor to give a vivid rendering of nuances of the flesh; and also of Lysippus as regards the articulation of movement in space. All these things, however, are realized with a peculiar freedom of expression, impaired from time to time by a tendency to exaggerate the contrast between a restrained intimacy and gigantic proportions. Here, however, Hellenism displays a clear and free rhythm (which some writers have described as 'antique Baroque'), typical of periods when individualism was tending to disrupt the uniformity of culture, customs and styles, and to attach importance to the values of fragmentation and gestures.

On the other hand, Domenico Morelli's *The Iconoclasts* takes us back to late nineteenth-century Italian painting, to the cultural milieu of southern Italy, where Realism, combined with a type of Romanticism conceived as a sentimental attitude, produced hybrid and misleading works. The atmosphere in this picture, to which we shall return later, turns it into a melodramatic episode, in which the gestures are studied and complacent and without any real rhythm, because everything is fundamentally descriptive and superficially theatrical. Two other pictures—Stefano Ussi's *The Duke of Athens*, which at one time enjoyed such great popularity, and Cesare Maccari's *King Victor Emmanuel receiving the Plebiscite of the People of Rome*—introduced a superficial Romanticism into the category of historical paintings. The original source was David's neo-classicism, but the artists took their subjects from Italian history and paid more attention to the realism of details.

Nineteenth-century historical paintings of this type, although they undoubtedly reveal a certain degree of skill, are nothing but illustrated narratives, without the slightest trace of that rhythm which is so essential in works of art.

The eye becomes critical as soon as it has learned how to change its angle of vision and view works of art against the historical, cultural and social background that produced them, taking into account the career of the artist, his individual temperament and the civilization which he reflects, always providing that we know anything about these things. Critical judgement is thus synonymous with basic knowledge, which enables us to penetrate into the very essence of each particular work by examining the technique and the style employed in order to achieve expression.

Real criticism is thus an acquired faculty which anyone of normal intelligence can acquire, though this cannot be done quickly by relying solely on distinctions based on attractiveness, lifelikeness and other superficial impressions.

We must not let ourselves be led astray by the universality of art.

It may seem to be timeless and is, in a way, absolute, but it always has roots of its own, which must be sought in the atmosphere of the various periods and civilizations, and in the actual personalities of individual artists.

Beyond Pure Art: on the Fringes of Magic, Religion, Contamination and Symbols

THE idea that art could be pure was a product of individualistic civilization. Art has never been pure, and to consider it as nothing but beauty is wrong.

For an artist liberty means renouncing his functions and his direct usefulness to the society to which he belongs. The relationship between the artist and society has changed in the course of time, because in olden days the artist was useful to the community as a whole, as the vehicle of magic, religion, moral or even political persuasion. He was a magician, a propagandist and a potential persuader. Obviously, in those days there was no great difference between artists and craftsmen, or between art and rhetoric considered as a means of persuasion, and this encouraged the artists, who in certain brilliant works achieved the maximum of success. Nowadays, however, artists no longer have any real function; in our society they are luxuries. They are free to create products of their own imagination, which have a certain 'purity', it is true, but 'serve no purpose'. In fact, artists have to pay for this state of liberty, especially at the beginning when they are only on the fringes of an individualistic society. Bohemianism is a means of escaping from society, which has no use for artists and rejects them.

Today artists are tolerated. Society esteems them only after they have achieved success (and with success, wealth), which is now the foundation of prestige. In modern society, more useful functions are fulfilled by publicity agents, industrial designers and architects (whose functions, however, are often usurped by surveyors and builders), because the imagination, genius and skill of such men serve a more immediate purpose. (It is true that certain works of painting and sculpture eventually become forms of economic wealth, but such works, as I have said, are produced only by successful artists.) In the world of today poets, painters and sculptors are like perfumes—in other words they are not indispensable; whether their works, if they are real works of art, are actually more necessary than other products which find a more immediate use, is another question. Society does not worry about that and consigns all artists to the fringes.

In prehistoric times and in tribal civilizations the equivalent of the artist was the witch-doctor. Nowadays we consider certain totempoles, masks and propitiatory hunting scenes as works of art, but they were not meant to be art, and even less art for art's sake. They are undoubtedly expressive, and for this reason they still appeal to us,

121

thousands of years later. Their expressiveness, however, is not based on any study of beauty; it was a ritual necessity, like magic and religion in the early days of collective psychology. The symbolism in these primitive works is not in any way individualistic, nor does it conform to any real system of aesthetics. In them art is bound up with the irrational demands of a cult and it was used for propitiatory purposes and as a collective form of expression. Its products were not regarded as being just pictures, but as means whereby a magical or religious end could be achieved.

89 *Creation of the Fishes and Birds*, 12th-century mosaic, Monreale, Cathedral.
The symbolism in this mosaic is derived from Byzantine origins and has an evocative power far greater than the mere representation of an episode. The effect is heightened by the harmonious composition reduced to bare essentials of surfaces and lines, while the colours and other means of visualization convey the sensation of a mysterious infinity, as symbolized by the gold ground, suggesting things beyond human comprehension set in abstract space.

90 Imprints and Bison, from the Castillo cave near Santander, Spain, palaeolithic Aurignan era.

91 *Venus* from Lespugne, Spain, Aurignan era.
The expressiveness of this primordial work is at the opposite pole from the ideal of well-proportioned beauty so dear to the neo-classicists. The unknown prehistoric sculptor made no attempt to achieve pleasing harmonies or beauty, his aim being to express the magical aspect of the forces of Nature and the might of a female deity conceived as symbolizing the earth.

92 Fetish transfixed by nails and mirror, from the Lower Congo, Rome, Museo Missionario Etnologico.
When we are confronted with works dating from remote primitive times, it is impossible to say where art ends and magic, ceremonial and religion begin. The expressiveness of such works is based on forms of ritual which we are unable to understand and which are therefore all the more impressive. It is not a case of art being on one side, and life on the other. On the contrary, life is continually being contaminated by impure art, if by the latter we mean irrational feeling. Since the beginning of our own century Expressionism and the Surrealist trend, which first made its appearance in 1924, have taught us to appreciate primitive works like these imprints of hands and the outlines of bison in the Castillo cave, or the Fetish transfixed by nails — these being instruments of magic, in which the marked deformations were due to the demands of a cult — and transform them into awe-inspiring images.

93 Marcel Duchamp, *Bottle-holder*, 1914, Milan, Schwarz Gallery.

94 Kurt Schwitters, *Merzbild 25A*, 1920, collage.
The idea that art is contaminated by life and *vice versa*, so that it is impossible to draw sharp distinctions between the two, has recently been revived, though in a form differing from that given to it previously by Dadaism. In those years the First World War had plunged civilized and rational men into the midst of a crisis, and the Dadaists, like the Italian Futurists, protested against the apparent indifference of an art designed to be contemplated.

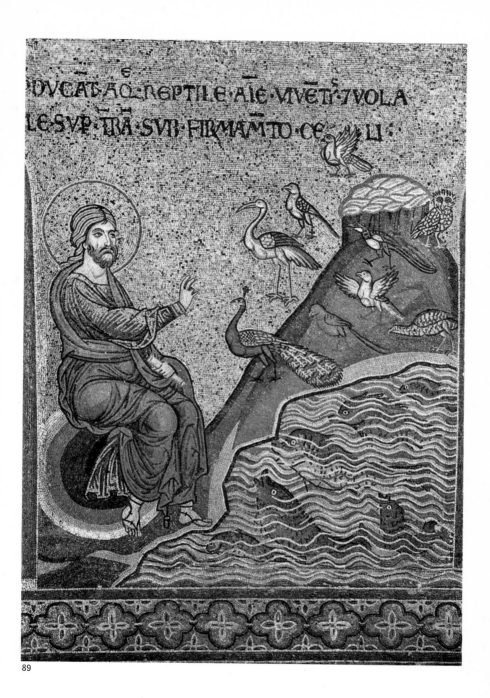

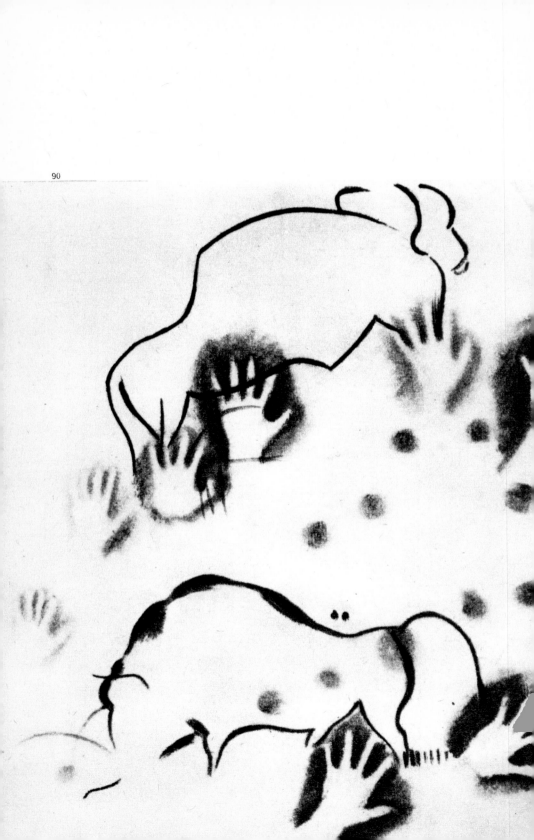

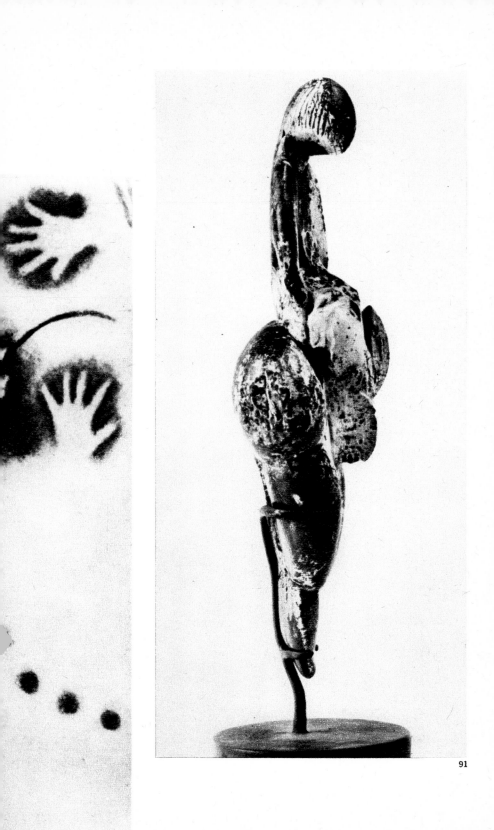

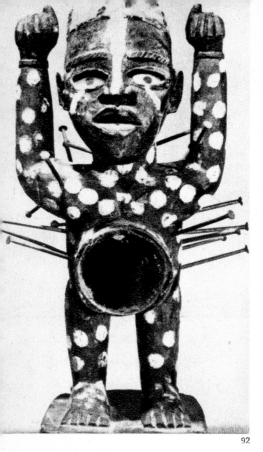

92

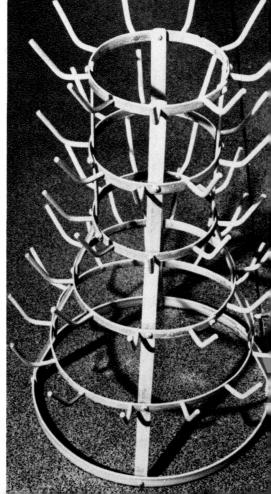

93

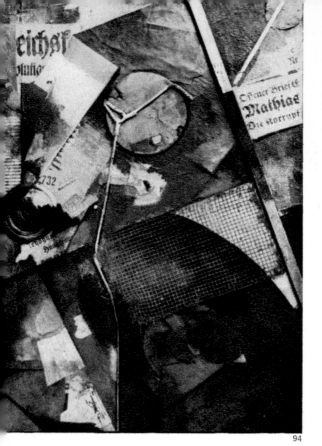

94

95

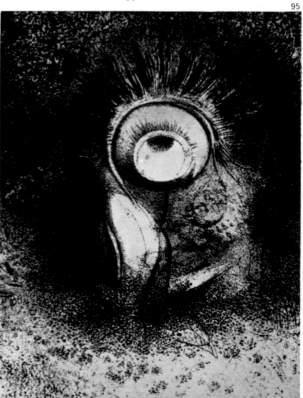

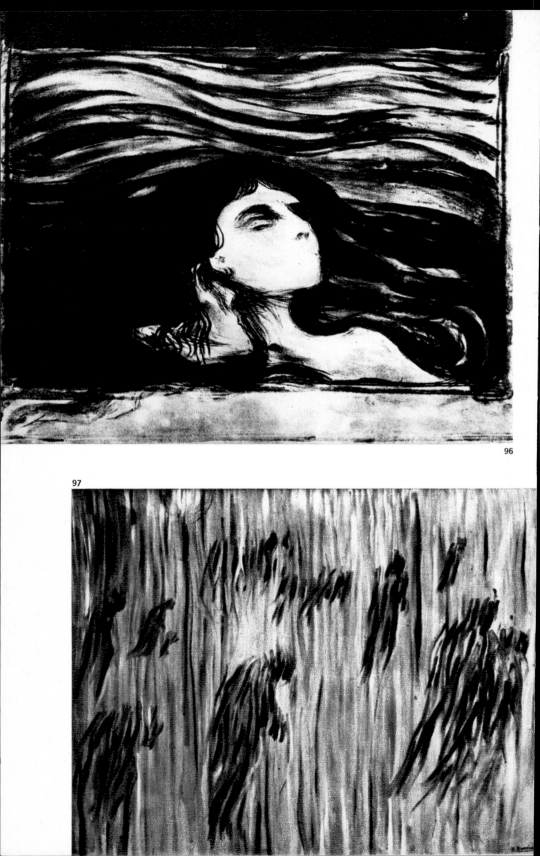

96

97

Consequently, when we are dealing with this primitive phase of art, it is quite impossible to distinguish it from magic, ritual or religion, and moreover its noticeably abrupt and aggressive expressiveness is derived from forms of ritual which to us are often quite incomprehensible, and therefore all the more suggestive. It is not a case of life being on one side and art on the other; there is a continual and reciprocal contamination of life by impure art, if the latter is understood as being irrational feeling and a means.

If, for example, we of today study a fetish (Fig. 92), what we admire is the violent deformation which makes it so expressive; and Expressionism, which did not come into existence until the beginning of our own century, but is now generally accepted, helps us to appreciate this primordial image. But this fetish, though based on aesthetic values (using 'aesthetic' in its original sense, from Greek $\alpha \ddot{\iota} \sigma \theta \eta \sigma \iota \varsigma$ = sensation, feeling), was never intended to be a work of art; it was just a magical instrument, in which the marked deformations were essential parts of a rite and signify some threat to mankind. The symbolical transposition and the defiant expressiveness produce an immediate effect and inevitably compel us to participate, since we are not in a position to distinguish between actual life and art. That, obviously, is the direct opposite of artistic enjoyment (which often obscures the effect of certain works of our own time). This genuine and complete participation in the 'aesthetic' act surprises and fascinates us, but that is because the work was not intended to comply with any demand for art, but was simply the expression of a custom, of a magical rite. If, then, we consider the fetish exclusively as a work of art and treat it as we do the works of Brueghel, Rembrandt or Masaccio (which are equally expressive, but were produced in different cultural surroundings and form part of more complex civilizations), we are adopting an ambiguous method which the study of history has made superfluous.

95 ODILON REDON, lithograph from *Les Origines*, 1883, '*Il y eut peut-être une vision première essayée dans la fleur.*'
 In this lithograph from *Les Origines* the French Symbolist Redon, who was a delicate artist with literary aspirations, evokes the occult by depicting a flower which is at the same time a sinister-looking eye, thus suggesting psychic action.

96 EDVARD MUNCH, *Liebespaar in Wellen*, 1896.

97 UMBERTO BOCCIONI, *State of Mind: Those who stay behind*, 1911, Milan, Civica Galleria d'Arte Moderna.
 After 1880 Symbolism stressed the value of psychic echoes created by colours, light and line, as distinct from the objective representation of an episode, and concentrated on the evocation and suggestion of images.

Similarly, certain prehistoric propitiatory hunting scenes and tribal totem-poles (Fig. 87), although they are extremely expressive, were not created as works of art, but as items of a ritual or as awe-inspiring symbols of power, in which magic, communal life, religion and aesthetic expression are combined to form a whole.

This concept of the contamination of life by art and *vice versa* (it is impossible to draw a sharp distinction between the two processes) has returned in modern times in the form of Dadaism. In some ways this was due to changes in customs, but it was influenced by Italian Futurism and was an avant-garde movement which originated in Zürich about 1916 and almost contemporaneously in Paris and New York, among its exponents being Marcel Duchamp, Tristan Tzara, Man Ray, Picabia, Arp and Schwitters, at a moment, that is to say, when the war had plunged cultured and rational men into a crisis. The Dadaists found a new way of expressing their opposition to the apparent indifference of an art intended only for contemplation and isolated in an uncontaminated sphere. They deliberately tried to contaminate art; in other words they demolished the old tradition of aesthetic beauty, attacked the current 'good taste' and maintained that beauty can be discovered everywhere, if we only know where to look for it. They accordingly portrayed manufactured articles in everyday use (in some cases without the slightest variation, as for example in Marcel Duchamp's *Bottle-holder*, Fig. 93) and maintained that these were works of art, as if it was merely a question of choosing one out of many everyday articles and simply willing it to become art. Hence the series of pictures representing 'ready-made' articles, of which the *Bottle-holder* is a good example.

Behind this attitude lay a cultural crisis which affected a whole civilization and rejected the absurdity of the situation. Dadaism, however, was not just a moral protest; it was an answer to the urge to find new subjects and new possibilities of expression among the ordinary things of everyday life, in other words to allow art to be contaminated by life. And above all it was a breaking away from the old conception of art as something to be admired, and also from the tradition that pictures were made to be hung on walls. These artists tried to stress the contribution that the spectator's eye can make to the concreteness of a work of art, and consequently the relativity of beauty and even of art itself, demanding an unceasing and active collaboration on the part of the spectator's eye, which his own imagination can constantly renew.

Evidently, for the Dadaist the intromission of a mere gesture or of purely fortuitous circumstances would suffice to create works of art which, if set against a certain background, would produce artistic effects; hence the series of broken mirrors and glasses—chance occurrences wherein the broken fragments provide suggestions for a new beauty; in other words, the insertion into works of art, whether painted or carved, of physical objects taken from real life and transformed, thanks to the new climate of juxtapositions, into other, un-

foreseeable expressive effects, invariably bordering on the absurd, since in any case the Dadaist choice of themes revealed a predilection for the irrational and ridiculous aspect of our lives.

It is also obvious that many of these objects posing as works of art without being subject to any alteration whatsoever, in accordance with the concept of the contamination of art by life, were not in themselves works of art, any more than the old fetishes or instruments of magic were. But whereas the primitive tribal artists were fulfilling a definite function and the objects they depicted were part and parcel of the communal life, Dadaist contamination signified a complete break between the public and the artist. The latter moved in a sphere of his own, well aware that he would never be able to transmit his ideas to the public at large, because they were still under the influence of traditions which they idly accepted and which were no longer really alive. Consequently the artist endeavoured to stimulate their reactions by resorting to a violent polemic and thus to find new modes of expression. This was consequently a stage during which the contribution made by criticism was a dominant factor and there was a deliberate upsetting of values. As a result, the expressive contamination achieved by primitive tribal artists and that brought about by the Dadaists ended up at opposite poles, the former being a kind of collectivism and the latter a predominantly critical subjectivism. But neither of these movements, so far apart in time, had the slightest intention of producing works of pure art.

When, however, Kurt Schwitters produced works like his *Merzbild 25A* (Fig. 94), he used contamination in his collages in order to produce a new kind of picture. The various elements were not glued on to the ground as they were in Cubist collages (by the so-called synthetic Cubists, after 1912, as exemplified by the one by Braque reproduced in Fig. 32), in which colour was the only value and consequently the colours used in normal brushwork were replaced by scraps of paper which gave the composition a rhythm based on broad surfaces, clear and flat, but still having chromatic values. In Schwitters's works these various elements are things which would normally be thrown away–pieces of very ordinary material which nobody would pay any attention to, rags, wire-netting and corroded fragments which have a life of their own and thus awaken disturbing psychical echoes, rendering the picture extremely expressive. The concept of the contamination of art by life and *vice versa* is thus used to achieve new values. Within the spatial setting of the collage the humblest piece of refuse, when juxtaposed with other items, acquires a novel power of suggestion. In other works Schwitters inserts into his collages the soles of old shoes, side by side with rusty nails, but the result is still a picture, a compositional whole, which with its hidden rhythm goes beyond the concept of contamination, here used merely as a means of renewing the expressive content. Incidentally, before he produced these collages, Schwitters had already experimented with Expressionism, which he conceived as being

131

based on—among other things—social motives. And he was a close follower of the neo-plastic trend as represented by Mondrian and Van Doesburg, even if he subsequently found it necessary to make drastic changes in his compositions in order to make them more polemical and enhance their psychic echoes.

At the root of all this Dadaist concept of contamination, according to which no definite line can be drawn between life and art, lay the idea of Symbolism, which ever since 1880 had been proclaiming that colours have values as awakeners of psychic echoes, thus making it possible to go beyond the representation of objective facts and evoke or suggest something. This was a reflex of the individualistic crisis of the nineteenth century, and art thus became a state of mind. Obviously, this symbolical phase in art, although it likewise had its roots in the irrational, in the power of suggestion rather than in the representation of actual objects, differed from the symbolism of the Primitives, which was always something outside human experience and held that the absolute (whether magical or religious) was the focal point of reality and beyond the comprehension of mankind. In this Symbolism of the late nineteenth century, on the other hand, human and individual experience had its roots in the subconscious, in the borderland of psychoanalysis discovered about that time by Freud, and it gave birth to other irrational modern avant-garde movements, in particular to Surrealism, which was based on dreams and the life of the subconscious. Nineteenth-century Symbolism was, in short, an offshoot of Decadentism, which was based on the provisional and produced a particular type of art that was a reflexion of the individualistic crisis.

A twelfth-century Byzantine mosaic, the *Creation of the Fishes and Birds* (Fig. 89) provides a good example of mediaeval symbolism, space being reduced to two dimensions which, with the aid of the gold ground, can suggest an infinity beyond the range of our vision, while the colours have a suggestive power far superior to that seen, say, in a naturalistic representational work; whereas Munch's *Liebespaar in Wellen* (Fig. 96), painted in 1896, evokes with the aid of the new Symbolism a state of mind in which the woman's head and the surging waves are merged, thus suggesting the psychic ambiguity of the preconscious.

Boccioni's *State of Mind: Those who stay behind* (Fig. 97), dating from the early days of Futurism when the movement was still in its symbolical phase, reveals the influence of Munch and belongs to the series of *Farewells* in railway stations (in Boccioni's works there is always some reference to the loneliness of his mother whenever he went away); everything is in a state of flux, an unstable, fluctuating element suggesting an anxious state of mind, as if submerged in a liquid, ancestral infinite.

The French Symbolist Redon evokes a suggestion of empty, lowering space, which is endowed with an impressive psychic movement. But in France, contrary to what we see in Munch, who was a pre-

cursor of Expressionism, a complex, refined culture was still flourishing. Here there is no attempt to convey direct messages, though Redon had a predilection for images in which Symbolism was almost on the fringe of preciosity, of art conceived as a kind of 'game', this being a consequence of Decadentism and thus at the opposite extreme to the symbolism of the Primitives, which started from faith in a collective absolute.

Illustration, Propaganda, Utility

BEYOND the borders of pure art, which is a myth of our own civilization with its liberal origins, we find not only a relationship to magic, to religion and to the irrational transcending human experience, but also a relationship to functional purpose, utility and practical needs.

In the past artists were in the service of mankind, in conformity with a clearly-defined social scheme. Portraits, the commemoration of historical events in paintings or sculptures, and episodes such as the building of a bridge, while they strengthened the contacts between craftsmen, painters, sculptors, draughtsmen, engineers, architects and scientists, also provided artists with a definite function in society; and, as I have already said, this meant that art could also be rhetorical, that is to say persuasive, or art turned to practical use.

Today the word 'rhetorical' has a pejorative sense and is generally used to denote undue emphasis, affectation and superficial taste. But in its higher sense, rhetoric was the art of persuasion, and when the artist's name happens to be Giotto, recounting stories from the life of St Francis or the Gospels to the populace, then 'rhetoric', provided it aims only at persuading and is not just art for art's sake, is the loftiest form of art, producing results which astonish us with the integral purity of their expressiveness, with the absence of all artifices and the power of their rhythm. Nevertheless, Giotto's aim was not purity; what he set out to achieve was not pure lyricism, but an art that was dialectic.

If, on the other hand, the artist is a man who has nothing to say, if he has not got his own way of conveying a message, then he remains a mere craftsman, whose function is purely illustrative. Whole series of portraits of 'ancestors', ornamental panels over doors, the illuminations found in manuscripts (some of which, however, are stupendous) and, generally speaking, all the works of minor followers prove that it is very easy to remain just a craftsman without ever achieving real art. But in older civilizations artists, no matter whether they were great or only mediocre, drew no distinctions between art and non-art, between art and artisans' work, between arts and crafts, or between art and rhetoric. And it was this multiple complex that formed the

98 The Column of Trajan, detail of the reliefs depicting the exploits of Trajan, Rome, A.D. 113.

99 ARMANDO TESTA, Modern poster.
Here is a poster which is both beautiful and useful. The clarity of the colours of the orange and half-orange set against a light background stress the fact that *Punt e Mes* consists of oranges and vermouth. In advertisements comparisons are all-important and here they are realized in a very clever way and are immediately intelligible.

134

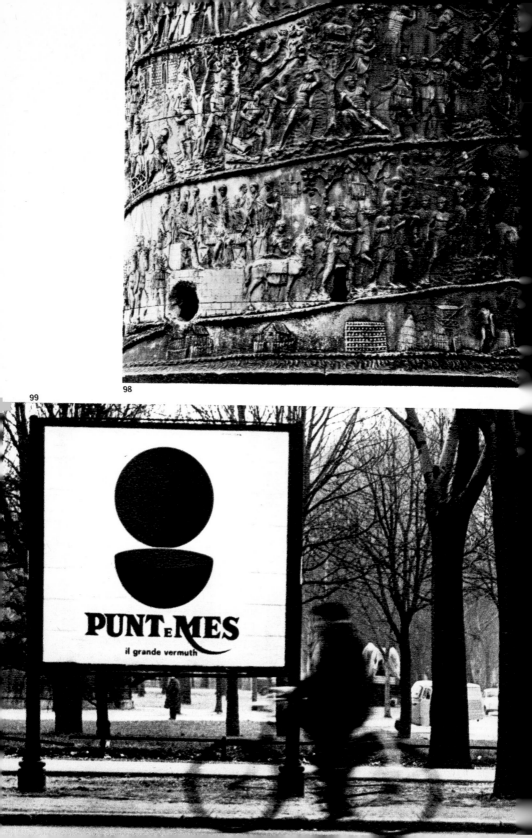

98

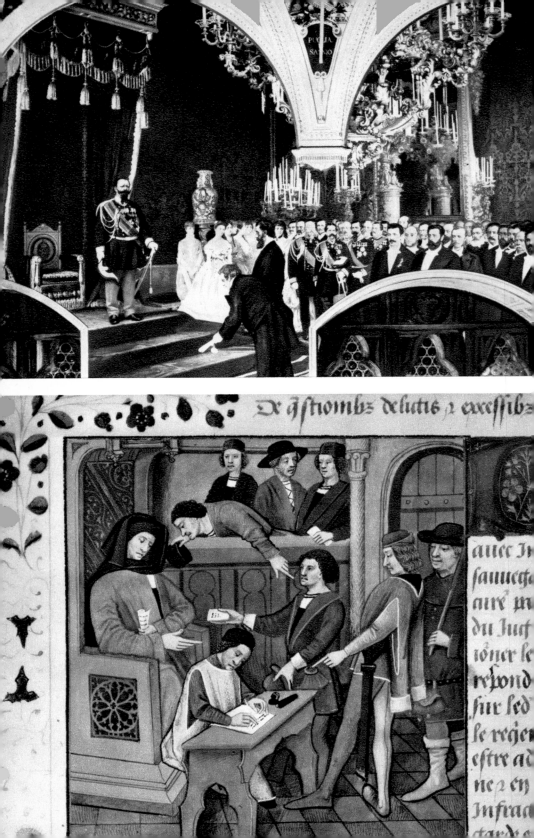

Dur
vng
sible
evrcps
aaõ de
cced se p
ademēt
faire ad
nuāt po
pnire²
hi le cas
ne peut
i survev
ou ila
saune
ce le n

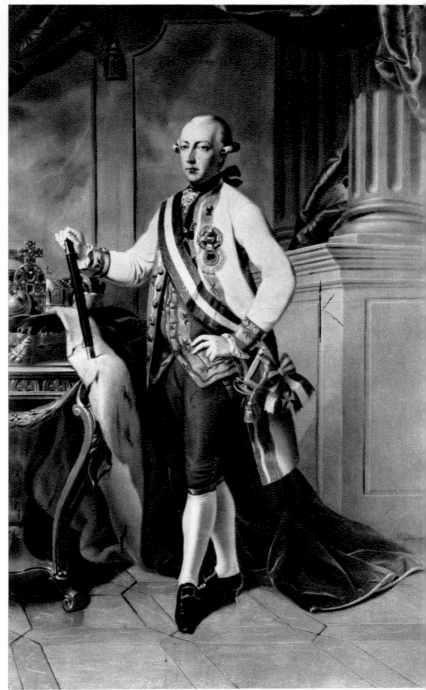

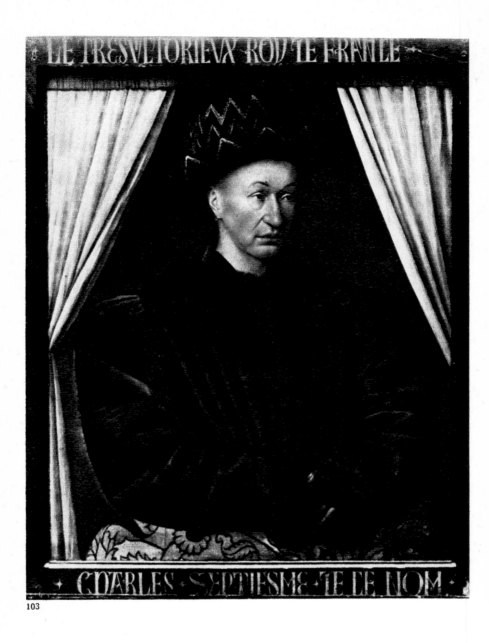

basis of their activity, nor did they ever feel that there were any gaps, such as the individualistic civilization of today, with its demand for pure invention, often perceives.

Style was always fundamentally a question of the artist's skill, and artists were ready, not only to depict any subject that might be suggested to them, or to execute works on commission, but also to undertake engineering or purely technical work. Examples are Leonardo, Michelangelo, Sangallo and numerous other Renaissance artists, who built fortifications and accepted other technical jobs, and this is a confirmation of the fact that in those days, simply because their work was necessary and fulfilled a social need, artists did not feel it necessary to form themselves into isolated groups, or to escape from society by practising Bohemianism. In such circumstances no distinction between arts and crafts, between artists and artisans or between pure and rhetorical art could possibly exist. It was simply a matter of difference in quality.

That is why, when we study the art of the past, we must be careful to eschew all such distinctions, which are just myths and merely hamper us when we are trying to form critical judgements.

Distinctions (since criticism is a matter of discernment and therefore of choice) must be made, not by drawing sharply defined lines, but by examining the inner processes of the artist's mind. The *Column of Trajan* (Fig. 98), for example, was a commemorative work which, although it is a form of narrative not unlike a modern cinema film — or, if we really want to say it, a strip cartoon — is nevertheless so original that it reaches the apex of great art. But at the same time it

100 CESARE MACCARI, *King Victor Emmanuel receiving the Plebiscite of the People of Rome*, 1870, Siena, Palazzo Pubblico.

In this 'historical' painting, which was so popular in the last decades of the nineteenth century, the dominant features are the event itself and the craftsman's skill displayed by the artist, who, although influenced by David, does not succeed in creating a truly rhythmical synthesis or achieving originality in his style.

101 *Questioning of a witness*, miniature from the *Style du droit français*, Paris, Bibliothèque Nationale.

Here is a typical example of mediaeval illustration; the story is clearly told and is instructive, but there is little more than craftsmanship in the work.

102 Unknown artist, *Portrait of Joseph II of Austria*, 18th century.

103 JEAN FOUQUET, *Portrait of Charles VII* of France, 14th century, Paris, Louvre.

Fouquet, a great painter, did not consider his sitter merely as a pretext, but endowed a large composition with a stringent rhythm, based on austere draughtsmanship harmonizing with the subtle colour values.

The other portrait, of Joseph II of Austria, painted by an unknown artist in the eighteenth century, is nothing more than an illustration, executed with meticulous care. It has no rhythm, the sitter's attitude is casual and it is lifeless; it is just an ordinary photograph (like a modern passport photo), and in no sense is it a work of art.

is a story, intended to be told in the hope of persuading people, and it is therefore rhetoric. And it was for this reason that it fulfilled one of the chief requirements of Roman civilization.

The portrait of *Charles VII* painted by Fouquet (Fig. 103) during the sixteenth century is an austere, original work of art; but it is not pure art, since it does not appeal to us solely on account of its compositional values, its cadenced rhythm and the harmonious colouring and draughtsmanship. It is a portrait; it is no use looking at it upside-down and its value as a portrait does not lie in the fact that it used the sitter as a pretext. It is illustrative art, a work the aim of which was rhetoric in the best sense of the term. When we compare it with the portrait of *Joseph II of Austria* by an unknown painter (Fig. 102), it is easy to see that the latter is nothing more than an illustration and that the craftsman has not managed to find an original method of expressing himself, since it lacks the liveliness which we find in Fouquet's portrait, painted in the style of a different period.

If we then turn to a painting in the city hall at Siena, Maccari's *King Victor Emmanuel receiving the Plebiscite of the People of Rome* (Fig. 100), we find that this representation of an historical event, Romantic in its origins but revealing the influence of the Napoleonic era as painted by David, bears witness to the exceptional technical skill of the artist; nevertheless, it is merely a commemoration of an historical event, lacking the secret life of rhythm and plastic imagination. By the end of the nineteenth century, the products of artisans no longer had any connexion with true rhetoric and art, and any large commemorative picture could easily become rhetorical in the pejorative sense of the word. Culture, customs and individualism tended, after the Impressionist period, towards fragmentation, symbolism and the provisional, and there was a seeking after lyrical purity, far removed from the rhetoric and persuasive art of former times.

Nowadays artists of a new category fulfil the functions of rhetoric and utility and meet the requirements of science and industrial technique, but such artists are not classified as real artists, because they merely execute work that was formerly entrusted to artisans. Classifications of this kind are wrong, for in our own times there is plenty of scope for functional and persuasive art, as well as for pure art. By this I mean that there is scope for advertising and industrial design, and the men who are engaged in such work are the real social artists of today. An attractive poster, or the lines of a car-body, are works of art, and they ought not to be relegated to the category of the minor arts merely because they are forms of persuasion, that is to say of rhetoric in the better sense.

When the architect Gropius founded the Bauhaus school, gifted artists like Kandinsky, Klee and other innovators, who at the same

104 BENJAMIN BAKER and JOHN FOWLER, The Forth Bridge, 1881–88.

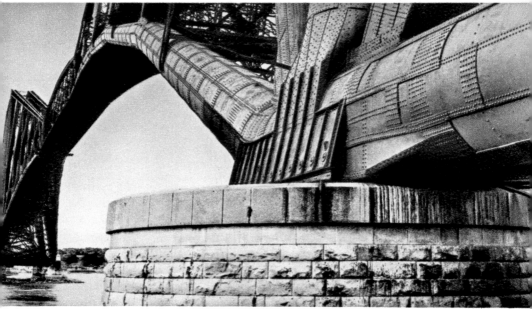

104

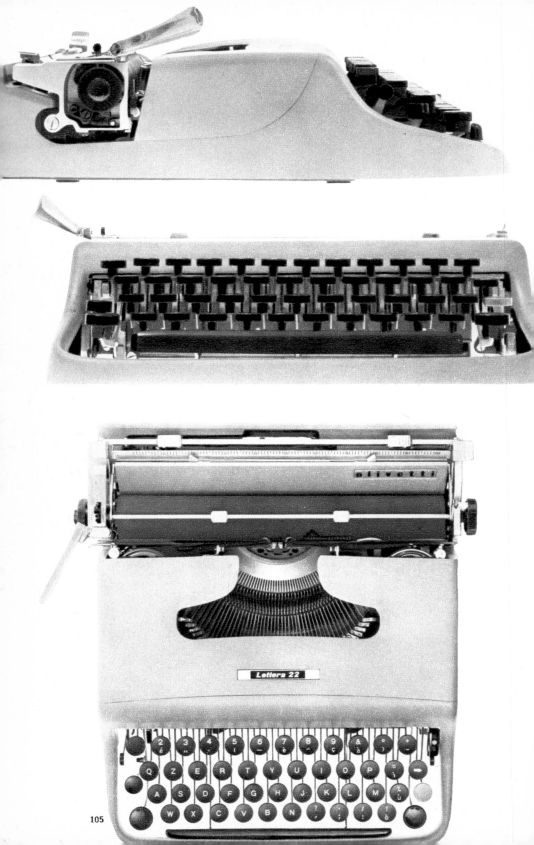

time were also introducing a new, avant-garde lyrical art, soon discovered that the shapes of mass-produced articles, advertising and industrial design, where quantity rather than quality was the prime factor, since they had to meet the requirements of a society in which the old crafts had been superseded by industry, could offer artists new possibilities for expressing themselves, and above all a social function.

The poster by Testa shown in Fig. 99 (and among the innumerable commonplace posters we can find plenty of others in which imagination, inventiveness and inspiration are transformed into the vivid language of direct communication, from Cappiello to Dudovich and Nizzoli, from Toulouse-Lautrec to Cassandre), the design of an industrial product (Fig. 105), or the purely functional lines of an engineering work like the Forth Bridge (Fig. 104), show that side by side with a purely lyrical art there now exists a functional and persuasive art which it is wrong to consider as 'minor' art or even as 'not being art at all', as people are all too fond of saying. Nor is it any use saying that 'real' art cannot be found in advertisements for soaps or shoe-polish, or in the purely functional lines of what is nothing but a machine, for we are forced to admit that all these things belong at least to the field of applied art.

Adverse criticism of this kind is bound to go wrong. Advertisements and industrial products are not necessarily forms of art, just as a picture is not art merely because it is painted, or a sculpture merely because it is carved. What we have to discover is which individual works reveal new forms of expression, and this implies true critical judgement. To take three examples—the Testa poster, the lines of a car designed by Missoli and the Forth Bridge—all these, although they are forms of advertisement or products of industrial design, are nevertheless works of art because they reveal imaginativeness, austerity and novelty, reflecting their intimate association with technique. We must therefore consider them as phases in the careers of the artists who produced them. Many other posters (Fig. 31), industrial products and bridges fail to achieve this coherence of expression, which is artistic and at the same time functional. But in order to get a clear idea of all these things. we must first train our eyes to recognize the means of visualization.

105 MARCELLO NIZZOLI, Olivetti 'Lettera 22' Typewriter.
 The products of industrial designers, when, like the two above, they combine utility with harmony, deserve to be considered as works of art without any reservations.

The Values and Symbols of Pure Visibility

WHAT exactly are those values and symbols of pure visibility about which the art critics are so fond of talking? How can we distinguish them? And do they help us to form a critical opinion or do they just confuse our minds even more?

Everybody knows that the true value of a poem lies in its rhythm, the arrangement of words and stresses, its assonances, rhyme, and caesuras; just as in another branch of art, namely music, the important things are the sequences of sounds, the pauses, modulations, rhythms and contrasts, which in longer works require very careful scoring.

In painting and sculpture the elements which, apart from the subject represented, give concreteness to the image are the symbols of visualization and their values. And here, too, the concreteness of the treatment of pauses and beats within the work must be transformed into rhythm.

These values are the result of an absolute harmony between the visual elements within the composition; that is to say, the harmonies of masses, volume, line, surface, chiaroscuro, nuances, tones, lighting effects, brushwork and the other media which can lead to new forms of expression. Sometimes one of these media will tend to exclude the others (for example, where masses predominate, there can be no *sfumato*), but quite often several media can coexist (for example, in special cases, surface and line).

A twelfth-century monk called Theophilus maintained that painting was exclusively a question of harmonizing colours and arranging the composition. In the fourteenth century Cennini asserted that it depended on draughtsmanship and colouring, while a century later Leon Battista Alberti declared that the prime factors in painting were the outlines and the compositional arrangement of the planes, since at that time colour was conceived as being a contrast

106 Neolithic sphere, Glasgow.

107 ANDREA VERROCCHIO, *The Incredulity of St Thomas*, 15th century, Florence, Orsanmichele.

These two examples — a neolithic sphere and Verrocchio's two figures in their niche above the Tabernacle, which is by Donatello — give us some idea of the meaning of 'closed' and 'open' form, the latter being understood as also including 'colour'. If the form is 'closed' the boundaries between light and shadow are clearly stressed and the atmosphere does not invade everything, since 'closed' forms have a sculptural prominence which excludes half-lights. On the other hand, 'open' form needs half-lights and niches, and blurs the outlines; it becomes colour in the sense of atmosphere. Such a distinction is obviously useful when we are studying works, but it should not be taken too literally. No 'closed' form exists that is not to a certain extent 'open' in its relationship to the setting, and *vice versa*. We can speak only of a 'tendency' towards 'cloded' or 'open' forms *cf.* p. 156.

106

107

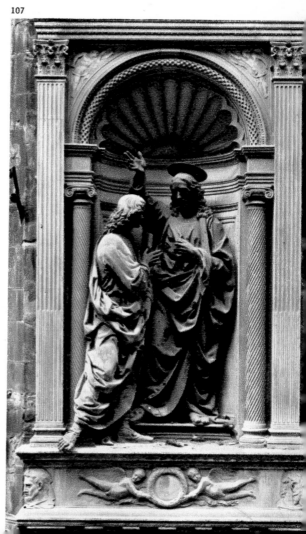

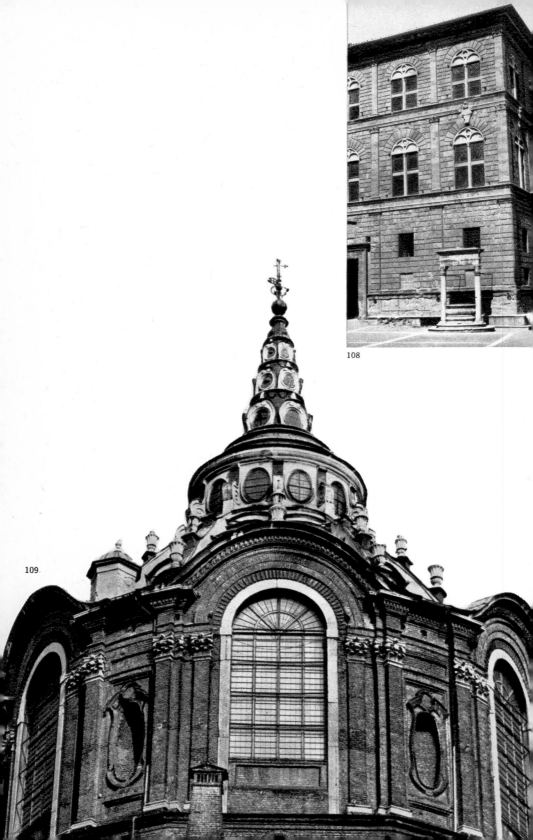

108

109

between light and dark. Theophilus thus teaches us how to understand a Byzantine mosaic (Fig. 89), in which the symbols of visualization are indeed the colour harmonies and the composition, and this explains why the painters of those days did not worry about perspective and foreshortening and used only two dimensions (height and width), while the relationships between colours in the whole composition conformed with the particular ideas about painting which were prevalent in the culture and society of the Late Middle Ages. Cennini's words help us to understand thirteenth- or fourteenth-century paintings, for example a Tuscan painting on gold ground by Bonaventura Berlinghieri (Fig. 52), in which the balance between line and colour is evident, these being the two basic visual symbols in the new conception of Tuscan art on which Giotto laid the foundations of Renaissance art. And lastly, Alberti helps us to understand fifteenth-century frescoes, for example those of Masaccio (Fig. 219), which emphasized the values of chiaroscuro and thus led to a prevalence of relief and plastic forms. This was in conformity with a new ideal, a new conception of reality, in which space was conceived as forming part of human experience and could therefore be 'lived' by mankind. To achieve all this, however, new means of visualization had to be found.

Once we have grasped all this, we shall no longer be ready to believe (as people did not more than fifty years ago) that art is a process of evolution. Nowadays we are aware that every period and every civilization — and consequently every style and form of expression — makes use of certain elements or visual symbols. Accordingly we no longer accuse a Byzantine mosaic-worker of 'knowing nothing about foreshortening', because we know that his ideal was based on composition and colour without any chiaroscuro or perspective. Similarly, Tuscan painters of the thirteenth and fourteenth centuries no longer seem to us to be 'inaccurate' because 'they did not know how to copy Nature', when in actual fact they were very meticulous in their use of outlines and colour, and Masaccio and the other Renaissance artists were not superior to Giotto, but simply made coherent use of different visual elements, in conformity with a different conception of the language of painting and sculpture.

108 BERNARDO ROSSELLINO, Palazzo Piccolomini, Pienza, 15th century.

109 GUARINO GUARINI, Dome of the Chapel of the Holy Shroud, Turin, detail, 18th century.
The distinction between, or tendency towards, 'closed' and 'open' forms can be found in architecture as well as in sculpture. Rossellino's Palazzo Piccolomini in Pienza is an example of 'closed' form with sharply defined edges, whereas Guarini's dome in Turin and Piazza Navona in Rome (*cf.* Fig. 141), with Borromini's church of Sant' Agnese and Bernini's Fountain of the Rivers, have more irregular settings. The same distinction can be applied to drawings (the one by Michelangelo shown in Fig. 68 is 'closed', whereas Titian's are 'open') and to paintings (e.g. Giotto, Fig. 168, tends towards 'closed' form, and Rembrandt, Fig. 8, towards 'open').

Towards the end of the nineteenth century appreciation of all these factors was greatly facilitated by the emergence of the theory of 'pure visualization', which had its genesis in conversations between the painter Hans von Marées, the sculptor Adolf von Hildebrand and the philosopher and art historian Konrad Fiedler (who in a number of essays published between 1876 and 1895 formulated a theory of this doctrine).

They maintained that the prime factor in art was neither beauty nor the 'ideal of beauty' so dear to the neo-classicists, nor the concept or imitation of Nature, nor the depth of feeling demanded by the Romantic school, but simply the ability to 'visualize'.

This theory attributed a share in the production of works of art to the human eye, and it has been discussed and attacked by other theoreticians. Its real value, however, lies not only in the theory itself, but in the effects it produces when put into practice. It has made people pay more attention to the perception of the various visual symbols, to pictorial and plastic concreteness, and consequently to the rhythm of the whole composition.

Following this track and using new methods, students of art have elaborated a concrete, critical — and therefore historical — method of judging art. When explaining the 'relativity of ways of seeing' in his *Stilfragen — Grundlegungen zu einer Geschichte der Ornamentik* (1893), Alois Riegl rejected the old and incongruous hierarchies of 'major arts' (e.g. painting and sculpture) and 'minor arts' concerned mainly with ornamentation, and drew the attention of critics to the 'tactile values' (which Berenson also used as a means of distinguishing between the various schools of painting) and 'optical values'. In his *Principles of Art History* (1915, English translation 1932), Heinrich Wölfflin, famous as the leading exponent of the symbols of pure visualization, cast fresh light on five of these symbols — the development from the 'linear' to the 'painterly', from 'vision of surface' to 'vision of depth', from 'closed' to 'open' forms, from 'multiplicity' to 'unity', and from 'absolute clarity' to the 'relative clarity of objects'. Although this theory has been the subject of much controversy, there

110 DONATELLO, *The Prophet Habakkuk*, detail, 1427–36, Florence, Museo dell'Opera del Duomo.

111 CONSTANTIN BRANCUSI, *The Cock*, 1924, Paris, Musée d'Art Moderne.
The distinction between modelling and modulation enables us to understand the various conceptions of plastic form from ancient times down to our own. The head of the Prophet Habakkuk is an example of modelling, with transitions which create a number of shadows, which are expressive and reveal the hand of a great sculptor and the thumb of a man who knew how to model. Brancusi's *The Cock* is an example of more modulated sculpture with geometrical planes tending towards the abstract, while the lights and shadows are clearly marked. Many ancient Cycladic works (Fig. 72) and certain Negro carvings consisting of innumerable superimposed schemes, are likewise examples of modulation (*cf.* p. 161; on the other hand, the sculptures of Phidias (Fig. 135), Giovanni Pisano (Fig. 183) and Michelangelo (Fig. 1) are examples of modelling.

110

111

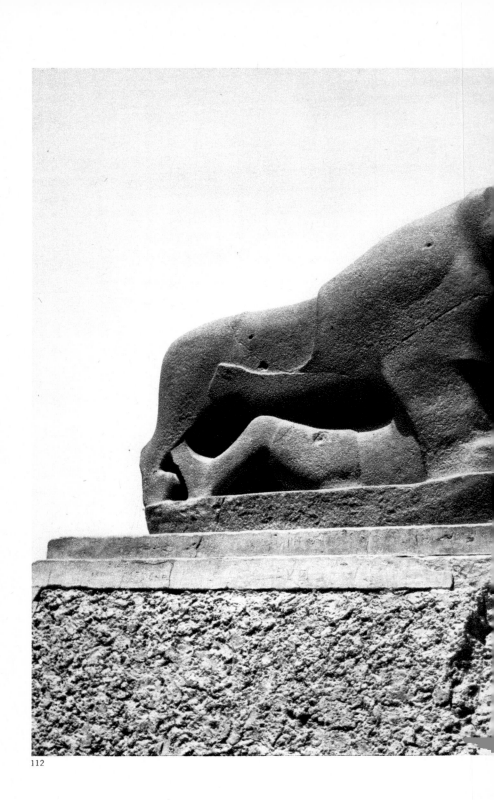

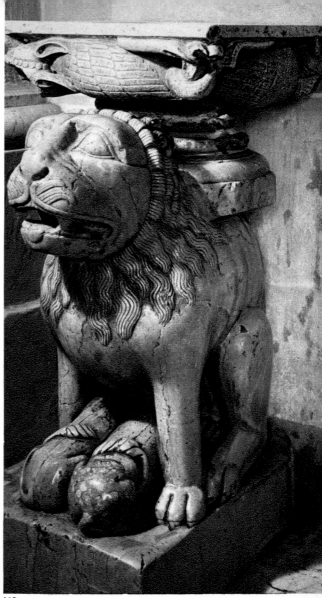

113

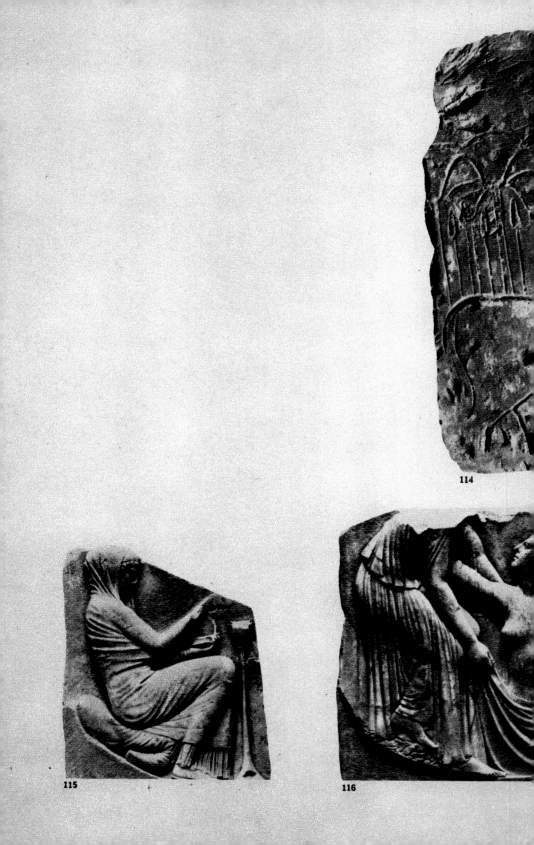

114

115

116

117

118

can be no denying that nowadays the symbols of visualization are generally used by art historians and critics.

There have been, however, and in some cases there still exist, a number of misunderstandings which have to be eliminated if we wish to form a correct opinion. If we try to trace the history of line, masses, surfaces, colouring and the other means of visualization without also studying the history of the whole cultural and social background, or if we ignore the fact that each of these means answered the needs of individual artists, we can easily fall into the mistake of creating abstract genres and schematic tendencies, thus losing sight of the concreteness of style itself.

We may also go wrong if we concentrate too much on the search for formal characteristics alone, since most of the works produced in the past did not, as we have already seen, start exclusively from a desire to create forms. Line, masses, surfaces and the other means of visualization were not the primary aim, but only means adopted by certain artists, in certain circumstances and periods, in order to express certain concepts.

Even when these misunderstandings have been eliminated, however, we must still, if we wish to understand the concreteness of the image, be able to detect the values of the composition by analysing the symbols of visualization, and we must never forget that everything is subordinated to rhythm, to the requirements of the milieu, and to the need to express ourselves in words (real art, including visual art, is always a 'word', an answer to the need we feel to communicate our ideas).

*　*　*　*

112 *Lion attacking a man*, Babylon, first millennium B.C.

113 Romanesque stylophorous lion, Bologna, San Pietro, 13th century.
Here are two works in which the visual symbols—that is to say, the dominant notes in the rhythm—consist of masses. The solemn and primordial deformation of the expression is due to the synthesis created by the masses (*cf.* p. 162).

114 *The Cow-Goddess Hathor*, bas-relief from the wall of a New Kingdom tomb, Turin, Museo Egizio.
Here the visual symbol is line, which dominates the whole rhythm of the composition with its well-balanced treatment of internal space.
115, 116, 117 *The Throne of Venus*, generally known as the 'Ludovisi throne', 5th century B.C., Rome, Museo Nazionale.
The reliefs on this marble throne, dating from the Ionic period (latter half of 5th century B.C.), make use of linear modulation as a visual symbol, and this gives animation to the rhythm. The anonymous artist who carved them certainly knew nothing about the possibilities of line, and it is we of today who can perceive the linearistic rhythm in such works. Nevertheless, the artist had a feeling for linearism and managed to create an image which is still archaic and basically religious by exploiting the tension of the symbols and modulating the rhythm.

118 SIMONE MARTINI, *The Dream of St Martin*, detail, 1324–26, Assisi, Church of San Francesco.

First of all, then, we must draw a distinction between form and colour, since this will serve as a prelude to our consideration of the other means of visualization.

Such a distinction cannot possibly be sharply defined, because in reality there can be no form without colour, and *vice versa*, though there may, of course, be a predominance of form, or a predominance of colour. This distinction, however, already takes us beyond the limits set for the old genres, e.g. painting, sculpture and architecture. Form should not always be identified with sculpture, nor colour with painting; there may well be form in the pictorial genre, and colour in sculpture or in architecture.

In fact, the very concept of form implies restriction within clearly marked boundaries, with a clear distinction between light and shadow. A sphere on a flat ground is form; it is relief accentuated in the clearest possible way (Fig. 106); and the same can be said of a Doric capital (Fig. 136), of a carving by Antelami (Fig. 133) and, generally speaking, of all works dating from the early periods of the various civilizations, when rhythm was noticeably concise and compact. But there may be form in architecture as well, for example in the temples at Paestum, and in paintings, as there is in the blocks making up the composition of Giotto's *Deposition* (Figs. 5, 168), in the statuesque figures to be seen in Andrea del Castagno's frescoes, in a drawing by Michelangelo (Fig. 68) and in Picasso's *Mother and Child* (Fig. 10).

The concept of colour, as opposed to form, implies (in sculpture, too, as regards the surrounding space) the need for a flowing rhythm; in the case of sculpture the most suitable setting is a niche, or at all events a background which creates plenty of half-shadows and blunts or eliminates the outlines. Examples are Verrocchio's *The Incredulity of St. Thomas* (Fig. 107) in its niche on Orsanmichele in Florence (it should not be forgotten that Verrocchio was Leonardo's teacher and that Leonardo himself, by using *sfumato*, immersed his forms in the surrounding atmosphere; *cf.* Fig. 184); or the sculptures of Medardo Rosso (Fig. 70), who often used wax instead of the harder quarried materials (though he always remained a sculptor, defining the movement of the atmosphere in a way of his own by means of delicate touches); or the statues from the Pergamon altar (Fig. 182),

119 LORENZO MAITANI, *The Creation of Eve*, detail, 14th century, Orvieto, façade of the cathedral.

During the Gothic period, in architecture as well as in painting and sculpture, linearism was felt to be an essential element of every composition. Simone Martini modulated his lines to make them harmonize with his delicate, sensitive and typically Sienese colours, and he confined his treatment of space to the surface. In the reliefs on the façade of Orvieto Cathedral (some of which are attributed to Lorenzo Maitani and others to various sculptors of the same period), the treatment of line is in harmony with the broad surfaces enlivened by the breaking-up of the lighting effects and by the movement of the smooth portions and the undulating hollows and projections, which the delicate chiaroscuro causes to vibrate.

119

120

121

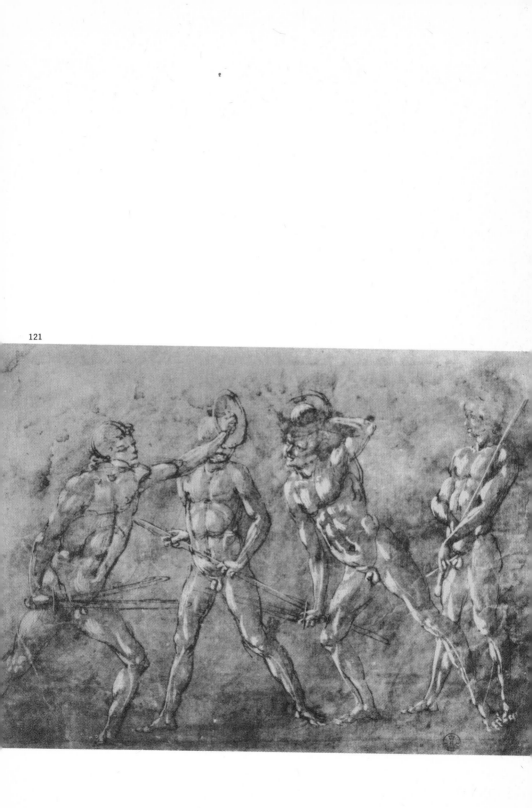

which lend movement to their setting, Renoir's Impressionist paintings (Fig. 172) or the Baroque setting of the Piazza Navona in Rome (Fig. 141).

This distinction between form and colour is, however, a purely abstract concept, though it is useful as a method, provided we do not follow it too literally. What is really important is the vivacity of the rhythm, which may be either 'closed' or 'open', according to the various trends towards conformity, individualism or freedom. Similarly form and colour can be either 'closed' or 'open'.

Nowadays, however, if we want to avoid misunderstandings, further distinctions are necessary—between modelling and modulation and, in painting, between the values of tone and those of timbre.

The head of *The Prophet Habakkuk*, by Donatello (Fig. 110), is modelled with the aid of plastic transitions revealing the hand of a sculptor. Modelling implies a varied chiaroscuro and planes developing smoothly but broken by innumerable internal contrasts and corresponding features. On the other hand, Brancusi's *The Cock* (Fig. 111) is modulated, the sharply defined form being attuned to a rhythm set by the planes, which do not require the use of the thumb or the chisel in order to create variations of light and shadow. Modulated works have frequently been described as not being art at all, because they are supposed to be examples of imperfect modelling; but in reality we have here to deal with two completely different concepts, which have followed each other alternately from the days of the ancient civilizations down to our own times.

Another distinction—this time concerning the technique of painting—must be drawn between the values of tone and those of timbre. As we shall see later, tone is atmospherical depth, whereas timbre is all on the surface. Giorgione's *The Tempest* (Fig. 129) is a tonal painting, and so is the *Still life with lamp* by Morandi shown in Fig. 130. Certain Egyptian compositions, a Ravenna mosaic dating

120 PAOLO UCCELLO, Study for a *Mounted Warrior* 15th century, Florence, Uffizi.

121 ANTONIO POLLAIUOLO, *Nude Warriors*, study, 15th century, Florence, Uffizi.
The Tuscan Renaissance tended to give prominence to the plastic values and to 'closed' rhythm; linearism was used to stress the modelling of the chiaroscuro, but always with a feeling that it was potential movement, possessing a vitality which could give tactile concreteness to an abstract theme. This *Study for a Mounted Warrior* by Paolo Uccello has an essential absoluteness, stressed by the modulations of the plastic lines. In his study of *Nude Warriors* Pollaiuolo restricts his lines even more and is always prepared to interrupt them in order to give animation to a modelled drawing, in which chiaroscuro of the background accentuates the potential movement so full of energy.

122 SANDRO BOTTICELLI, *La Primavera*, detail, 1477–78, Florence, Uffizi.
Botticelli modulates his compositions by resorting to a kind of linearistic counterpoint; but his linearism is based on a Renaissance conception of space in its relationship to mankind and on a knowledge of the laws of Nature, which are interpreted in a new way and given a new rhythmical movement.

161

from the sixth century (Fig. 125) and abstract paintings like those of Albers (Fig. 124) are examples of timbre, because the colour cannot serve to create perspective depth, but remains on the surface and, just as skill is needed to render the graduations of tonal values, in the same way it needs a skilful artist to balance the surface effects of timbre colours, to make them produce a lively rhythm with corresponding features in the spatial sectors. Once he has grasped this, the ordinary man can understand that, in order to formulate a critical judgement, he must not look for the tonal effects of perspective in a picture based on timbre, which is always a surface matter. In this case, too, we are dealing with two conceptions of painting which have differed ever since the early days of art criticism.

Next, we come to the values of the visual symbol of 'mass'. If by 'mass' we mean a block, this implies the concept of form, with a clear distinction between light and shadow; for example, the values of masses can be seen in the rhythm of the Babylonian Lion (Fig. 112), in the Romanesque stylophorous lion (Fig. 113), in the statues of the rock temple of Abu Simbel (Fig. 137), in the Doric metopes now in the museum at Palermo, and, in a painting, in Giotto's *Deposition* (Fig. 5), composed of blocks, with the actual painting and the draughtsmanship closely interrelated and giving emphasis to the forms.

Masses tend to produce an architectural construction made up of large blocks giving the effect of a broad synthesis, and the resulting rhythm can never be complicated. These blocks produce an effect of weightiness; they are primordial and make us feel weight in relation to the construction of the whole. It is thus obvious that the concept of verisimilitude (and consequently anatomy, foreshortening and truth to Nature) can be completely eliminated by the rhythm of the masses. If our eyes are not accustomed to such distinctions, they are apt to form an unfavourable opinion of works which are coherent and vivacious, simply because the presence of masses or blocks makes them appear to be 'distorted'.

On the other hand, the values of the visual symbol 'volume', prominent though they may be, do not produce any effect of weight. A Greek amphora has volume, but no mass. The balance of volumes, especially in architecture, gives prominence to inner space. For example, in the apse of the cathedral in Parma, in the apse and cupola, designed by Bramante, in the church of Santa Maria delle Grazie in Milan, and in the Etruscan carvings on the *Sarcophagus*

123 BENVENUTO CELLINI, *The Nymph of Fontainebleau,* 12th century, Paris, Louvre.
The Manneristic trend, which developed during the sixteenth century as the third phase of the Renaissance, had a predilection for distortion even when making use of linearism, and also for brusque interruptions of the rhythm, since regularity in the latter could no longer express the feeling of instability prevalent among the artists of the new generation.

124 JOSEF ALBERS, *Study for Homage to the Square 'Blue Depth',* 1961, Milan, Galleria del Naviglio.

123

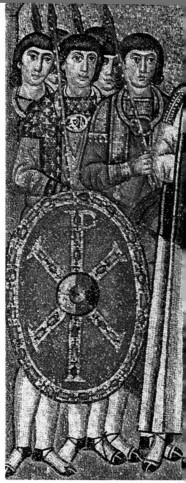

125

124

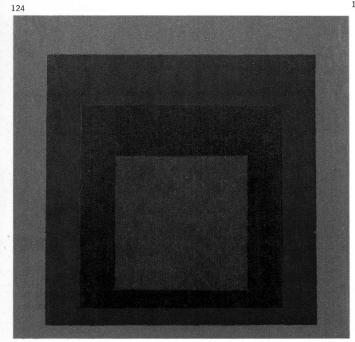

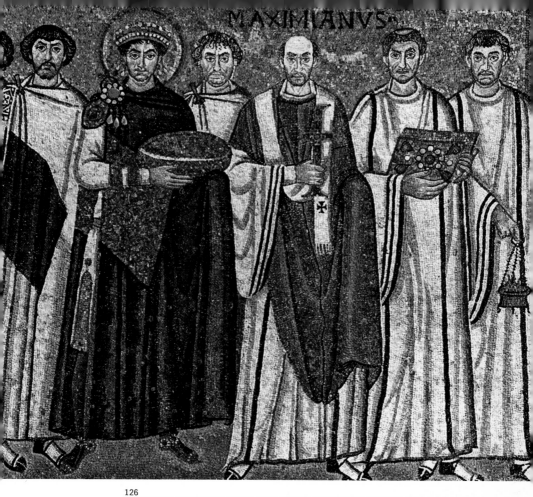

MAXIMIANVS

126

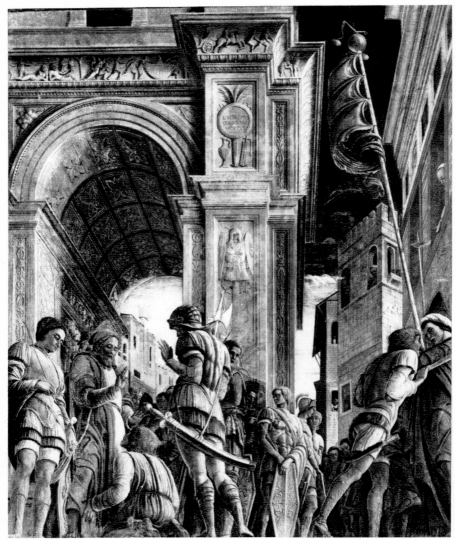

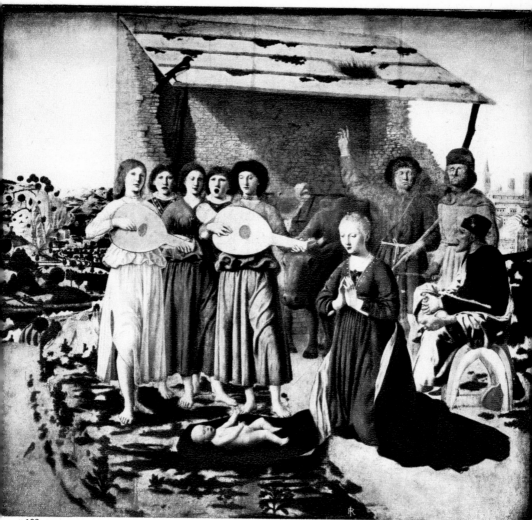

128

129

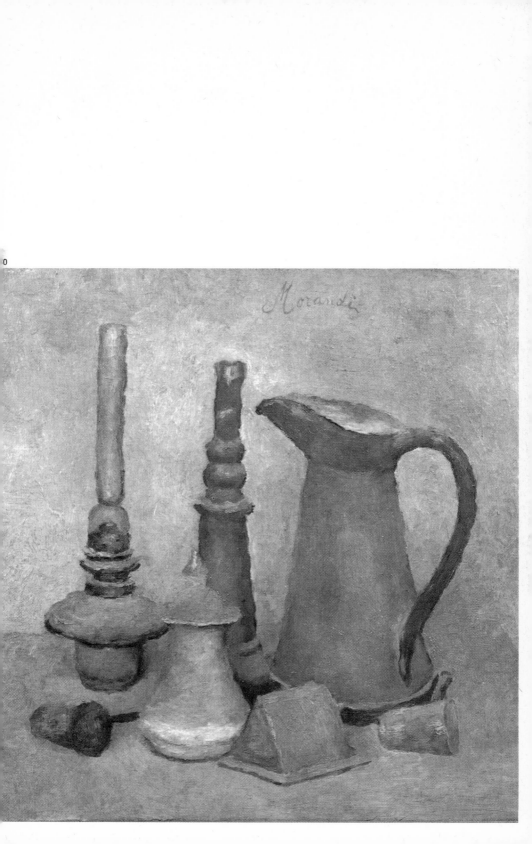

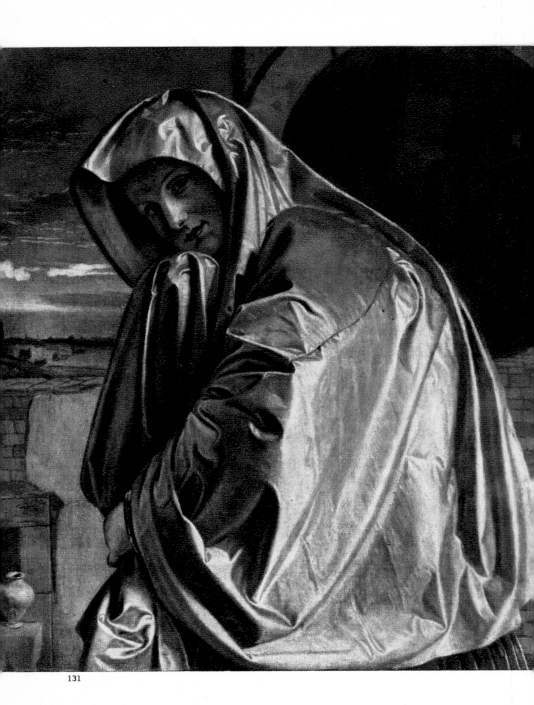

131

125 *The Cortège of Justinian*, mosaic, 6th century, Ravenna, San Vitale.

In painting the values of timbre consist of surface harmonies, since there is no third dimension, or perspective depth. The colours therefore need to be balanced, and this requires considerable skill, because the rhythm of the composition may be broken if the artist does not bear in mind that any colour can change its value when placed alongside others or if it is confined within a space which is either too large or too small. The values of timbre, which are in accord with a particular, non-naturalistic and to a certain extent abstract conception of space, make it possible to heighten the colour harmonies, because they eliminate chiaroscuro. The three examples from different centuries shown here give some idea of the values of timbre. And Picasso's *Girl before the Mirror* (Fig. 63) is also a painting in which the values of timbre are used.

126 PAUL SIGNAC, *Boats in the harbour*, detail, 1911, in a private collection.

Here is an example of 'touch painting' executed by Signac (1863–1935) in the Neo-Impressionistic style and using only pure colours, without any complementary tones. The individual strokes of the brush can be clearly discerned, and in this particular case they create a painterly texture constructed by a completely detached mind. Van Gogh (Fig. 212) was also a Neo-Impressionist and consequently he, too, made use of 'touch painting', but his strokes were more agitated, since they were the product of a different, emotional and visionary temperament, and in this respect he was a forerunner of Expressionism.

127 ANDREA MANTEGNA, *St James on his way to martyrdom*, 15th century (destroyed during the last war), Padua, church of the Eremitani.

128 PIERO DELLA FRANCESCA, *Nativity*, 15th century, London, National Gallery.

129 GIORGIONE, *The Tempest, c.* 1510, Venice, Accademia.

130 GIORGIO MORANDI, *Still Life with lamp*, 1923, Milan, G. Mattioli collection.

Mantegna's *St James on his way to martyrdom* is an example of linear (or, as it is sometimes called, geometrical) perspective, which is based mainly on draughtsmanship, the images of three-dimensional bodies being transferred geometrically to the pictorial plane, the eye of the spectator being supposed to be at a point known as the point, or centre, of vision. In the mosaic shown here, the focal point is low and this gives an effect of greater monumentality to the whole of the architecture and also to the personages. Piero della Francesca's *Nativity* is an example of aerial perspective, in which the colour values produce the effect of distance, while the rhythm is suggested by the geometrical structure, the group being illuminated by pure, bright light. In his *La Gioconda* (Fig. 58) Leonardo used another form of aerial perspective, relying on the shades of blurred half-lights and on an atmosphere which softens and submerges the outlines. The visual symbol of 'tone' is yet another variant of aerial perspective, good examples being Giorgione's *The Tempest*, a Renaissance work, and, among the moderns, Morandi's *Still life with lamp*. The intensity of the light emanating from the colours gives the effect of graduated perspective. It is a common fallacy that in tonal paintings there is only one predominant colour; there may be several, and they may even be contrasting colours, provided always that the intensity of the light produces the effect of graduated perspective.

The effect of perspective can also be achieved in more superficial ways, as, for example, in the landscape shown in Fig. 21. Perspective is only a symbol, a means of visualization, and what we ought to consider in a work of art is its concreteness and its inner life; and we should never let ourselves be influenced by effects which may be purely superficial.

131 GIROLAMO SAVOLDO, *Mary Magdalen, c.* 1530, London, National Gallery.

This *Magdalen* by Savoldo is a good example of luminism and reflects the thoughtful temperament of this Lombard artist who had a predilection for lunar silence. The chief exponents of luminism were, however, Caravaggio (Fig. 33) and his followers.

of Caere now in the Villa Giulia museum, where the terracotta figures of the man and wife are volumes, but not masses.

Another visual symbol is 'surface', which can provide values in only two dimensions, height and breadth. Very often, however, since it is not based on any naturalistic imitation of life, surface can produce an effect of infinity, as it does with the gold grounds of Byzantine works of art (Fig. 89) or in compositions created in the more symbolical East. The use of surface as a means of expression produces the values of timbre which we have already mentioned; from the art of ancient Egypt down to Cubist (Figs. 32, 63) and abstract (Fig. 124) painting, runs a clear line of rhythm marked by surface timbre values.

In general, this visual symbol, while it implies a clearly symbolical conception of space, makes an intimate relationship with the walls of the building possible. It thus performs a decorative function (though we must not attach any pejorative meaning to the word 'decorative'); for example, in tapestries, Polynesian *tapas* and mosaics development on the surface was essential and, above all, it fulfilled the requirements of civilizations which had a great feeling for the decorative value of space. It was only after the Renaissance, in the days of Baroque and as a result of the misconceptions current in the nineteenth century with its pedantic adherence to realism, that these genres lost the feeling for surface, which has been revived, for decorative and also for lyrical purposes, by certain modern trends in art.

There may be a tendency to stress the values of surface whenever, either intuitively or by mere chance, there is a suggestion of perspective depth (e.g. in certain Gothic compositions which are also linearistic (Fig. 171) or in Gauguin's synthetic symbolism (Fig. 76)). In such works the surface, strictly speaking, is not everything, but space tends to become a matter of surface, because the artists were not trying to render perspective, but wanted to create broad colour-schemes and interwoven rhythms.

Another visual symbol, linearism, has its roots in the predominance of a linear type of modulation and in a rhythm which builds up the essential outlines of the composition, or, in some works, moves across the surface like an arabesque. Examples of this are the *Hera of Samos* which I have already discussed and the stupendous 'Ludovisi Throne' triptych showing the birth of Venus and two female figures (Figs. 115–117), in which the lines have a subtle, harsh expressiveness, but at the same time produce poetical effects as a result of the clarity of the composition, reminding us of music. In Egypt, too, linearism produced works which reveal a coherent modulation of space, for example, the *Cow-Goddess Hathor*, a bas-relief from the wall of a New Kingdom tomb (Fig. 114).

Mediaeval Gothic used line (together with colour) as a basic means of expression. Simone Martini, in the city hall at Siena (Fig. 188), and Maitani, in Orvieto Cathedral (Fig. 119), created modulated rhythms based on linear systems revealing a refined imagination.

In fifteenth-century Tuscany Pollaiuolo (Fig. 121) was one of the greatest plastic designers of all times, while Botticelli also modulated his lines to create rhythms of forms set in counterpoint, of which a detail from his *La Primavera* (Fig. 122) is an outstanding example. Cellini's linearism (Fig. 123) was affected by the Mannerist movement, the sixteenth century's third Renaissance trend; he gives us a more distorted, restless linearism, always ready to break a rhythm which no longer interpreted the feeling of instability prevalent among the artists of the time. The Liberty style, Art Nouveau and the Jugendstil (which were really one and the same thing with only slight variations due to the fact that they flourished in different countries) developed linearism as a symbol for mental confusion. Beardsley (Fig. 175) preferred dry, sharp lines and Pre-Raphaelite experiments, which could easily be converted into calligraphy, though the keynote was one of symbolistic lyricism; Horta's staircase (Fig. 144) is an example of line used to create a setting in space, while Matisse, whose cultural origins were different, after experimenting with the free methods of Fauvism, produced drawings (Fig. 178) in which the lines suggest light, colour, flesh and the senses; in fact his sensitive lines have the function of colours and were the result of previous experiments in painting and drawing of a more complex type, such as we find in the whole of modern French painting.

Picasso's drawings would also seem to rely a great deal on linearism, but in his case the construction is always Cubist in origin. His drawings are not entirely linearistic, even when he uses line as his only means of expression. In his *Fall of Phaëton* (Fig. 18) he relies to a great extent on outlines, and this confirms that he felt an urge towards broken forms, quite unlike those of arabesques.

The values of another visual symbol, chiaroscuro, make inter-mediate transitions in the modelling necessary. A drawing by Michelangelo (Fig. 68), rugged and reduced to essentials, creates a rhythm of plastic chiaroscuro which is extremely synthetic, as if petrified, and suggested rather than actually expressed. In Leonardo's works (Fig. 58), the chiaroscuro becomes a barely perceptible transition from shadow to a mysterious half-light, an atmospherical *sfumato* in which every outline is blurred. In a drawing by Paolo Uccello (Fig. 120) the chiaroscuro, bounded by the modulation of the outlines, achieves an effect of sculptural relief leading to a broad synthesis, without any insistence on accidental shadows.

And now we come to another visual symbol — perspective — which uses the third dimension in order to achieve that effect of distance so much admired by the general public. Earlier artists sometimes managed to give the effect of perspective by using their intuition, but the first man to make a thorough study of it was Brunelleschi, in the early fifteenth century. Sometimes it is linear, in which case it is called geometrical perspective (e.g. in Mantegna's *St James on his way to martyrdom*, Fig. 127), because the artist starts by making a drawing and then transfers the images of three-dimensional bodies to the

plane of his painting in accordance with a geometrical scheme, imagining that the spectator's eye is at a point known as the focal or viewing point. And it may also be aerial, when it is transformed into a pictorial effect by progressively graduating the atmospherical colouring, which, quite apart from any fixed rules, always produces an effect of considerable distance. In Leonardo's *La Gioconda* (Fig. 58) the perspective is aerial, but not tonal, since he makes use of the graduations of blurred half-lights.

Previously Piero della Francesca (Figs. 86, 128) had used a different kind of aerial perspective, achieved by using chromatic values combined with an austere rhythm inspired by geometry and setting the planes of the volumes in an extremely pure, noonday light with hardly any shadows.

The visual symbol of 'tone' is another variant of aerial perspective. It was first developed in Giambellino's workshop in Venice, after he had come into contact with Antonello da Messina in the closing years of the fifteenth century, and it was developed still further by Giorgione, Titian and other artists down to Guardi in the eighteenth century. In Giorgione's *The Tempest* (Fig. 129) the intensity of light in the colours acquires all the graduations of perspective. Morandi's *Still life with lamp* (Fig. 130) is also a very subtle and well-graduated tonal painting.

Those who want to train their eyes to be critical must therefore learn how to perceive the different means employed to achieve perspective (whether linear, chromatic, aerial or tonal) and to detect their values, because the effect of perspective can be achieved in a number of different ways.

There are innumerable works in which the effect of distance is achieved, but which are in no sense works of art because they are just commonplace daubs. The various aspects of perspective are only one of the means of visualization, and what we ought to try to discern is the whole process underlying the creation of the image with its essential hidden rhythm. And we should never let ourselves be influenced by effects which in reality are purely superficial.

Yet another visual symbol is 'luminism'. This, though it may often seem to be the same as 'tone', in which the luminosity is due to the more or less intense values of the colours, is in reality always derived from a source of light illuminating only certain parts of the scene and leaving others in shadow. Miniature-painting, especially in Lombardy, was a harbinger of this trend, but it was first developed in painting during the sixteenth century by Savoldo, whose *Mary Magdalen* (Fig. 131) transposes Giorgione's Venetian lyricism into a more Lombard key, and it found its chief exponents in Caravaggio (Fig. 33) and his followers. Here, too, we must not allow ourselves to be misled by superficial lighting effects. We must always consider 'luminism' as a means of expression, for real painters, even when they seem to be using only black, know how to graduate it with subtle shades of brown and grey, so that the colour effect is not entirely eliminated.

Among the best 'luminist' painters was Caravaggio's disciple Orazio Gentileschi, whose palette included greys which are almost silvery.

And lastly, we must learn how to distinguish the values of 'touch painting' (Fig. 126), a method employed by Magnasco and other eighteenth-century artists, who introduced what was called 'contemptuous' painting because they stressed the individual strokes of the brush, and carried on by the Impressionists, Divisionists and other modern movements. And we must also be able to detect the pure values of symbols, of which I shall speak later.

Other visual symbols were created as the result of the emergence of new trends; for example the collage used in various ways by Cubists (Fig. 32), Futurists, Dadaists (Fig. 94) and other painters of our own times, involves the use of gummed paper, other materials and even objects. Instead of applying colours with the brush, they used scraps of paper or other materials that can be glued on in order to achieve new harmonic values, psychic echoes and expressiveness, but the spectator's eye has to become accustomed to detecting them.

Such methods of visualization do not, as I have already said, provide an adequate basis in themselves for the formulation of a critical judgement, since they are merely a means enabling us to penetrate into the core of a work of visual art. We must always consider first of all the milieu in which the artist spent his formative years and his individual temperament. Only when we have made as deep a study as possible of the historical process of the art of expression, can our judgement be final.

The Decorative Function in Relation to the Setting

THERE is another factor which must be borne in mind. If we want our judgement to be really critical, to what extent and in which cases must we place a work of art—or at all events try to imagine it—in the architectonic setting for which it was originally intended?

As I have already said, I often wonder what effect the Acropolis in Athens would produce on us today if it were still intact, as it was in the days of Pericles, with its painted temples and its carvings not yet corroded by time. We would probably be surprised and bewildered, because our eyes are now accustomed to regarding the Acropolis as a fragment, as an impressive ruin which reminds us of the distant past and makes the prospect of further excavations exciting. Since the days when the Acropolis was built we have had the Arcadian movement, born at a time when the neo-classicists were thrilled by their rediscovery of Antiquity, and after that came Romanticism, Impressionism and Symbolism. Our passion for patina and ruins makes us regard carvings, buildings, frescoes and mosaics as fragments removed from the settings in which their creators placed them as forms of decoration. The concept of functional decoration in strict harmony with an architectural rhythm has lost its original value and, especially as a result of the restorations undertaken during the nineteenth century, has assumed a pejorative connotation. A superficial painting and a sculpture that has no life are condescendingly described as being

132 The Baptistery in Parma, detail, 12th–13th centuries.

133 B. ANTELAMI, *Last Judgement*, detail from the lunette over a side-door of the Baptistery in Parma, 12th–13th centuries.

134 *St James*, corner pilaster in the Abbey of Moissac, France, 12th century.

135 PHIDIAS, *The Three Goddesses*, fragment from the east pediment of the Parthenon, 5th century B.C., London, British Museum.

The carvings of Antelami and his school, as can be seen from Fig. 133, were intended to be decorations in the proper sense of the term, and this implies that the artist must have had a share in the whole architectural design of the Baptistery. The same may be said of Phidias, to whom the vigorous carving of *The Three Goddesses* is attributed, since it is the 'decorative' element in the setting provided by the tympanum. Phidias (as we know from the sources) collaborated with Ictinus and Callicrates in designing the whole of the Parthenon, and this explains the intimate relationship between the sculptures and the architecture. During the Romanesque period, Antelami must certainly have had an important share in the building of the Parma Baptistery, since the architectural elements, the plastic rhythm and the pauses created by the relationships between full and empty spaces show that there was a close connexion between the style of the architect and that of the sculptor. It is quite possible that Antelami himself may have designed the whole Baptistery. The Abbey of Moissac is another mediaeval example of the decorative value of sculpture in an architectural setting.

176

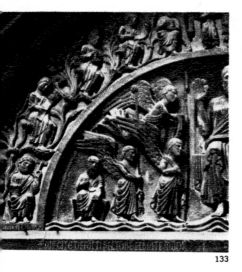

133

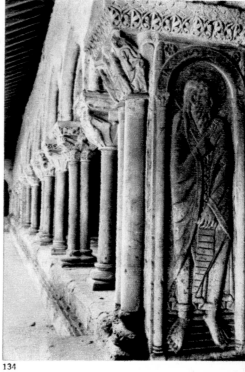

134

132

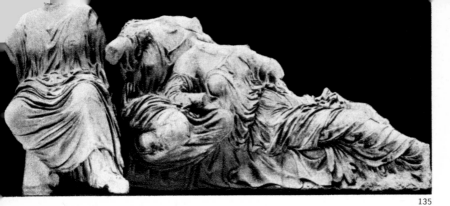

135

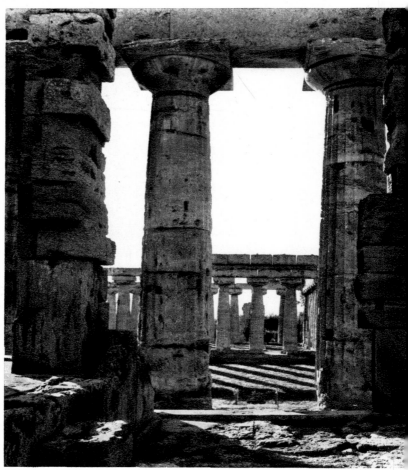

136

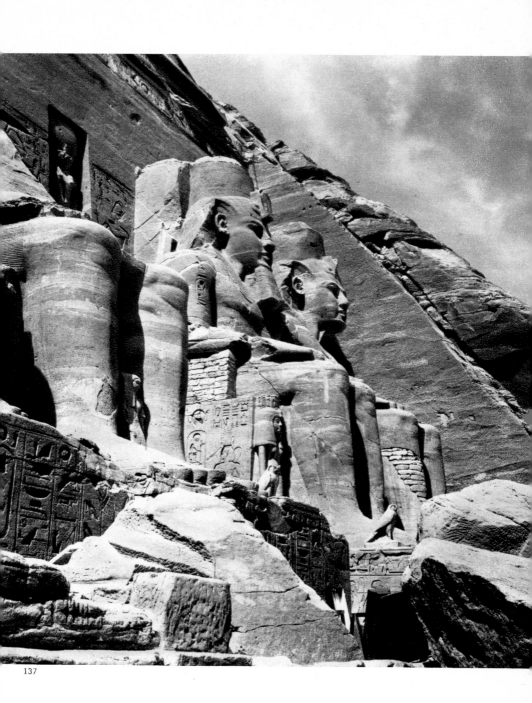

137

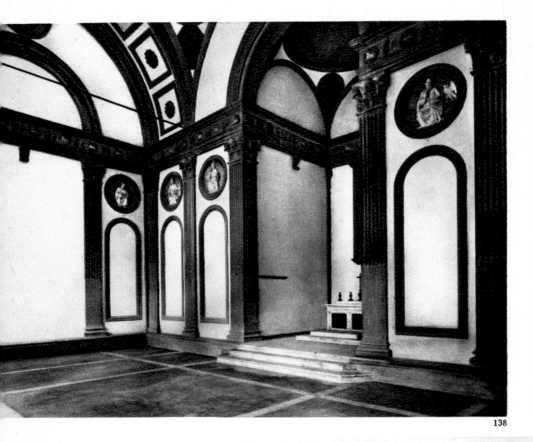

138

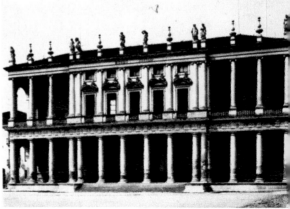

139

decorative. And we no longer draw any distinction between the ornamental elements, which may have been added after the completion of the original structures, and decoration which, if it really is decoration, must have a rhythmical austerity and be in tune with the architectural setting.

In reality, the prevalence, since the nineteenth century, of easel paintings and small carvings has resulted in decoration being considered as a task for craftsmen, who today are hardly to be found any more, and there is no longer any close collaboration between painters, sculptors and architects.' Realism and individualistic Decadentism have taught us to appreciate the values of fragments, of small paintings and small sculptures. The fact that most works are now exhibited in public or private galleries and that artists are no longer in close contact with their patrons (works are rarely executed on commission nowadays, because our modern society has other means at its disposal) has brought in its train a proliferation of easel works. Painters and sculptors spend all their time in their studios and often have no idea where their works will eventually be exhibited. The 'Liberty' style, which was a sequel to the Pre-Raphaelite movement and the trend started by William Morris in Britain, was a last attempt to make decoration harmonize with the architectural setting (and this in itself led to a clash with the eclecticism of the huge and pompous 'Universal Exhibitions'), no matter whether it consisted of ceramics, glass, mosaics, wrought iron or carvings. And very often, especially in the provinces, everything was still influenced by residues of realism.

The 'twentieth-century' trend, which started in Italy after the First World War, but was in reality due to the crisis prevailing throughout Europe, tried to restore prestige to decoration by following mediaeval models. This, however, implied nothing more than a return to the antique, a reactionary movement contrary to modern ideas and therefore unacceptable. The relationship to society is no longer the same as it was in the Middle Ages and in earlier civilizations, and it was useless to consider decoration as being merely monumentality and

136 Detail of the Temple of Poseidon (foreground), 5th century B.C., and the Basilica (background), 6th century B.C., in Paestum.

137 The Rock Temple of Rameses II at Abu Simbel, 19th Dynasty, 1300–1200 B.C.

138 FILIPPO BRUNELLESCHI, Interior of the Pazzi Chapel, Cloister of Santa Croce, Florence, 15th century.
During the fifteenth century Brunelleschi interpreted Tuscan Renaissance culture by applying anthropocentric concepts to architecture, mankind being felt as the focal point of spatial relationships stressed, as they are in the Pazzi Chapel, by dark profiles which constitute a kind of sober and extremely subtle sculptural decoration in harmony with the architecture itself.

139 ANDREA PALLADIO, Palazzo Chiericati, Vicenza, 16th century.

declamatory gestures. Painters and sculptors of the 'twentieth-century' trend like Sironi and Arturo Martini found wider scope for expression in non-monumental works. The façade of the *Popolo d'Italia* newspaper offices and the gates of the Arengaria in Milan did not help in any way to solve the problem of decoration.

This is because decoration is something quite different, since in reality it is an inherent part of the architecture, or at all events an indispensable element of the setting. It must be morally—and not just aesthetically—suitable, and it should never be merely an artificial device.

If, therefore, we consider individual works of painting or sculpture designed for a particular setting as mere fragments and lyrical outbursts, we can never appreciate their intimate relationship to the setting, thanks to which the whole of the surrounding space was given life.

For example, we do not know the name of the architect who built the baptistery outside the cathedral in Parma, but one glance at the relationship between the sculptures and the architecture as a whole (Fig. 132) suffices to show us that Antelami, even if he was not the architect as well as the leading sculptor, must certainly have had a decisive share in the design of the whole complex. The gaps between the statues and columns and the prominence of certain reliefs give vitality to the whole setting and are thus decoration in the loftiest sense of the term, and they reveal a feeling for proportion that takes us back to the distant classical tradition, which during the Middle Ages was never completely eclipsed.

Again, the works of Phidias reveal a close collaboration with Ictinus and Callicrates, who built the Parthenon (as is specifically stated by the sources), because the carvings, including those in the tympana, are endowed with movement and fit in with an architectural setting based on a uniform conception—in other words they are a form of decoration which is related to the whole structure and provides a setting full of lively rhythms and never inert.

We find the same thing in Egypt, in the rock temple at Abu Simbel (Fig. 137), if we study the relationship between the architectural masses and those of the sculptures. Here the decoration is not just superimposed, it is an integral and essential part of the whole.

Similarly, the Doric capitals and columns in the ancient temples at Paestum (Fig. 136) were not merely external adjuncts, since the

140 LORENZO BERNINI, Chair of St Peter in St Peter's, Rome, 17th century.

141 The Piazza Navona in Rome, detail showing Bernini's Fountain of the Rivers and the façade of the Church of Sant' Agnese by Borromini, 17th century.
Piazza Navona is one of the best examples of a Baroque setting, in which the rhythm pervades everything and is as if submerged by the spatial relationships. Bernini's Chair of St Peter is another example of Baroque decoration with its exaltation of ample spaces and the effects of light and shadow.

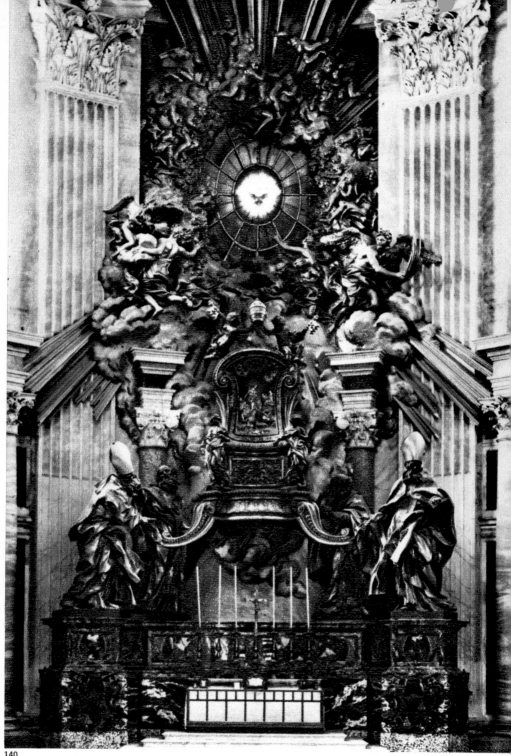

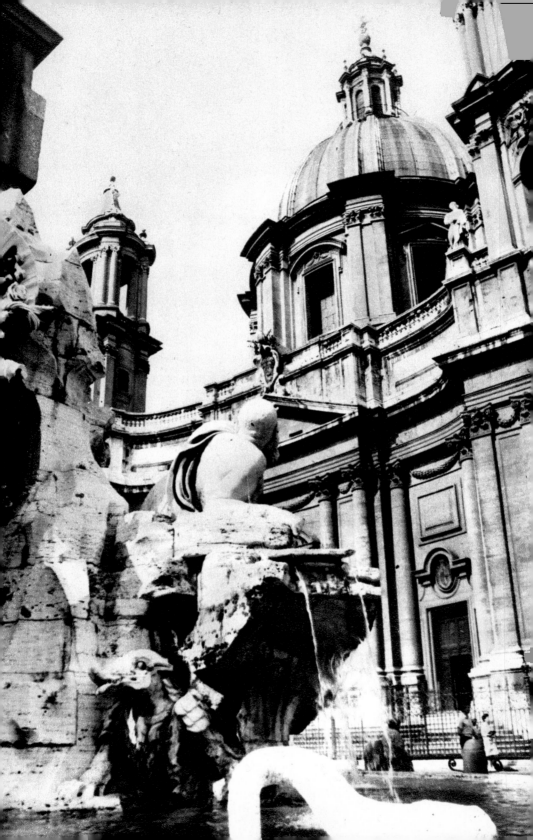

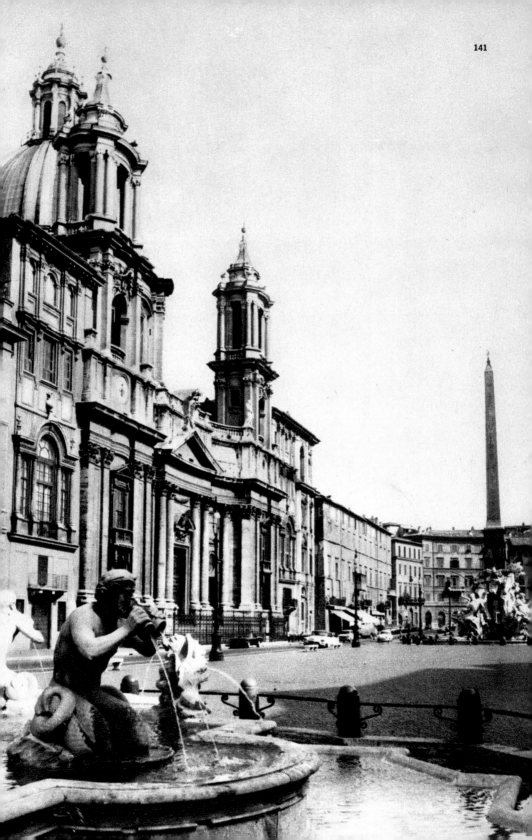

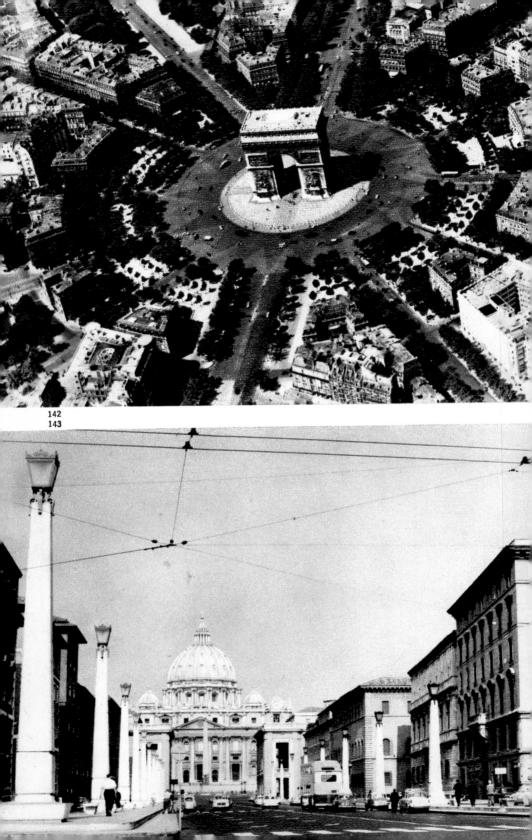

peristyle surrounding the cells of the temples had a structural function revealing a clearly defined rhythm which at the same time served as a form of decoration.

Think, too, of the effect of relief produced by the ribs of the vault in the Romanesque basilica of Sant'Ambrogio in Milan. They are structural elements contributing to the dynamism of thrust and counter-thrust and, together with the ceilings, the pilasters and the buttresses on the outside walls they have a decorative and expressive value, just like the capitals on Romanesque columns. (For that matter all capitals have a structural and decorative value, starting with the Doric and Ionic capitals of ancient Greece.)

Then we have the projecting edges in the interior of Brunelleschi's Pazzi chapel in Santa Croce, Florence. From the purely functional standpoint they are not strictly essential, but they provide such a striking rhythm, such a subdivision of space, that without them the harmony of the architectural proportions would be less perfect. They are, therefore, necessary decorations, to such an extent that they become part of the architecture itself, the focal point of which is the human figure (Fig. 138).

On the other hand, the façade of the Certosa near Pavia, likewise dating from the fifteenth century, is a superimposition which is not in tune with the rest of the Gothic architecture. It was intended to be an embellishment, but the effect is one of pretentiousness. It has no relationship to the Gothic buildings behind it and is a typical example of superimposed ornamentation, revealing the crisis through which the whole concept of decoration was passing. But not very far away, in Pavia, we have the Romanesque basilica of San Michele Maggiore (Fig. 75), which is another example of functional decoration, with its splayed doorways, its polistyle fillets, corresponding with the nave and aisles, the penthouse form of its façade giving us an idea of what the interior will be like, its sandstone carvings (which have unfortunately suffered from the ravages of atmospheric conditions), its rhythm which acquires the value of local colour, and the harmonious equilibrium of thrust and counter-thrust provided by the series of perimetral buttresses and the volumes of the transept and apses—all of these things giving vitality and uniformity to the whole relationship between architecture and decoration.

In the sixteenth century Palladio, like the great architect he was, realized the value of such relationships. In the Palazzo Chiericati at Vicenza (Fig. 139), the rhythm of the filled spaces and voids and the

142 The Place de l'Étoile, Paris, 19th century.

143 MARCELLO PIACENTINI and ATTILIO SPACCARELLI, detail of the Via della Conciliazione in Rome, 1932–50.
 The new Via della Conciliazione in Rome is a very poor example of a spatial setting. The new buildings and the horrible obelisk-shaped lamp-standards give a tone of false decorative monumentality to the whole setting.

whole ensemble of carved decorations combine to give an effect of active space, and the building looks out over the surrounding country which provides subtle effects of Venetian colouring. But when Palladio's architecture is combined with the frescoes of Paolo Veronese in the stupendous Villa Maser near Bassano the result is a unified collaboration which is really exceptional. The villa is set in the landscape, and it has proportions as well as colour. Inside, Veronese's frescoes are placed in settings designed by the architect, with a natural, flowing rhythm and a vitality so great that the decorations become an integral part of the whole.

The Baroque period, with its predilection for wide open spaces, produced some very striking and theatrical decorative effects. Occasionally, the illusion of perspective, the abundance of vanishing points, and the urge to produce something wonderful at all costs, resulted in the opposite effect being produced—monotony and a superabundance of generic details. This, however, was the case when Baroque had achieved wider popularity or when it was practised by minor followers, and not in the spatial settings created by a gifted artist like Borromini. The church of Sant'Ivo alla Sapienza in Rome (Fig. 83) is an example of decoration and architecture based on constructive elements and on functional requirements, and Borromini displayed all his ingenuity in his treatment of space. And we must look again at the Piazza Navona (Fig. 141), undoubtedly one of the most beautiful public squares in the world. Borromini's façade for the church of Sant'Agnese and Bernini's River Fountain, set as they are in this great helicoidal space, which was once a Roman circus, with curving houses all round it, create repetitions of spatial movement endowed with a varied and almost imperceptible rhythm. Here decoration plays a leading role, and it is inspired by the very breath of the sculptures and architecture, and by the colour-scheme of the whole.

Bernini's Chair of St Peter is another, though perhaps less spectacular, example of a Baroque spatial setting. It is decorative because it is sculpture full of movement with a flowing rhythm, and because it is space which does not stand motionless, but vibrates as it expands (Fig. 140).

When we turn to the Arc de Triomphe in the Place de l'Étoile, Paris, we find a work which in itself is anything but beautiful (Fig. 142) and reminds us of stage scenery. Nevertheless, it vindicates itself because

144 VICTOR HORTA, detail of the staircase in the Solvay building, Brussels, 1895–1900.

145 LUCIO FONTANA, illuminated sign shown at the Ninth Triennial Exhibition in Milan, 1951.

146 GAUDÍ, Battló building, Barcelona, 1905–7.
 Like Horta's staircase and Fontana's illuminated sign, an example of real spatial decoration.

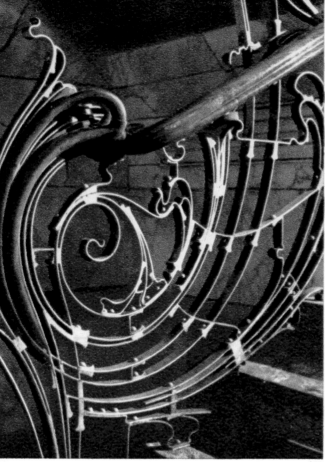

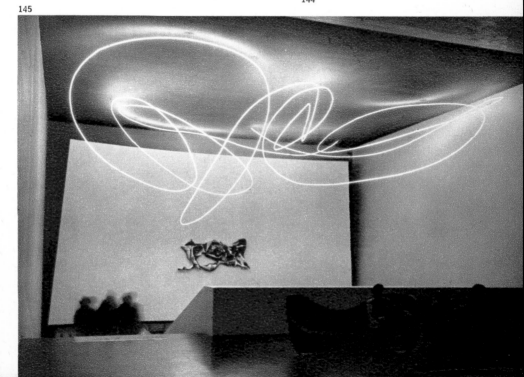

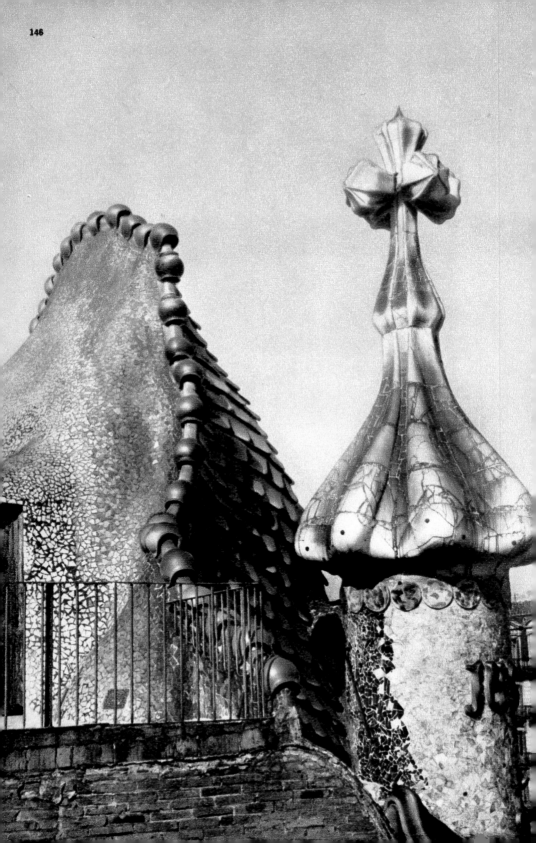

147

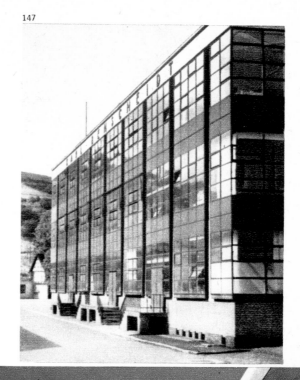

148

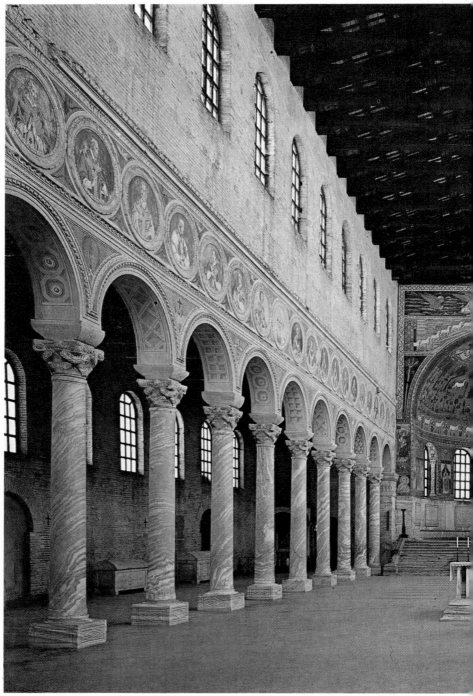

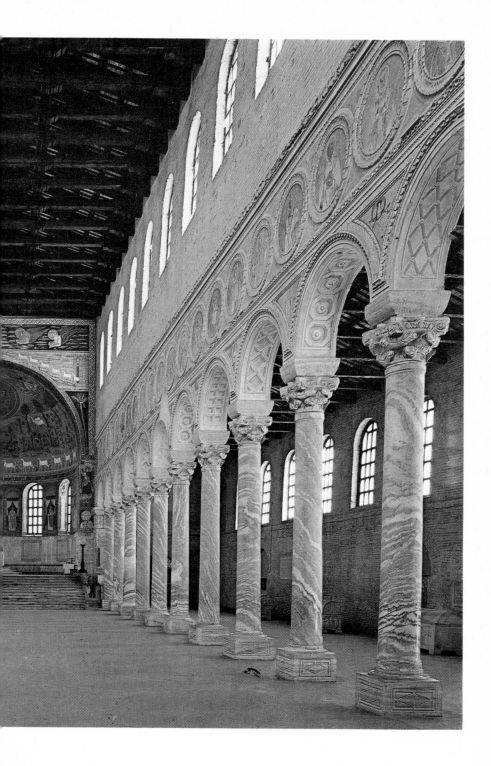

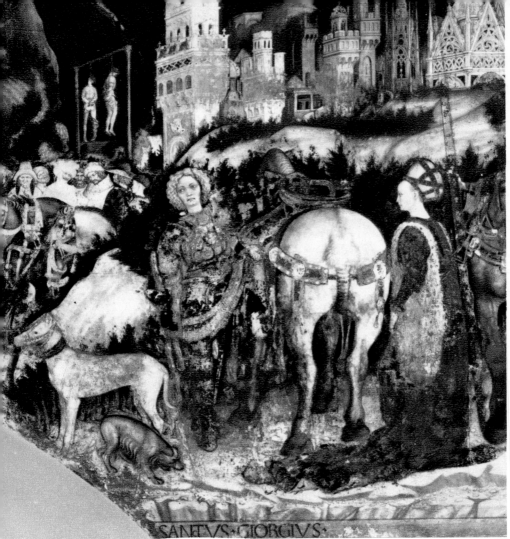

SANCTVS · GIORGIVS ·

150

it is part of the urban scene and because its decorative effect is essentially due to the fact that it is the meeting-point of a number of city streets. This enables it to assume a different aspect and to give vitality to its setting and harmony to its surroundings.

Horta's staircase (Fig. 144), a typical product of the Liberty style, is another example of lively decoration. Thanks to the movement of its lines it fits into the architectural setting, which in its turn could not exist without it.

In our own century, after the sober starkness of rational architecture, while Gropius and his Bauhaus movement, Kandinsky, Klee and other avant-garde artists were trying to create a new conception of applied art, industrial rather than artisan's work, decoration has too often not been developed along uniform lines or in settings conceived as playing an active role. And yet the very functionalism of buildings ought to encourage the development of true decoration.

Lucio Fontana was an artist who throughout his career, and to a greater extent than any of his contemporaries, felt the need for a new approach to decoration. The Spatialism trend which he started immediately after the Second World War tackled the problem of finding the best way to reconcile paintings and sculptures with their settings. He even went beyond the boundaries of sculpture and painting in his use of symbolical gestures, but above all he realized the need to open up and give vitality to the surrounding space by using new methods. Those canvases with bits torn or cut out, which he actually called 'Spatial Concepts', his still-lifes with gaps in them, his streaks of moving light, as exemplified by the work he showed at the ninth Triennial Exhibition in Milan (Fig. 145), invariably reveal a novel decorative character. In Fontana's case, however, decoration is also a symbol of poetical invention and it can be described as a spatial setting without any derogatory connotation. He has given new life and movement to the architecture of today.

147 WALTER GROPIUS, Fagus factory building, Alfeld (Germany), 1910–11.

148 E. SAARINEN and collaborators, detail of Kennedy Airport, New York, 1962.
Gropius was one of the leading exponents of rationalism in architecture, which eliminates all decorations, but he opened the way to a new conception of decoration based on the rhythm of the buildings. Saarinen's airport building shows that the new architecture, by giving rhythm to the structures, can achieve plastic decorative effects which are not in any sense ornaments, but are created by the rhythm of constructive elements.

149 Ravenna, Sant'Apollinare in Classe, 6th century.

150 PISANELLO, St George freeing the Princess, detail, 15th century, Verona, Sant'Anastasia.
A problem of real decoration arises in mural paintings when they are placed in suitable architectural settings, and conversely they fail to produce the effect of decoration if they are not in harmony with their architectural background. The sixth-century mosaic in the vaulting of Sant'Apollinare in Classe is one of the finest examples of this art; Pisanello's fresco of St George freeing the Princess is a lyrical masterpiece with the subtle harmonies of its lines and colours; but considered as decoration for the area it occupies in the church of Sant'Anastasia it is a failure.

Because the fact remains that a work of art may be extremely lyrical, or even a masterpiece, without necessarily having any decorative function. We need only cite as an example Pisanello, one of the greatest artists of the early fifteenth century. Nobody can deny the subtle, ingenious, poetical coherence of his fresco in the church of Sant'Anastasia in Verona (Fig. 150), showing *St George freeing the Princess*, which has all the expressiveness of 'international' Gothic, combined with linearistic modulations and delicacy of colouring. Nevertheless, when considered as pure decoration, the fresco does not function, simply because it is far too high up on the wall of the church. This stupendous work needs to be viewed from close up; and when it was taken down from the wall and exhibited at the 'From Altichiero to Pisanello' exhibition in the Castello Scaligero, all its lyrical beauty was revealed, even down to the smallest details, and those who saw it were able to form a better idea of its high degree of imaginative inventiveness.

In any case, what is certain is that decoration must create the necessary relationship between architecture, painting and sculpture, even as regards the rhythm of the narrative, when there is a narrative content.

That is why in really great decorative cycles it is not always possible to distinguish the hand of the master from those of his assistants. Nowadays our individualistic way of thinking has given rise to another myth, namely that we ought always to do our best to pick out those portions of a work which were directly executed by the hand of a painter or sculptor. This idea has been the cause of many misunderstandings and has led to a wild chase after attributions, which, if they are to have any value at all, must be based on positive data—on documents, sources, analyses of technique, in addition to questions of style. In the particular case of great decorative cycles it is a well-known fact–which many people are inclined to ignore—that there was always a guiding mind, someone who collaborated closely with the architect. There were, of course, numerous assistants, but it does not follow that each assistant was given one specific task; the work was subdivided in such a way that what one assistant had begun might well be completed by another, and finishing touches added by the master, so that what really matters is the 'school'. Moreover, such cycles were conceived, not as poetical creations in themselves, but as decoration for a setting, and no one ever expected that they would be signed. In olden times artists rarely signed their works, and it was only after the Renaissance that the practice became general, owing to the prevalence of the humanistic conception of personality.

In the decorations on the Parthenon, for example, where does the work of Phidias end and where does that of his assistants begin? And are the Months in the Parma Baptistery by Antelami or were they executed by his assistants? Were the bronze doors of San Zeno in Verona really executed by three masters? How many masters contributed to the execution of the cycles of mosaics in Ravenna? Was

the great mosaic in Torcello the work of only one man? And what about the mosaics in St Mark's in Venice, at Monreale and in the Palatine Chapel at Palermo? And as for the great Romanesque façades, which masters executed which sculptures, and how many anonymous assistants were there altogether?

I have mentioned at random some of the great decorative cycles; but even when we know the names of the masters, the fact that it was their job to decorate a particular spatial setting often induced both masters and assistants to pay the same attention to the decorative and architectural factors, and consequently the myth that we can easily detect the individual hands vanishes into thin air.

Things of this sort could certainly happen in days when individual conception did not result in the creation of a work that was lyrical and nothing else, and still less could it lead to the representation of a state of mind. Nowadays things have changed and even decoration, in the best cases, can be the creation of an individual artist, and it is precisely for this reason that he finds it difficult to fit his decorations into the architectural setting. Today decorations can only be added by kindred spirits, living in the same cultural clime, and it is another well-known fact that kindred spirits rarely collaborate in the production of works of art.

We should not, therefore, apply the individualistic standards of today to decorative works produced by ancient civilizations. We must try to study the schools, the groups, and above all the particular spatial setting for which such works were originally intended, simply because theirs was a purely decorative function.

Rhythm, Proportion and Movement

THE most important thing, if we want our judgement to be really penetrating, is to be able, when looking at a work of the visual arts, to distinguish the various cadences of the rhythm, which may be due merely to impulse, but is often dictated by laws, as is also the case in music and in many kinds of poetry.

Rhythm in art is an internal equilibrium of spaces, achieved by means of beats and pauses. It implies modulations, and consequently motion, even if everything may appear to be stationary. It means the movement created by spaces, by similarities which may correspond either to beats or to pauses. That is why proportion is a variant of rhythm, since it involves a concordance of harmonies. Proportion is born of the need for restraint (whereas rhythm, as we shall see, knows no limits). Proportion presupposes some kind of scheme, but one consisting of multiples and submultiples, from the relationship between which the rules governing composition can be deduced.

There is, however, one fundamental difference between proportion and rhythm. Proportion can exist as a mechanism of abstract relationships — it may be simply construction or a scheme — whereas rhythm, with its cadences, must always be understood as implying vitality (at all events in the concrete forms which it assumes in sculpture and painting). A statue may be well-proportioned because its parts are equally balanced, but it may appear to lack rhythm because it is cold and lifeless; and, conversely, it may contain a very marked rhythm and yet lack proportion, because everything in it is distorted or else because the cadences are repeated *ad infinitum*.

The ancient Egyptians had rules of proportion (though it is not quite certain whether these were based on the sole of the figure's foot or on something else); in Greece where, according to Protagoras, man was 'the measure of all things', there was the 'canon' of Polycleitus, though only a few fragments of his thesis have come down to us, a thesis which laid down the rules for proportion in sculpture, the standard being the head, and all the parts of a statue being in proportion to one another.

In the stricter meaning of the term proportion thus implies a rational law; it is a rough scheme for the construction of something which will be harmonious. In practice, however, no artist can afford to dispense with colour, with the vague and the mysterious. Polycleitus himself, when discussing the problem of ponderation, or

151 Attic figure, fragment, 5th century B.C., Athens, Archaeological Museum.
In this Greek work the value of 'closed' rhythm can be clearly seen in the modulation of volumes, lines and chiaroscuro transitions; the arsis and thesis, that is to say the beats and pauses in the rhythm, create a potential movement which is far more important than the pose and is enhanced by the concrete treatment of spaces.

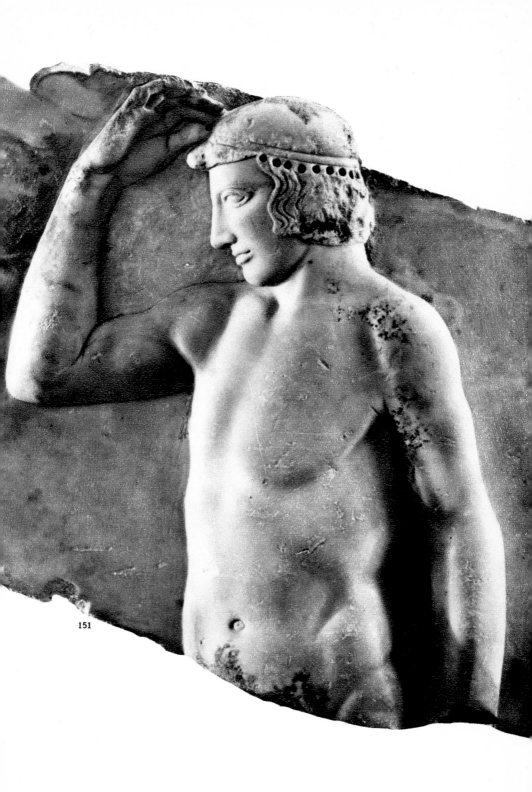

151

152

153

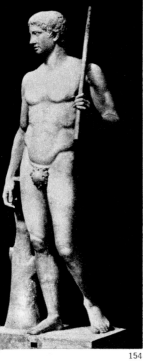

154

155

157

156

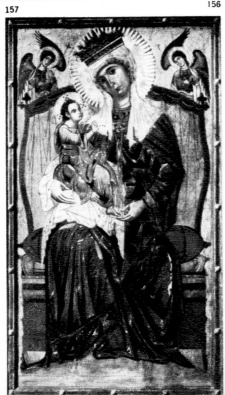

balance of weights, admits that rhythm is something more than strict adherence to proportion. And whereas rhythm in its various forms, even if these are only impulses, is always an essential factor in art, proportion may be absent in the concordance of relationships, or dispensed with altogether when the desire for expressiveness is so great that everything is distorted in order to achieve a more aggressively direct effect. Proportion is typical of civilizations such as that of the Greeks, who had a feeling for harmony, and consequently for beauty as an absolute numerical ratio, and it is also found in certain abstract trends in modern art. The neo-classicists used proportion in the most superficial and mechanical way; at best they succeeded when they managed to express themselves by using the movement of colour as well, in settings such as parks, gardens or public squares.

During the Renaissance the study of proportion did not prevent Leonardo from rendering the atmosphere vaguer and more suggestive — existentialist, as we should call it today, in its irrationality (Fig. 184).

The abstract neo-plastic trends (Fig. 195) are based not so much on the non-representationalism introduced by Kandinsky (Fig. 199), who after his return to Expressionism remained irrational, but rather on the new conceptions of ratio and proportions. In such cases, however, colour eventually acquired a more decidedly lyrical value, despite the fact that all composition was based on an attitude of mental aloofness.

Actual examples will provide a better explanation of these ideas. If, for a start, we glance at an Attic relief of the fifth century B .C . (Fig. 151), we can easily detect its rhythmical value; the outlines are modulated to enclose carefully calculated volumes, so that the spaces and the barely perceptible chiaroscuro have a secret equilibrium, achieved by using ovoid shapes, but without any fixed plan. The arsis of the

152 *Hercules and Athene,* metope from the Temple of Zeus, Olympia, 5th century B.C.
Archaic elements in this metope are the closed rhythm and the rugged outlines of the Centaur against the flat ground; but the rhythm of the full and empty spaces becomes even clearer when we study the other metopes and triglyphs which go to make up the frieze.

153 *Thesauros Centaur,* metope from the shrine of Hera at the mouth of the river Sele, 6th century B.C., Paestum, Museo Nazionale.

154 Hellenistic copy of the *Doryphorus* by Polycleitus, Rome, Museo Vaticano.

155 ALBERTO GIACOMETTI, *L'Heure des Traces,* 1930.

156, 157 COPPO DI MARCOVALDO, *Madonna with the Child and Angels,* 13th century, Orvieto, Church of the Servites.
Those who are accustomed to the rhythm of modern Cubist works are in a position to appreciate the skill displayed by Coppo di Marcovaldo in designing his composition, since he gave constructive values to Byzantine graphic symbols.

upraised arm creates limpid, restful zones and is counterbalanced by the thesis of the left arm. But all the movement of the blurred planes, of the lines and volumes, is, so to speak, suspended and the rhythm is perfectly balanced. The relief dates from the fifth century B.C., the heyday of Greek art, after the archaic phase and during the sway of Attic civilization, which loved light, restraint and the harmony of life.

A harsher rhythm, however, can be discerned in the metope of the Thesauros Centaur (Fig. 153) at Paestum. Here archaism (sixth century B.C.) makes itself felt in the stringency of the rhythm, which, however, is stressed by the relationship between the abstract and sober triglyph and the relief of the Centaur standing out from the flat ground of the metope, while the rugged linearism of the carving creates a kind of heraldic movement with its alternation of filled spaces and voids. The full value of this can be appreciated if we compare it with the whole series of metopes and triglyphs making up the frieze. Another metope, originally in the Temple of Zeus and now in the museum at Olympia (Fig. 152), dates from the fifth century B.C., and here again we find an Attic harmony reminding us of Phidias, for the rhythm has a sweeping cadence, the proportions are well balanced and the treatment of space within the work gives vitality to the whole.

The sculptor Polycleitus was born at Argos and lived in a Doric milieu, but only copies of his works dating from a later, Hellenistic period have come down to us. In the case of the *Doryphorus* (Fig. 154)—

158 CARLO CARRÀ, *Woman on a balcony*, 1912, Milan, R. Jucker collection.

159 ANTONELLO DA MESSINA, *Salvator Mundi* (detail), 1465, London, National Gallery.

160 PIERO DELLA FRANCESCA, *Madonna and Child*, 15th century, Urbino, Palazzo Ducale.

161 JUAN GRIS, *Still life*, 1917, Philadelphia, Museum of Art, A. E. Gallatin collection.
During the Renaissance the conception of proportion tended to bring the rhythm into relationship with human life; in other words it was an anthropocentric conception, even when it achieved absolute values by adhering strictly to the rules of perspective. A *pentimento* can still be discerned in Antonello da Messina's *Salvator Mundi*, the hand having previously been closer and parallel to the breast and later drastically foreshortened, and this is very significant. After being influenced by Flemish painting in his early years, Antonello came into contact with Italian Renaissance culture, of which Piero della Francesca was the most rigorous exponent. In Piero's works proportion is achieved by means of a rhythmical balancing of volumes, and also in the colours with their subtle shades of grey and in the imaginative aerial perspective. Among the moderns Juan Gris achieves a similar purity of proportional relationships by other means not based on perspective, because the spatial effects are confined to the surface. Carrà's *Woman on a balcony*, painted in the midst of his Futurist phase, reveals the influence of Cubism; the segments of the composition create a rhythm which is not one of accidental movement, but potential, and the spatial zones have an internal balance. This is one of the most calibrated and vivacious works by a modern artist, also on account of the effect produced by the subdued colours with their limpid harmonies.

204

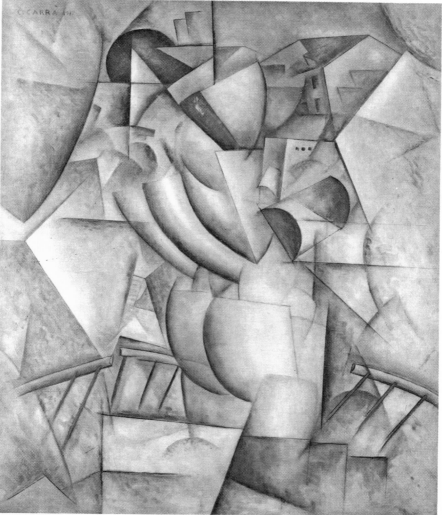

158

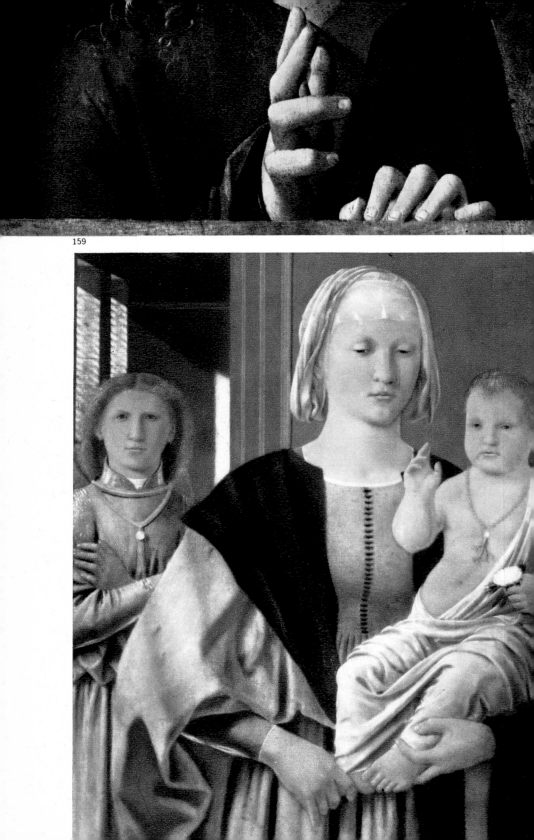

159

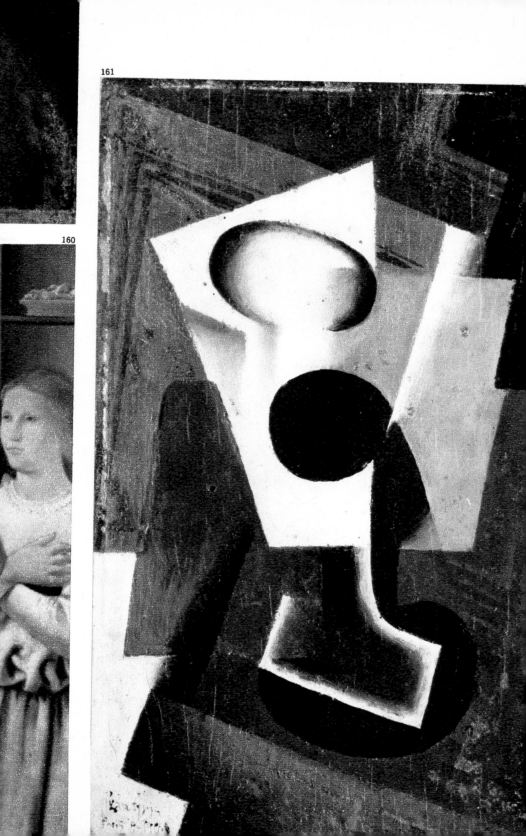

160

161

162

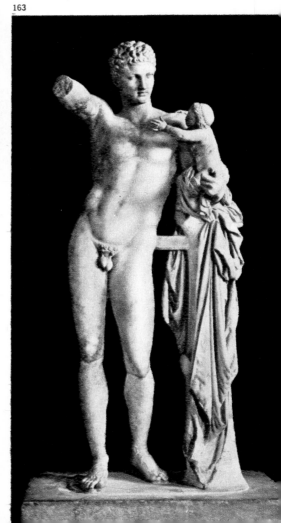

163

this being the example quoted in the 'canon' (rules of proportion based on multiples and sub-multiples of schemes) — it is thus impossible for us to form an exact idea of what the original was like. Nevertheless, the attention paid to proportion is obvious. This was typical of the late Doric style, and we can also discern the rhythmical movement of ponderation, the bent left arm and the taut right leg being counterbalanced by the more restful poise of the right arm and left leg, while the succession of beats and pauses creates light and shadow in the masses, which become more indefinite.

Even among the moderns — and not only among abstract artists — the search for proportion and harmonious relationships leads to new developments. A good example is the sculptor Giacometti's *L'Heure des Traces* (Fig. 155), he being an artist who followed the Surrealist trend. In a setting imagined as having definite boundaries, but which produces a sensation of infinity because it consists of linear schemes set in a void, the two plastic forms remain suspended; proportion, in accord with the golden rule, here creates a metaphysical atmosphere, beyond the borders of reality. This, however, is once again the result of suggestion; in reality the rhythm is created by the various spaces — it is suspended movement, the fruit of lyrical invention.

On the other hand, the lion of Babylon (Fig. 112), which I have already mentioned, has a rhythm based on ample masses. The relationships between arsis and thesis can be discerned in the heavy masses and sharply defined voids, which complement and integrate one another, whereas in the Romanesque stylophorous lion (Fig. 113) the mass is also stressed by lines. Imagination is given a free rein in the rhythm created by the solids and voids, with plastic transitions full of energy and potential movement. Here there is also a kind of proportion, because there is a certain relationship between the weights of the masses, but it is an intuitive proportion which does not follow any rules, and it is distorted in the interests of expressiveness.

An unusually strict adherence to the rules of proportion is to be found in a mediaeval work, Coppo di Marcovaldo's Madonna in the church of the Servites at Orvieto (Figs. 156, 157). This dates from

162 *Gaul killing himself*, 3rd century B.C., Rome, Museo delle Terme.

163 PRAXITELES, *Hermes with the child Dionysus*, 4th century B.C., Olympia, Museum.
The gifted Hellenistic sculptor who carved the *Gaul killing himself* was obviously trying to endow his composition with rhythm, but the whole relationship between light and shade, between full and empty spaces, is superficial; the gesture is declamatory and reveals the artist's desire to impress. On the other hand, Praxiteles' Hermes has a hidden rhythm; living as he did in the fourth century B.C., he already had a feeling for the movement of light and the vagueness of existence, though in the structure of the figure and in the whole composition he shows classical restraint. The rhythm is created by very subtle plastic transitions which almost fade away into the light, while the setting is already 'open', reflecting the vague anxiety of the individual prevalent at that time, far removed from the formalized moral ideas of the archaic period.

the latter half of the thirteenth century, and we can see how Byzantine tradition taught the painter to appreciate the value of graphical symbols (the folds of the draperies are not modelled by the alternation of light and shadow, but symbolically suggested by a Byzantine type of gold network). There is, however, a novelty in this work, which the whole of the Renaissance subsequently adopted. This is the use of a 'scheme' — in this case a sphere — together with an attempt to base the composition on new proportional relationships. Coppo di Marcovaldo was a Tuscan, which means that he had a feeling for the structure of forms; consequently he chose a sphere as his basic scheme — a sphere which expands, breaks and is then repeated. The focal point of the whole composition is the right hand, forming part of the graphical concept of a sphere, but the whole system — which to us of today seems even more vivid because our eyes have become accustomed to Cubist experiments — is a rhythmical sequence of these proportional schemes. Marcovaldo's Madonna at Orvieto and the so-called *Madonna with the pilgrim's staff* in the church of the Servites at Siena are among the most austere and poetical works produced by the Middle Ages.

Next we come to the full Renaissance and the works of Piero della Francesca. His *Madonna and Child* (Fig. 160) in the Ducal Palace at Urbino is striking on account of the austerity of its proportions, the rhythmical balance of the volumes, its colour-scheme based on subtle shades of grey and its aerial perspective; and this gifted and imaginative artist enlivens everything by making a strong light fall from the window on to the expanse of greys. And there is also rhythm in the modulations of the curves, in the broad planes without shadows, in the purity of life suspended amidst cadences conveying the sensation of infinity. Among the moderns, Juan Gris in his *Still life* (Fig. 161), tending towards Cubism, achieves a similar purity of proportional relationships by using other means. Here rhythm is created by the grey tones of corresponding surfaces, by the harmony of spaces which seem to move because they are counterbalanced by others, while everything else appears to be motionless. In a painting, this is genuine movement, relying on modulated spaces and hidden rhythms. Juan Gris was a Spaniard, and his compositions are very austere. When we study the works of this original painter who, together with Picasso, Léger and Braque, joined the Cubist movement in Paris as long ago as 1911–12, we feel that we are listening to a voice that was not formalistic, but filled with suppressed passion. And this gives additional value to the lively rhythm so full of tension, which we cannot appreciate after a first hasty glance.

Let us now again examine the *Gaul killing himself* (Fig. 162), a work of the Hellenistic period. Here the sculptor was certainly trying to

164, 165 CIMABUE, *Madonna enthroned with St Francis*, detail of the head of St Francis, 13th century, Assisi, Lower Church of San Francesco.

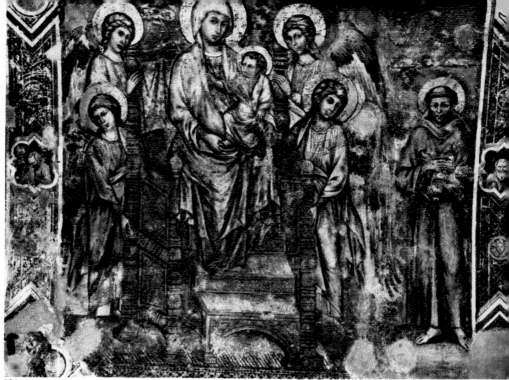

164

165

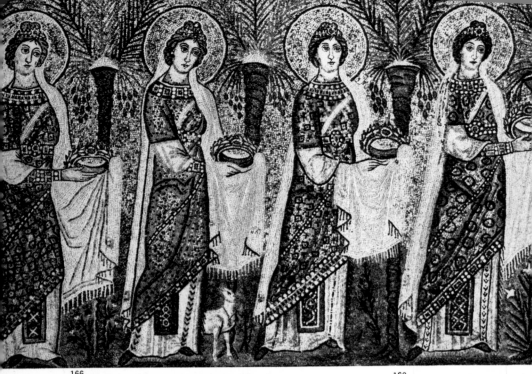

166

167

168

169

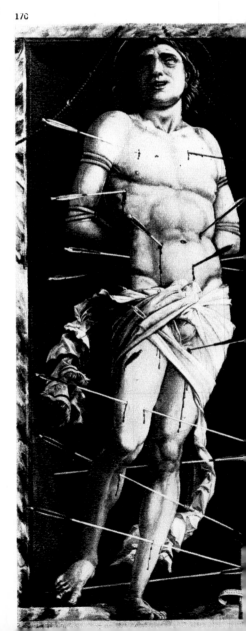

170

create a rhythmical composition, but the whole relationship between light and shadow, lines, volumes, full portions and gaps, is extremely superficial. The very gesture is declamatory and the whole work reveals a certain complacency. Despite all these things, most people think that it is a masterpiece, but the sculptor's obvious skill does not justify our classifying it as a real work of art, because it lacks rhythm and the pose is artificial. On the other hand, a hidden rhythm, barely perceptible at first glance, can be discerned in Praxiteles's *Hermes with the child Dionysus* (Fig. 163), now in the museum at Olympia. I am not referring primarily to the composition, which consists of two basic elements, but to the rhythm of the subtle plastic transitions, which almost fade away into the light, and to the inner tension of the body, especially when viewed from behind. Praxiteles, who lived in the fourth century B.C., was already aware of the fact that light can be mobile; he was more of an individualist, and liked the indefiniteness of existence more than he did the rugged essentiality of archaic art. He modulated his rhythms, and all but reached the stage of representing a state of mind, though his works were obviously still a long way away from art conceived as a state of mind. Before him, however, there had been the relativism of the Sophists and the Persian wars, and individualism was about to make its appearance. A little later

166 *Cortège of the Virgins* (detail), mosaic, 6th century, Ravenna, Sant'Apollinare Nuovo.
The rhythm of this cortège becomes an endless succession of beats and pauses; here the question of proportion is no longer an important factor, though each of the figures is instinctively given proportions of a kind. To the spectator the rhythm seems endless, like the refrain of a song, while the colour effects are meant to create an impression and not to be contemplated with a detached mind. In this way colour and rhythm are transformed into irrational psychic action.

167 DOMENICO MORELLI, *The Iconoclasts*, 19th century, Naples, Capodimonte Gallery.
The treatment of light might have given unity to this picture, but here it is not a determining factor, and consequently everything appears to be declamatory and false.

168 GIOTTO, *A madman paying homage to St Francis* (detail), 14th century, Assisi, Upper Church of San Francesco.
This detail from one of Giotto's frescoes shows the potentialities of a rhythm which is made to stand out, and which is created not only by the well-balanced volumes, but also by the careful draughtsmanship.

169 Mythological scene (forgery).

170 ANDREA MANTEGNA, *Martyrdom of St Sebastian*, 15th century, Venice, Ca' d'Oro.
In the 'mythological scene', which is meant to be an imitation of a work by an artist of the Mantegna school, we can note the complete absence of rhythm; in this modern forgery the painter, like all forgers, was trying, not to achieve rhythmical unity, but to copy details from numerous other pictures, or at all events to imitate the style of other artists. And the resulting composition is artificial and lacking in rhythm (cf. p. 224).
On the other hand, in Mantegna's *Martyrdom of St Sebastian* the rhythm can be clearly seen and it is accentuated by the placing of the arrows. It is created by the tension and expressive vitality of the painting.

came Hellenism, which exalted atmosphere, fragmentation and the individual, and resulted in a multiplication of cosmopolitan styles.

At this point we must pause to consider another kind of rhythm — a rhythm which is endless. Here proportion no longer counts for anything, though the single figures are still instinctively proportional in a way of their own. The *Cortège of Virgins* (Fig. 166) in the church of Sant'Apollinare Nuovo at Ravenna is a mosaic executed by sixth-century masters who were still influenced by Byzantine art and by that of the late Imperial Roman school. This work should not be judged as an ensemble; it is a procession having an aulic rhythm, the cadences of which are marked by the alternation of figures and palm trees, with the arsis and thesis stressed by the gold ground. And the procession is endless (the idea that the procession starts from the town of Classe and marches towards the Virgin seated on her throne amidst angels makes no difference, since from the point of view of the spectator the rhythm is endless). This was a new idea, though its origins go back to representations of processions dating from the classical era. The rhythm, however, is also endless, just as endless as psalm-singing, and is more elementary, more obvious, with its suggestively precious colour effects, rough modulations of surfaces and lines, and marked plastic variations. It is clear that two other mosaics, likewise executed by an anonymous but talented master, showing *The Escort of Theodora* (Fig. 19) and *The Cortège of Justinian* (Fig. 125) are based on a completely different conception, despite the fact that they date from the same century and are products of the same cultural clime. In the latter the rhythm terminates on the surface and is confined to height and width, within the boundaries of the compartments, while the proportions are more organically concentrated, even if they are not symmetrical.

We ask ourselves from what angle we ought to view Domenico Morelli's *Iconoclasts* in the Capodimonte museum at Naples. It would seem that the painter wanted to create a lively scene in the style of late Romantic nineteenth-century historical painting, combining natural-istic accuracy with sentimental pathos and, with the help of lighting

171 STEFANO DA VERONA, *Madonna of the Rosebush*, 15th century, Verona, Museo di Castelvecchio.

172 AUGUSTE RENOIR, *La première sortie*, 19th century, London, National Gallery.
There is a subtle rhythm in this work by Stefano da Verona, painted in the early years of the fifteenth century when he was still under the influence of 'international' Gothic. The starting-point is a linearism enlivened by the colour harmonies, which rise to the surface like those of a beautiful tapestry. Hundreds of years later the Impressionist Renoir seems to be returning to the values of linear rhythm, though he uses another style and relies more on colours which make even his shadows luminous; in reality it is the atmosphere that moves and the light and colours are adapted to the setting. The irregular rhythm is as if submerged by the vigour of the brushstrokes, by the touches which extend to the edges of the picture and seem to be trying to get beyond them. The rhythm is thus irrational, and typically atmospherical.

216

 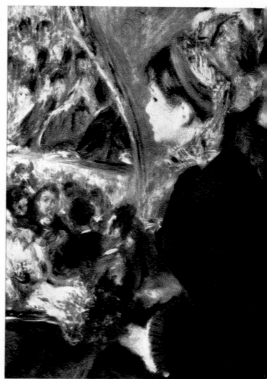

171 172

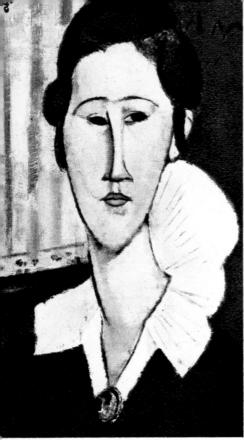

173

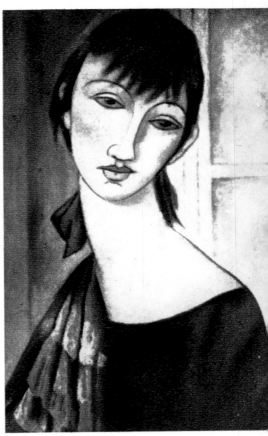

174

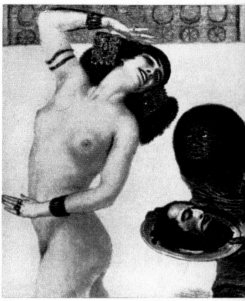

176

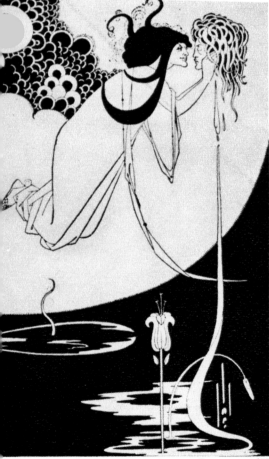

175

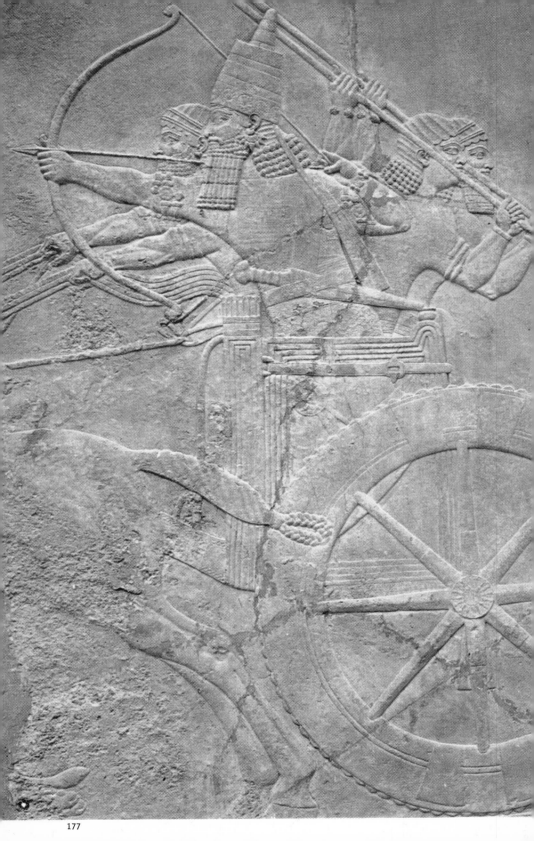

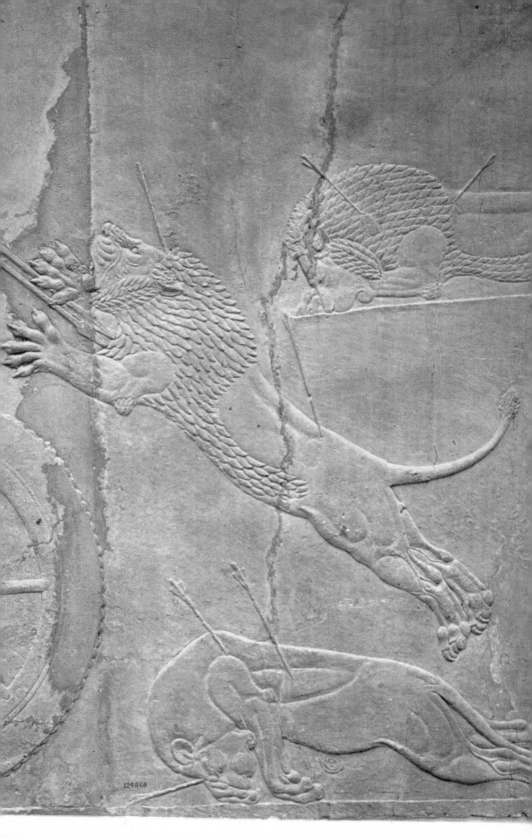

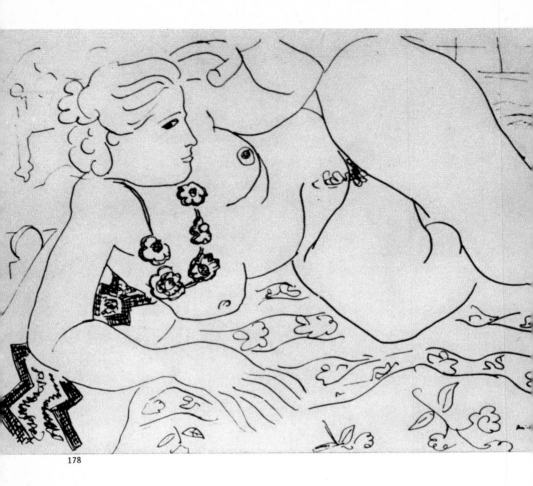

178

effects, to establish a certain synthesis and almost imperceptible rhythms. The resulting picture, however, is oleographic and false; although the poses and gestures reveal a certain skill in handling composition, they remain in the category of superficial description, lacking any real rhythm. And the contrast between the sentimental approach and realism shows how Neapolitan culture during the latter half of the nineteenth century was passing through a grave crisis.

After considering these examples, it may be helpful if we turn to a work with a clearly defined rhythm like the *Madonna enthroned with St. Francis* (Fig. 164) by Cimabue, who was a master of plastic conception and always achieved a high degree of austere expressiveness in his large compositions, in order to see how all these things can be ruined by time and restoration. The head of St. Francis (Fig. 165) in this fresco at Assisi has lost the stringent rhythm it originally must have had, while the chiaroscuro values have been spoilt by clumsy nineteenth-century restoration, or at all events show no traces of Cimabue's vigorous modelling.

From bad restoration let us pass to forgeries. If we examine the painting shown in Fig. 169, which was intended to be an imitation of

173 AMEDEO MODIGLIANI, *La Signora dal baveretto*, 1917, Rome, Galleria d'Arte Moderna.

174 *Woman's head* (forgery)
The *Woman's head* is a faked Modigliani; it has no rhythm, because the draughtsmanship, where the painter is trying to give movement to the spaces, is not modulated in any way. We need only mention the clumsy rendering of the eyes, the eyebrows, and the whole composition in which the chiaroscuro is all wrong. The genuine Modigliani has a modulated, free rhythm created by the tautness of the draughtsmanship and the treatment of colour, and all the decisiveness of an original style.

175 AUBREY BEARDSLEY, illustration for Oscar Wilde's *Salome*, 1894.

176 FRANZ VON STUCK, *Salome*, 1906.
Beardsley's drawing, which is in the English tradition, is something more than an illustration on account of the synthesis created by its sharp linear rhythm and the subtle and fertile inventiveness of the artist's mind. On the other hand, the painting by Stuck, who joined the Viennese Secession movement and had considerable success in his own lifetime, has no real rhythm, because there is no modulation and the spaces do not counterbalance one another.

177 *King Ashurbanipal hunting*, from the palace in Nineveh, 7th century B.C., London, British Museum.
In this Assyrian bas-relief the rhythm, created by the concordances in the various parts of the composition and by the draughtsmanship reduced to essentials, produces an effect of profoundly expressive and coherent tension.

178 HENRI MATISSE, *Study for a Nude*, 1935, New York, Pierre Matisse Gallery.
This drawing by Matisse is another example of linear rhythm, freely modulated by the artist's imagination; it is a subtle rhythm which evokes the form reclining in a two-dimensional setting and makes the realism a secondary factor.

the school of Mantegna, we immediately note the complete absence of rhythm. Since he was deliberately producing a fake, the artist, like all forgers, paid no attention to rhythmical uniformity, and devoted all his efforts to copying details from various pictures by the artist he was trying to imitate. The result was an artificial picture without any rhythm. Forgers of pictures can, in fact, be speedily detected by anyone who is accustomed to seeing forgeries, precisely because of this lack of rhythm. Rhythm of any kind is always a synonym of vitality, of an essential balance between the various parts of the picture, and of tension. And these things can never be achieved by a man who is just trying to imitate the style of another artist, without making the slightest attempt to interpret it properly. Anyone can make a good copy of a picture, but it will always be a personal interpretation, and a forger inevitably gives himself away because he is trying to imitate another artist, but cannot reproduce that artist's rhythm, which is a personal attribute.

179 ALEXANDRE ARCHIPENKO, *Standing figure*, 1920, Darmstadt, Museum.

180 ANTOINE PEVSNER, *Dancer*, 1927–29, New Haven, Yale University.

In Archipenko's figure the structural scheme is too obvious, and it has no real inner rhythm. The spaces are not as well counterbalanced and modulated as would appear at a first glance, and they are mainly the result of an external, essential stylization. On the other hand the figure of a *Dancer* by Pevsner, another modern artist of Russian origin and an exponent of 'constructivism', is rhythmical because the dynamic movement of the modulated spaces, though strictly conforming to rule, is less obvious and the resulting figure is thus freer and more imaginative.

181 *The Farnese Bull*, 2nd century B.C., Naples, Museo Nazionale.

182 Detail of the frieze from the altar of Pergamon, 2nd century B.C., Berlin, Staatliche Museen.

In the pyramidal composition of *The Farnese Bull*, which is a mediocre copy, with additions, of the well-known colossal group carved by sculptors from the island of Rhodes, the movement of the various figures is subjected to geometrical rules and is intended to be rhythmical, but the resulting group seems artificial and mechanically assembled, while the full and empty spaces do not create a concrete rhythm, because too much attention is paid to analytical details and the synthesis has no real unity. The artists would seem to have had a predilection for fragmentation and embellishment, with the result that the attitudes in the scene showing Dirce bound to the horns of a wild bull by the sons of Antiope seem very artificial. A far more vivacious rhythm, though rather too eloquently stressed, can be seen in the *Battle of Giants,* part of the frieze from the altar of Pergamon, which also dates from the Hellenistic period but with certain characteristics peculiar to Pergamon; here the rhythm expands and provides a new kind of setting for the figures on the steps, and it is heightened by the movement created by the patches of light and shadow.

183 GIOVANNI PISANO, *Miriam, the sister of Moses*, 1284–96, Siena, Museo dell'Opera Metropolitana.

In the sculptures of Giovanni Pisano a marked rhythm is created by the potential movement of the figures; the masses do not conflict with the Gothic linearism, but the sense of torsion produces a dynamic effect in the alternation of light and shadow, heightened by the internal contrasts and concordances, the final result being extremely expressive. Both Donatello and Michelangelo were influenced by this late mediaeval Tuscan sculptor.

224

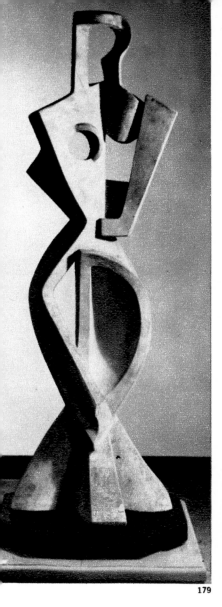

179

180

181

182

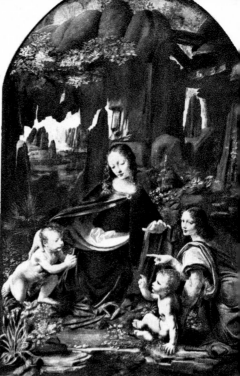

183 184

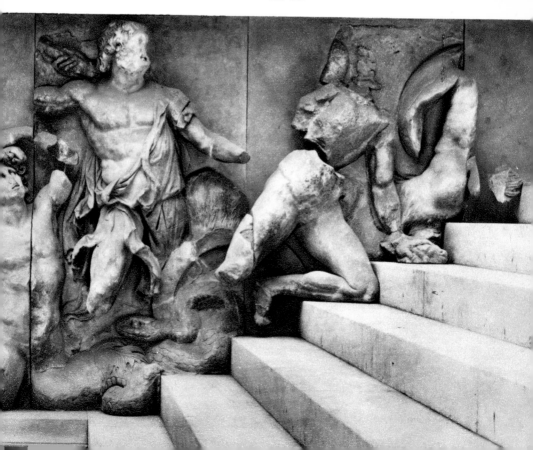

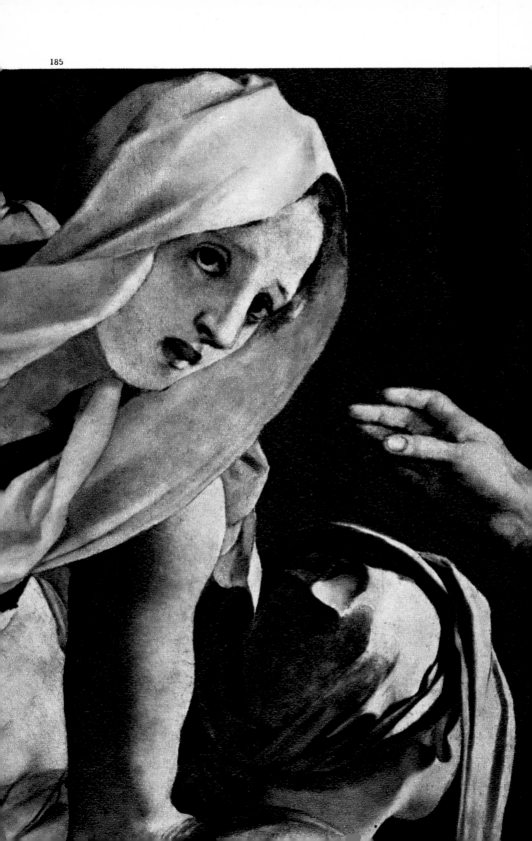

In Mantegna's *Martyrdom of St. Sebastian* (Fig. 170) the spatial construction clearly has rhythm, accentuated not only by the body of the Saint, which looks as if it had been forced into a niche, but also by the modulations of light and shadow and above all by the arrangement of the arrows. The picture is an excellent, complex example of rhythm.

Of Giotto I have already spoken. His *Deposition* (Fig. 5) has a rhythm deriving from the powerful expressiveness of the blocks, and there is also a definite rhythm in the detail shown in Fig. 168, in which we see *A madman paying homage to St. Francis*. The two heads, enclosed within the broad planes of the modelling, acquire a mysterious balance and produce that sensation of rhythm which reveals the quality of an artist's style. And this is not due solely to the fact that the two figures are wearing the same kind of headgear, or to the striking faces; the linear tension, the differences and analogies in the various portions, the clear synthesis — these are the things that constitute rhythm.

The portrait of Charles VII of France by Fouquet and that of Joseph II of Austria by an unknown artist have already been discussed, but at this point it is worth while stressing the rhythmical value of Fouquet's portrait (Fig. 103), in which the broad synthesis created by the form, the folds of the sumptuous robe and of the curtains on either side, and the relationship between the headgear, the face and the whole bust as it widens out, have a vitality due entirely to the stringent rhythm. In comparison, when we turn to the other portrait, even if we allow for the fact that it was painted in the latter half of the eighteenth century and in a very different cultural milieu, we cannot help being struck by its illustrative cheapness, lacking in rhythm (Fig. 102); the figure of *Joseph II* has an affected pose, and the other elements never get beyond mere description, and never achieve any unifying synthesis, based on rhythmical lines, colours and lighting effects.

184 LEONARDO DA VINCI, *The Virgin of the Rocks, c.* 1483–86, Paris, Louvre.

185 PONTORMO, *Deposition* (detail), 16th century, Florence, Santa Felicità.

Several of Leonardo's works — *The Virgin of the Rocks,* the *Last Supper* and *La Gioconda* — are based on pyramidal schemes, but inside them there is a kind of helicoidal movement, and as a result the half-lights, with the aid of *sfumato,* create expanding atmospheres which blur the outlines while at the same time revolving around precisely defined compositional structures, even if these are as it were submerged. Renaissance restraint as regards proportion — and in this case also as regards the aerial perspective — can be discerned, but the rhythmical movement is of a completely new kind. Mannerism, of which Pontormo was a leading exponent, tended to interrupt the rhythms, to shift the focal points and to violate all the normal rules of composition. Though the suspended equilibrium of early Renaissance days is no longer to be found, there is still rhythm, sharper and heightened by the breaks in the composition reflecting the greater anxiety of the times. Pontormo's *Deposition* is a very good example of Manneristic painting, but we must not attach any pejorative connotation to the term. Mannerism was just the third phase of the Renaissance.

Rhythm does not necessarily require a broad synthesis. It can be based on subtle analyses, provided that these are accompanied by a barely perceptible balancing of the various parts and by real vitality. Stefano da Verona's *Madonna of the Rosebush* (Fig. 171) shows the influence of 'international' Gothic; it is based on a careful and incisive treatment of line, enlivened by harmonious colours, and it creates on the surface, as in a tapestry, a counterpoint of symbols which has a definite rhythm. Centuries later, the Impressionist Renoir, in his *La première sortie* (Fig. 172) seems to return to these values of linear rhythm, though the whole character of his painting is different and he relies to a greater extent on lively colours which make even the shadows luminous. But on closer examination we find that there is also movement in the atmosphere, a harmonization of light and colour; the rhythm here is not carefully articulated, but is as if submerged by the impulses imparted to the brush, by the expanding strokes which seem to be trying to get beyond the edges of the picture.

As regards linearistic rhythm, let us now compare a fake Modigliani with an authentic painting by that artist. The picture reproduced in Fig. 174 is intended to be an imitation of Modigliani's manner, but as invariably happens with forgeries, it has not the slightest trace of rhythm, nor is there any concordance between the various spatial schemes; we need only glance at the relationship between the mouth, the nose and the shape of the whole head in order to convince ourselves that the forger must have been trained in the realistic school. Modigliani's *La Signora dal baveretto* (Fig. 173) shows a coherent treatment of the rhythms; the relationships between the various parts—the oval face, the neck, the V of the dress, the movement of the collar and the treatment of line—all reveal a hidden rhythm, which the painter has achieved by a process of synthesization, by simplifying the ovoid schemes, to which, however, his extreme sensitiveness gives a movement and life having analogies with music.

186 UMBERTO BOCCIONI, *Development of a Bottle in Space*, 1912, Milan, G. Mattioli Collection.

187 UMBERTO BOCCIONI, *Forms of Continuity in Space*, 1913, Milan, G. Mattioli collection.
 Boccioni distinguishes between universal motion, which all objects reveal even when they are motionless and which can be defined as the energy of expansion in space created by the 'force-lines' emanating from every form, and accidental motion, which occurs when an object actually moves. His *Development of a Bottle in Space* is a strict interpretation of universal motion. The *Forms of Continuity in Space*, on the other hand, reveals a twofold movement; accidental, because the athlete is shown in the act of running, and universal, because the force-lines, by heightening the anatomical characteristics of the body, cause the forms to expand in the surrounding space. The sensation of movement thus creates a movement of force-lines, of concave and convex planes and of spatial concordances which symbolically suggest the action of running. Boccioni is an exceptional artist, who knows how to turn a theory into a vivacious rhythm.

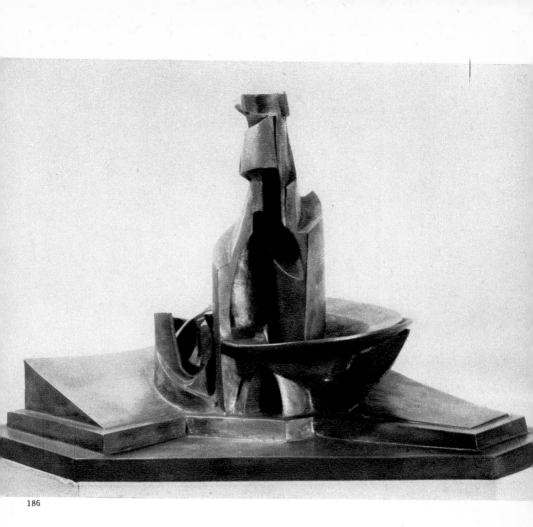

186

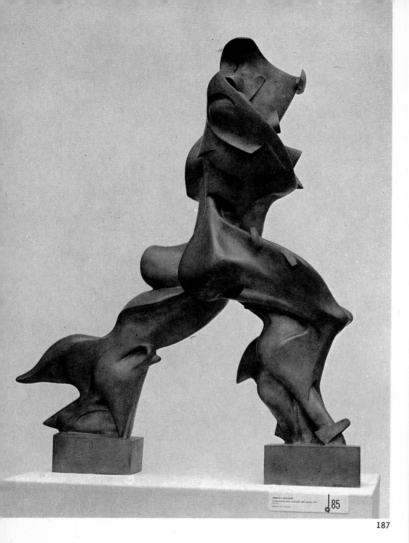

187

188

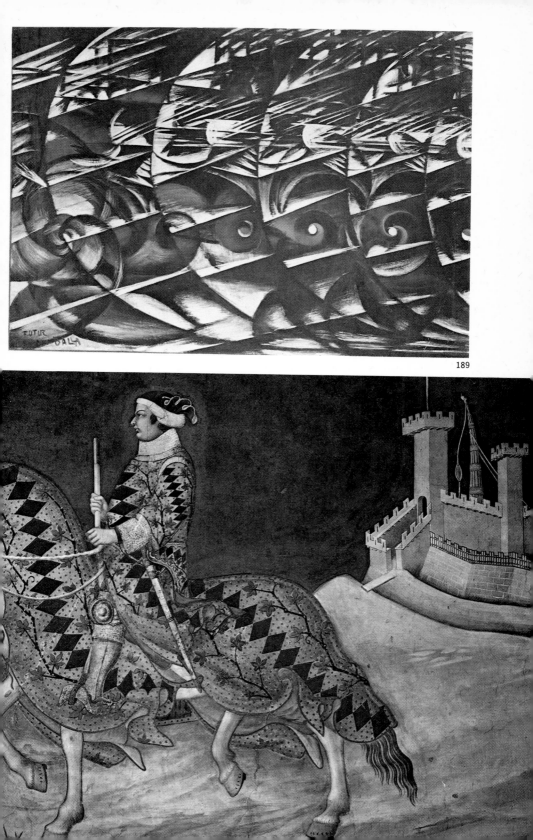

189

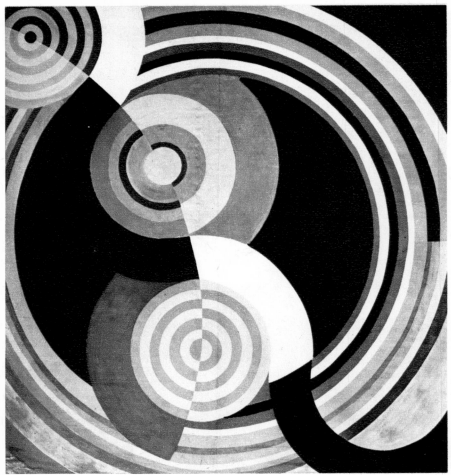

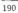

190

Another comparison may fittingly be made at this point, between two works dating from the same period — one of Aubrey Beardsley's illustrations for Oscar Wilde's *Salome* (Fig. 175), which I have already mentioned, and the *Salome* painted by Franz von Stuck (Fig. 176). The former, a refined work by an English artist, is something more than a mere illustration and acquires a lyrical value thanks to the synthesis of the well-defined linear rhythm; whereas Von Stuck, who belonged to the Viennese Secessionist school and was a very popular artist in his lifetime, tries to give his painting rhythm by counterbalancing the volumes and by using linear movement to make them more striking. The rhythm, however, is a false one, the chiaroscuro is merely descriptive, and there is no modulation; in short, his work is just a superficial illustration, despite the fact that it was never intended to be an illustration at all. Von Stuck introduces naturalistic elements without any coherent autonomy of style, together with vague and superficial symbolical references which were typical of Secessionist taste.

Evidently, when in a painting the means of expression are reduced to such an extent that they become elementary, the result is more likely to be rhythmical. The *Sketch for Bright Painting* (Fig. 199), which Kandinsky made in 1913, has no relationship to Nature and consequently cannot possibly be classified as an illustration. The various symbols, suggested by almost automatic impulses (here we see the influence of the Munich group known as the 'Blue Riders', from the title of a work by Kandinsky himself), become like musical notes, while the spaces — if the spectator can rid himself of all preconceptions — reveal the cadences of a hidden rhythm throughout the whole ensemble, reminding us of voyages of exploration into the

188 SIMONE MARTINI, *Guidoriccio Fogliani* (detail), 1328, Siena, Palazzo Pubblico.

189 GIACOMO BALLA, *Speed of a car*, 1912, Rome, P. Campilli collection.

190 ROBERT DELAUNAY, *Rythme No. 2*, 1938, Paris, Petit Palais.
Even in mediaeval times Simone Martini gave an excellent interpretation of movement, which in the visual arts can only be rendered by rhythm with the aid of symbols; in his fresco showing Guidoriccio Fogliani, there is no attempt to give a realistic rendering of movement (it has rightly been noted that the gait of the horse is wrong, since its legs could not be parallel while walking), but the sensation is conveyed by the rhombi on the horse's trappings and on the rider's clothing, and also by the lines of the surrounding landscape; the movement is thus potential, symbolical and suggested by the rhythm.

Together with Boccioni, Carrà, Severini and Russolo, Giacomo Balla was an exponent of Futurism, but from 1912 on he executed dynamic works in which he broke up the object and created a series of rhythms producing the sensation of movement. In other works, like his *Compenetrations of lights*, also executed in 1912, he anticipates the ideas of the geometrical abstractionists and relies on the values of timbre.

Delaunay's *Rythme No. 2*, sometimes called *Panneau décoratif* (though this latter term is somewhat misleading, since in reality it is an extremely imaginative painting), is a variant of the *Circular Forms* which he produced from 1912 on.

unknown zones of our own being. It is a subtle, homophonic rhythm, which finds its counterpart in every portion of the composition. This is an example of non-representational, abstract art, born of an urge for expression, which is not geometrical, but conveys a state of mind and 'speaks' to us, although it contains no representational elements taken from the reality of Nature. Reality does not exist exclusively in the outside world; there are infinite worlds within us as well.

Of Matisse's linear rhythm I have already spoken (Fig. 178). Since we are now discussing examples drawn from modern art, it may be helpful if we try to discover to what extent rhythm — in works which have a constructive purpose and therefore need rhythm — can be fully achieved instead of remaining merely schematic. Take, for example, the *Standing Figure* (Fig. 179) which Archipenko executed in 1920, Pevsner's *Dancer* (Fig. 180) dating from 1907–8, and Calder's *Mobile* (Fig. 201). In these three works the desire to achieve rhythm is evident; but whereas Pevsner's sculpture has real rhythm, more mysterious and lively in the spatial schemes, in Archipenko's *Standing Figure* the external stylization is somewhat schematic and, if we examine it more closely, we see that it is not an inner rhythm, but deliberate, without any hidden analogies in the rhythmical schemes, which are visibly superficial. And despite this it is a rigorously constructed work. On the other hand, Calder's rhythm is highly modulated and can be compared with musical notes; it is freely set in a space which becomes active and is endowed with movement and a secret life of its own thanks to the concordances in the schemes.

* * * *

This brings us to the problem of rhythm in its relationship to movement, which has too often been regarded as something created by the attitudes of the figures — a notion that has led to many misunderstandings. In the visual arts movement is always a question of rhythm, not of pose. Rhythm can be either 'open or 'closed', while

191 PIET MONDRIAN, *Oval composition — Trees*, 1913, The Hague, H. P. Bremmer collection.

192 PIET MONDRIAN, *The Red Tree, c.* 1909–10, The Hague, Gemeentemuseum.

193 PIET MONDRIAN, *The Silvery Tree, c.* 1911, The Hague, Gemeentemuseum.

194 PIET MONDRIAN, *Blossoming Tree, c.* 1912, The Hague, Gemeentemuseum.

195 PIET MONDRIAN, *Composition,* 1920, private collection.

These paintings show how Mondrian, an exponent of the abstract trend known as Neoplasticism, started by depicting a tree naturalistically and then, in his search for the essential movement of rhythm, produced Cubist syntheses of planes and lines, and finally abstract forms. The spaces and the timbre values of the colours are counterbalanced and create a movement which is purely rhythmical.

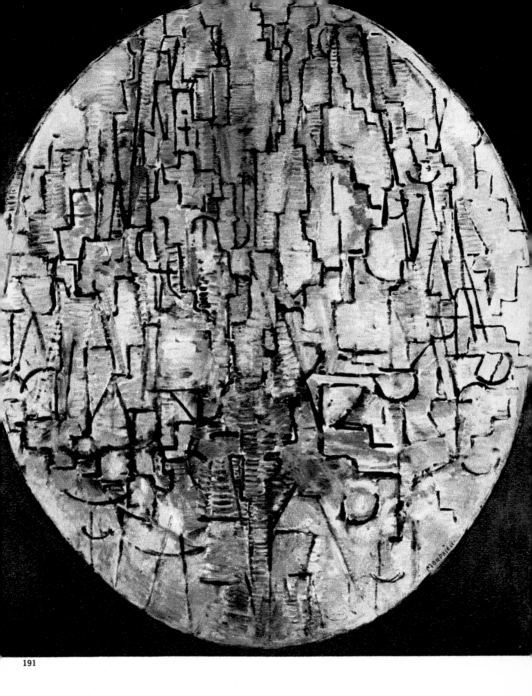

191

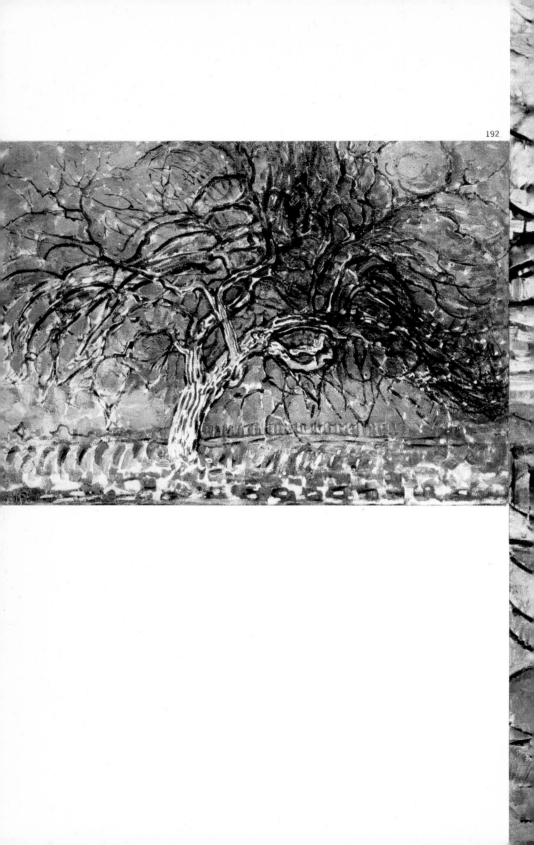

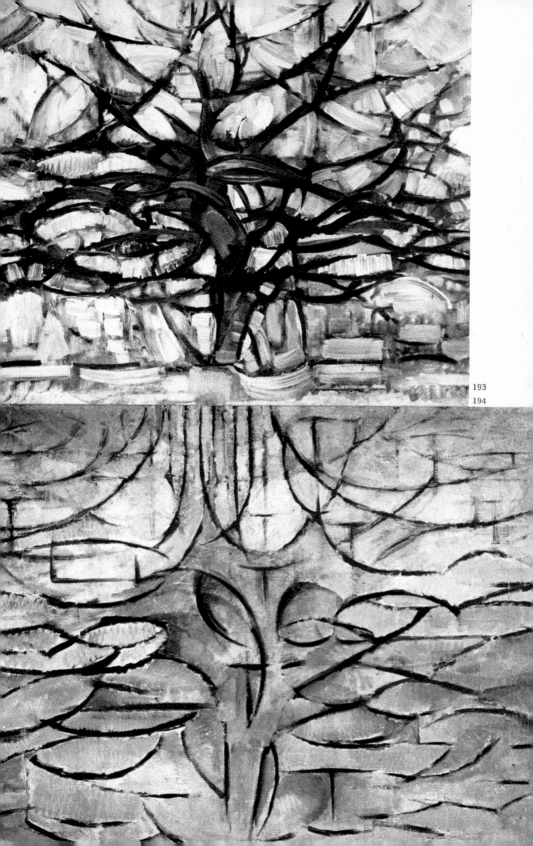

193
194

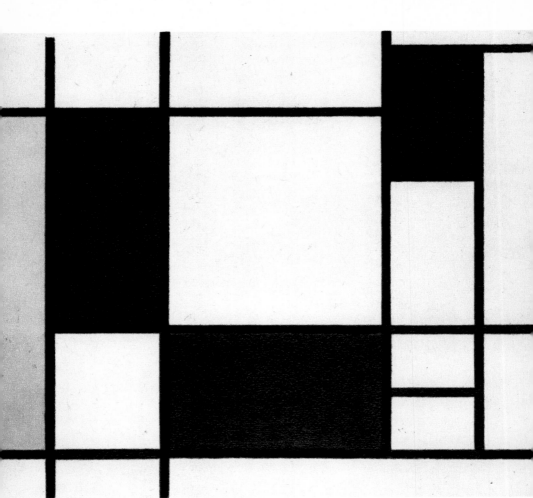

195

movement can be symbolically suggested by lines, volumes and the rhythm of masses, which can also be potential movement.

For example, The *Farnese Bull* (Fig. 181), hewn by Hellenistic sculptors in the island of Rhodes, is a pyramidal group, in which the movement of the various figures, subordinated to geometrical schemes, was intended to be rhythmical, whereas in actual fact it is excessively complicated and superficial, while the voids and full spaces do not manage to create a concrete rhythm, because the movement is broken up into a number of analytical and descriptive details having no synthetic unity. We can detect a delight in fragmentation, and a desire for embellishment resulting in affected attitudes. Such things are not real rhythm. But another work dating from the Hellenistic period, the frieze from the Pergamon Altar depicting the *Battle of Giants* (Fig. 182), reveals a different vitality in its rhythm, even if this is expressed in a broadly eloquent way. Here the rhythm is freer; it provides a setting for the figures on the stairs and is stressed by the potential contrasts of light and shadow — all this being due to the influence of Phidias, Scopas and Lysippus and, as regards the *sfumato* of certain external transitions, of Praxiteles himself. And we must also note the potential movement, creating a vigorous rhythm, to be found in the sculptures of Giovanni Pisano (Fig. 183), in which the sense of torsion, despite the Gothic linearism, produces movement in the chiaroscuro that is extremely expressive. Donatello and Michelangelo were both influenced by this great fourteenth-century sculptor.

The man who made the closest study of the problem of potential movement in rhythm and brought to it all his lucid imagination was, however, Leonardo da Vinci. In *The Virgin of the Rocks* (Fig. 184) and *La Gioconda* (Fig. 58) the composition is pyramidal and inspired by the traditions of the Tuscan High Renaissance (Masaccio's *St Anne* is rigorously pyramidal, and so is an even earlier work, Giotto's *Madonna* now in the Uffizi), but within this pyramidal layout, which Leonardo also used for his *Last Supper*, he suggests a kind of heliocoidal movement. Consequently, the counter-balancing penumbras, thanks to his use of *sfumato*, suggest expanding atmospheres, which, however, revolve around clearly defined compositional structures, even when these are, so to speak, submerged. The Renaissance conception of proportion and also, in this particular case, of aerial perspective, still persists, but here it is endowed with a new rhythmical movement. Other artists of the Mannerist school stressed the anxious tension of certain agitated rhythms, while those of the Baroque period expanded the atmosphere by means of focal centres which are only apparently dispersive, and all of them were therefore following the example set by Leonardo.

In our own century the artist who has devoted most attention to the problem of movement and its realization in the form of rhythm is Boccioni. Futurism, of which he may be said to have been the leading exponent as well as the theoretician, likewise aimed at

241

achieving the representation of movement in the visual arts by breaking the object up into a sequence of rhythms, as, for example, Balla did when, in his *Speed of a car* painted in 1912 (Fig. 189), he systematically broke everything up into segments of circular forms. Boccioni drew a distinction between universal motion, which all objects have even when they are stationary and which is the same as the energy of expansion in a space created by the lines of force emanating from each form, and accidental motion, occurring when the object actually moves. His *Development of a Bottle in Space* (Fig. 186) executed in 1916 is a sculpture the aim of which is the representation of universal motion; the concave and convex planes, the force-lines and the direction in which the object — in this case a bottle — rotates while apparently stationary, are all fused into pure rhythm and give the impression of abstract, universal movement in the relationship between the object and its surroundings. On the other hand, *Forms of Continuity in Space* (Fig. 187), which Boccioni executed a year later, represents both kinds of motion — accidental, because the athlete is shown running, and universal, because the force-lines alter the object by stressing its anatomical characteristics and cause the forms to expand within the setting. In paintings and drawings Boccioni also found other solutions to the problem of rhythmical movement, without breaking the object up into a sequence of moments and without impairing the solidity of the forms, though these are of course liable to be altered by the energy of the force-lines.

The *Nike of Samothrace* (Fig. 2), a work of the Hellenistic period, produces an effect of rhythmical motion because of the alternation of light and shadows, which almost makes us feel that a strong wind is blowing (in fact it looks like a winged Victory on the bows of a ship); but the figure, classical in origin, has been left as it was, because in those days art was still conceived as beauty. In the fourteenth century Simone Martini produced a symbolical rendering of the rhythmical motion of a mediaeval knight amidst turreted castles. His *Guidoriccio Fogliani* (Fig. 188) gives the sensation of movement, which is created by the rhombi on the clothing and the trappings of the horse, by the almost imperceptible linear analogies in the broad, undulating curves of the landscape. This is pure rhythmical motion, highly poetical in the effect it produces.

In his *Rythme No. 2* of 1938 (Fig. 190) Robert Delaunay breaks the colours up into circular rhythms, with gaps which produce an effect of abstract motion. As an exponent of Orphism (the name Apollinaire gave to the trend) Delaunay, with the aid of his fertile imagination, was able to extend his Cubist experiments to the rendering of rotary movement on one plane, creating rhythms which heighten the harmony of the colouring. This is, in reality, what Balla achieved in another way, by using pure abstractions; the representational motif disappears altogether and everything is reduced to analogies of spatial rhythm.

Finally, if we want to understand how the eager search for rhythm —

with which movement is identified—has induced many modern artists to resort to abstractions (which eventually acquire a concreteness of their own in the lines, colours and forms), we must study the development of a naturalistic motif in the works of Mondrian, a painter of the abstract trend known as Neoplasticism. His *The Red Tree* (Fig. 192), dating from about 1909–10, is still recognizable as a tree with branches and foliage; the influence of Post-Impressionism led him to make his colours brighter and to expand the whole composition in the atmosphere. His *The Silvery Tree* (Fig. 193), of about 1911, is already more synthetic, and in it the rhythm is based on clearly defined planes. In his *Blossoming Tree* (Fig. 194) the influence of Cubist planes is more evident, while the rhythm is more irregular, the tree is reduced to mere essentials and there are frequent overlappings of surfaces. Then we come to the *Oval Composition—Trees* (Fig. 191) of 1913, in which the rhythm is no longer naturalistic, but more abstract, revealing the influence of Cubism, while there is also a ferment of positive and negative relationships (in the earlier versions these were branches, leaves or empty spaces) creating a new rhythm and a new kind of movement owing more to the imagination. Lastly, we have his *Composition* (Fig. 195), painted in 1920, in which the construction is carefully stressed and produces an effect of coldness, while the spaces are strictly counterbalanced, thus producing a more regular rhythm. This is painted architecture exalting pure colouring, the extreme consequence of Seurat's neo-Impressionism, severe and in tendency not far removed from scientific research. There is no longer any attempt to reproduce a representational image, but Mondrian's first, naturalistic tree enables us to understand how, after many vicissitudes, he was finally converted to the Calvinistic austerity of the Neoplastic trend.

To sum up, if we want to form a critical judgement, we must first study the artist's background and his individual temperament, as well as the historical period during which the work was produced. Whether we like the work or not, has only a hedonistic value, and every spectator has his own taste.

The decisive function of rhythm—and of movement which is invariably bound up with rhythm—can be clearly seen from the examples we have given above. Without rhythm—no matter whether it is due to impulse or intuition or is constructed in accordance with strict rules, there can be no real art, since rhythm means life. When the movement is created solely by the pose, by a superficial attitude, it is easy to see that it is not real rhythm, which is always based on the concreteness of relationships, of chiaroscuro, colour, lines and spatial modulations. On occasions its beats and pauses may be subdued and barely perceptible at a first glance, but it always asserts itself as the hidden breath and life of the work.

Signs and Symbols

WHEN does a sign or symbol become art? And what kinds of symbols are used in the visual arts and what do they mean?

Today we are surrounded by signs and symbols which have created a new international language — from road-signs to abstract neon symbols, to signs without any explanatory captions, flags used as symbols, traffic-lights and an infinite number of other signals the meaning of which is quite clear.

They are also, however, used in art, and many artists draw their inspiration from such symbols and reproduce them in their works. In themselves they are not art, even if considerable inventiveness is displayed in designing them, as well as clarity of purpose. Under the influence of Dadaism many artists made use of symbols and stressed their artistic value (but of course individual choice played a part in this, too).

What I wish to discuss here is the type of sign or symbol that was originally intended to be art and has therefore an expressiveness of its own. Signs which, in short, function in the same way as gestures.

First of all we must make it clear that if art is to be understood as the representation of a fact (whether real or not, does not matter) and therefore as vision, then signs and symbols can have value only as forms of expression. For example, in one of Van Gogh's paintings (Fig. 212) the pictorial symbol of the comma can be seen, but it is not an independent symbol since it serves only to express the dialogue with Nature, which is distorted in a most terrifying manner. In Dufy's *Orchestra* (Fig. 35), which at first glance seems to be a tangle of intersecting lines, the symbol is derived from the vision and reproduction of a musical event, and here, too, it is used to express an episode and interpret it in a lyrical manner. In addition to the outlines, which give sculptural relief to the chiaroscuro, the symbols used by Michelangelo in one of his studies for figures (Fig. 68) are means of expression born of his vision. And lastly, Boccioni's *State of Mind: Those who stay behind* (Fig. 97) is based on the values of pictorial signs which he derived from the works of the Pointillists, but which here become symbols. These signs, however, have a functional purpose, and consequently they, too, are means of expression.

There is, however, another type of sign, not due to any urge to imitate reality, even if the final result is that this reality is transposed, evoked or reconstructed by the memory. In such cases signs have an autonomy of their own and lead us back into the labyrinth of the unconscious, or else they become fictional symbols.

196 HAKUIN, *Loyauté*, 18th century, Paris, Jean-Pierre Dubosc Collection.
Here is an example of symbols painted by the Japanese Hakuin (1686–1768), which are something more than the representation of a concept and have a cursive directness evoking psychic values.

244

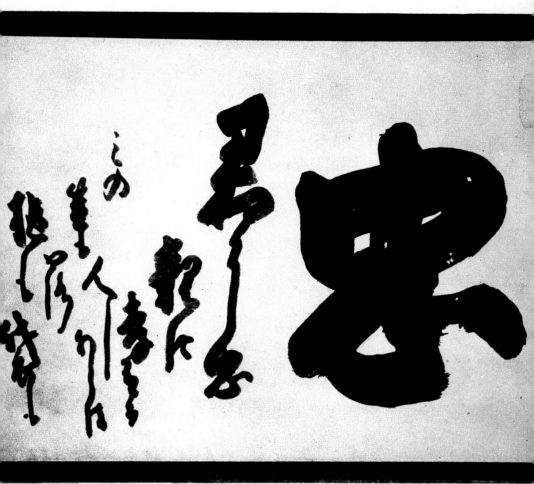

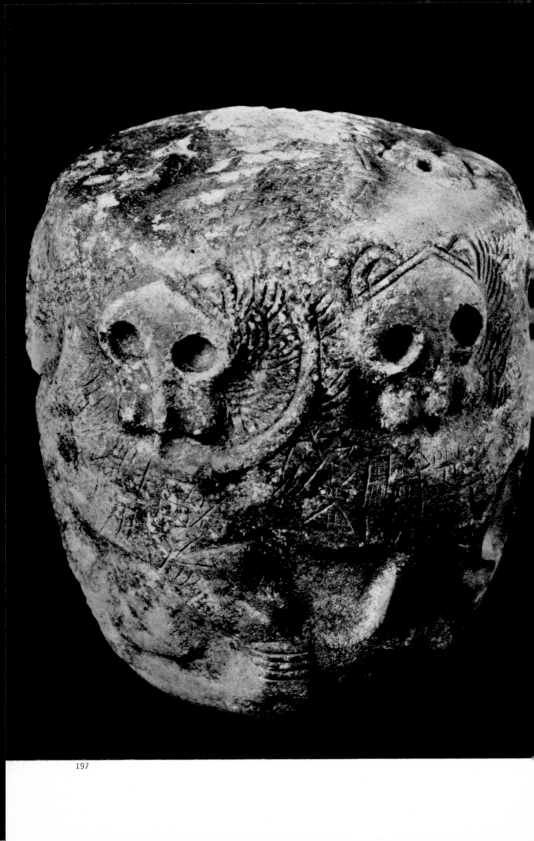

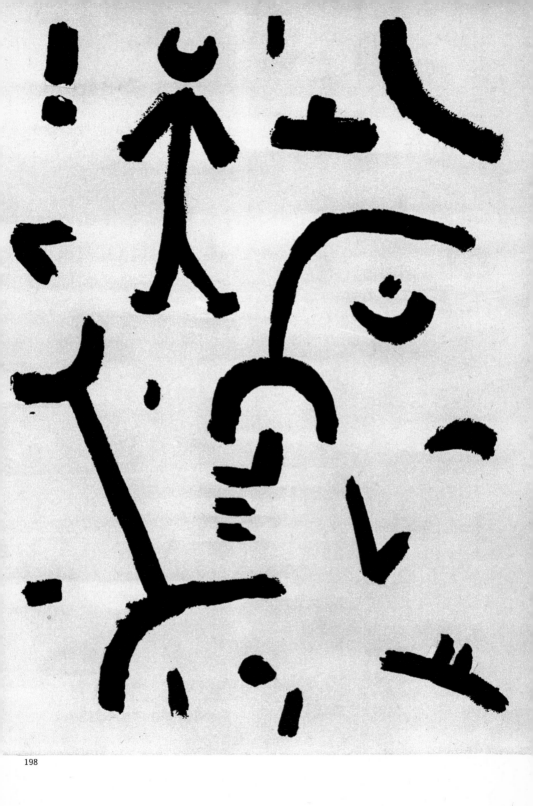

199

It is a well-known fact that in the ancient civilizations handwriting originated as a series of ideographical symbols for objects, actions and everyday happenings. Egyptian hieroglyphs (Fig. 200) are indicative in this sense; they evoke images by resorting to symbolical stylization. The signs of the cuneiform script used by the Assyrians, Babylonians and other peoples of Western Asia were originally pictographic, since they were schematic representations of objects; later they became more linear and abstract, and took the form of wedges (Latin *cuneus* = wedge) when people began to write on clay that was still soft, on which it was impossible to draw sharply defined lines.

In modern times handwriting has become cursive and consequently it can express the personal character of the writer, since it has become an almost automatic process. Today calligraphy as an artistic accomplishment hardly exists, and we have only a dynamic sequence of signs expressing temperament. About 1925, when Surrealism made its first appearance, automatic writing was interpreted as a desire to confess, to free oneself from the subconscious and express a psychical truth that was not influenced by any myth of beauty and harmony; it became a process of irrational mechanics and in many ways was like a return to the origins.

And in fact, in prehistoric times, signs and magic cohabited in symbols. The marks on certain prehistoric vases (Fig. 206), for example, consist of allusive references superimposed on one another and thus reveal a conception of space in which the labyrinth of the unconscious becomes the reality of Nature full of dangers and not yet subdued.

A funerary stele from Logrosan in Spain (Fig. 203), dating from the tenth or ninth century B.C., i.e. from a later civilization, shows more care taken in the arrangement of the symbolical signs, though the allusions are still irrational; there is still some connexion with reality, but the use of signs gives it an allusive and magical value and it is no longer representational, while the rhythm stresses the expressiveness of the symbolism.

197 Boulder from Mesilim, Chaldaean art of the dynastic period, Paris, Louvre.
Signs can be transformed into something more than graphic symbols, as they are on this striking boulder, which looks like an emblematic symbol.

198 PAUL KLEE, *The Little Boy is allowed out*, 1937, Zürich, M. Bill collection.

199 WASSILY KANDINSKY, *Sketch for Bright Painting*, 1913.
The value of almost automatic signs taking us back to the subconscious and creating a state of mind is evident in this sketch made by Kandinsky in his 'Blue Rider' days — the movement was founded in Munich in 1920 and another of its adherents was Paul Klee, in whose *The Little Boy is allowed out* the apparently childish symbols have a clear rhythmical purity. In Kandinsky's sketch, too, the rhythm gives unity to the symbols forming the composition, thanks to the hidden concordances of the spaces; it is all inner rhythm, subtle and tense.

It was thanks to this symbolical value and the conception of space as something that could be projected on to a surface without any need for the third dimension of perspective (because greater importance was attached to the symbolical representation of an infinity beyond human experience than to space as actually seen by mankind and thus dominated) that the use of signs and symbols spread not only among the various primitive peoples, but more especially in the East. With their systems of writing China and Japan raised signs to the rank of suggestively beautiful hermetic symbols, in which the rhythm is due to an allusive treatment of space. The Japanese developed a semantic process which in recent years has influenced the new American 'Pacific School' (of which Tobey is an exponent), in whose works signs have acquired a new artistic value.

But at this point, since we wish to discuss the use of signs and symbols in modern art, we must try to find a better explanation of Surrealism and automatic writing.

André Breton's Surrealist manifesto appeared in 1924; in it he defined Surrealism as 'pure psychic automatism' and maintained that it had established, in a highly original way, a connexion between the new psychological sciences (a kind of homage to Freud for his study of dreams) and all the phases of Romanticism down to the Symbolism of the late nineteenth century, which had exalted the irrationality of man. Breton re-established the importance of hallucinations, dreams and insanity, and he wanted 'to do away with that hatred for the unusual which dominates the minds of some men'. With the aid of a new psychic mechanics, automatic and direct 'dictation without any possibility of making subsequent corrections' ought to become an essential rite of a new mysticism. As regards the possibility of giving graphic form to a hallucinatory image, Breton maintained that this was 'not a matter of drawing, but simply of transference'.

The mere fact of adopting automatism, however, does not mean that the result will be a work of art, since art, however irrational it may be, always requires a certain amount of mental concentration (in reality this was one of the limitations of Surrealist automatism, because its devotees often allowed the lucidity of their own minds to

200 Funerary stele from Egypt, Middle Kingdom *c.* 2000 B.C., Turin, Museo Egizio.
Hieroglyphic writing used signs to form ideograms arranged in accordance with the requirements of the architecture. The compositions painted, engraved or carved on the walls of Egyptian buildings were often designed to harmonize with the rhythm of these hieroglyphic symbols.

201 ALEXANDER CALDER, *Mobile*, 1956, Milan, Galleria del Naviglio.

202 JOAN MIRÓ, *Giantess*, drypoint engraving, 1938.
The Surrealists attached new psychic and expressive values to signs even when they did not become completely automatic. Miró was influenced by Cubism, but after experiencing Surrealism his signs became freer, with allusions to their roots in the unconscious and our prehistoric origins, though they remained strictly rhythmical. Calder used signs to create suspended equilibrium derived from constructionism.

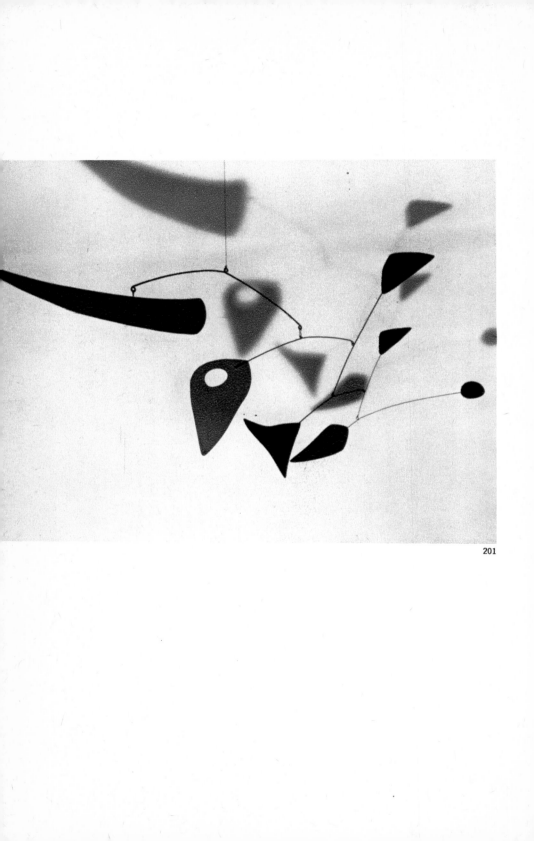

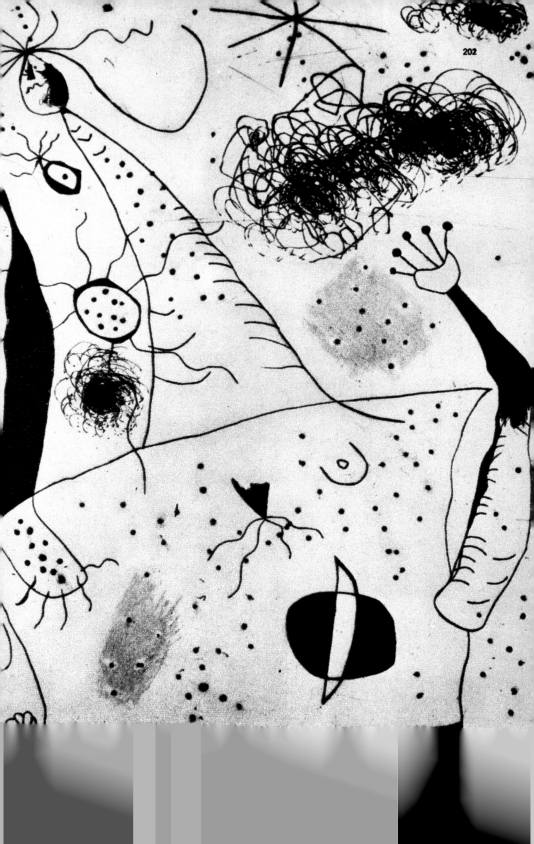

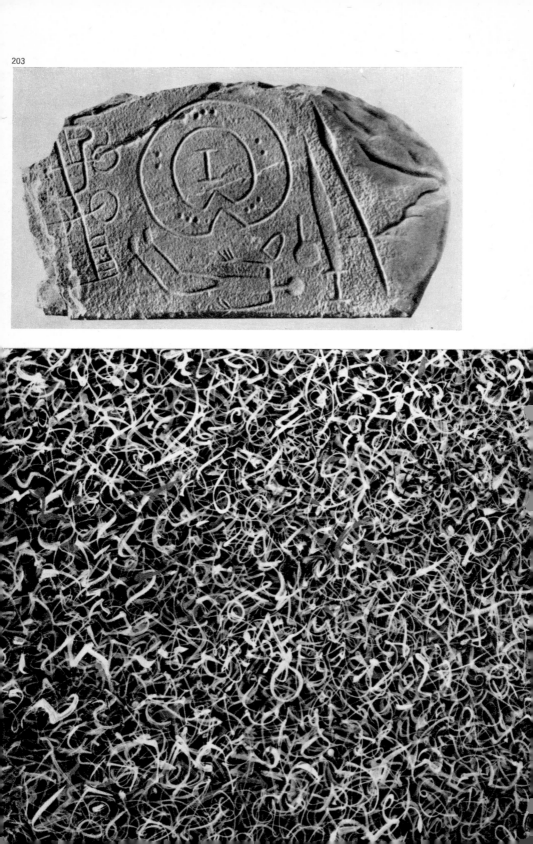

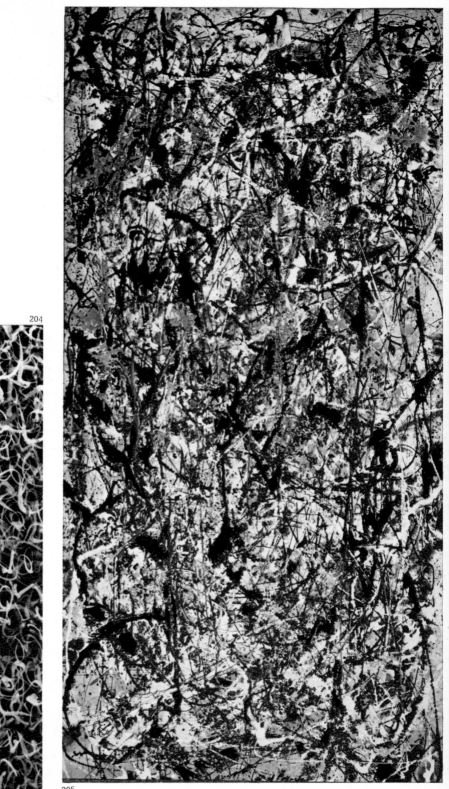

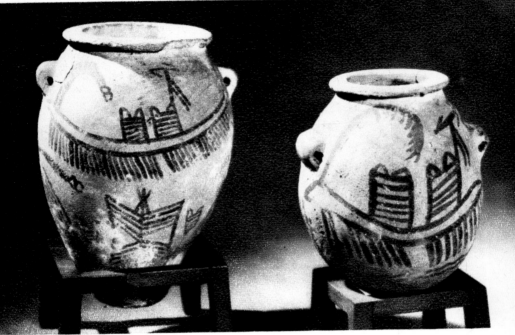

206

intervene in the composition), but undoubtedly Surrealism did lead to a reconsideration of expressive symbols. Even if they were not automatic in the stricter sense of the term, symbols did create new schools both in Europe and in America (in the East symbolism had always existed).

Before the emergence of Surrealism Kandinsky and Klee had already given a new value to signs as representing psychic actions. Kandinsky's first non-representational compositions—the watercolours he painted between 1910 and 1913 (Fig. 199)—derive their expressive life, as I have already pointed out, not from any attempt to imitate Nature, but from the values of symbols having some reference to the inner life of the mind, in other words almost on the borderlines of the unconscious. Expressionism gave a further stimulus to the use of symbols, since it interpreted art as a desire for inner truth, as an urge to give free rein to expression. The innumerable and extremely lyrical symbols used by Klee (Fig. 198) reveal a dimension which is all of the mind; they are like voyages of exploration into the interior and have a rhythm which relies exclusively on semantic means. Klee has exercised a great influence on the development of symbols in other modern trends, and more especially on those of the last twenty years.

Miró is one of the leading painters who use symbols, and some of his Surrealist compositions (Fig. 202) seem to be still based on mechanical automatism, because, among other reasons, they have value as expressive and original interpretations of the pre-conscious. Nevertheless, at the very moment when the symbols are transformed into pure rhythm, mental concentration takes control of the painter's lyrical imagination, which is lucid and at the same time primitive.

In Calder's works (Fig. 201) signs have a constructive function in the counterbalanced sculptures modulated as regards the surfaces,

203 Funerary stele from Logrosan (Spain), 10th–9th centuries B.C.
In this stele the symbols have allusive and magical values, and there is no attempt to be objectively representational.

204 MARK TOBEY, *Towards the Whites*, 1937, Turin, Museo Civico.

205 JACKSON POLLOCK, *Cathedral*, 1947, Dallas, Museum of Fine Arts.
In Tobey's works the symbols have a haunting, delirious rhythm and his tense, original imagination evokes the notion of crowded cities and states of mind in which the ups-and-downs of life are in a state of continual flux.
Pollock was an American exponent of 'Action Painting', in which symbols acquire an enhanced value as integral parts of the picture. In this respect, he owes much to Pragmatism, the philosophical trend founded by William James which had such a decisive influence on American everyday life, and consequently on art. Pragmatism exalted the practical and the useful, success and the active as opposed to the contemplative life.

206 Egyptian pre-Dynastic vases, c. 4000 B.C., Turin, Museo Egizio.
On these vases the symbols are allusive; they may suggest ships, but only emblematically. It is not always possible to establish a definite borderline between abstract and evocative symbols.

with edges marked by sharply defined lines; they create the setting, in which the forms expand, while the setting itself is given movement and becomes space-time.

Mark Tobey, a follower of the Pacific School, has exploited symbols by studying the experiments made by the Expressionists and giving them a new significance. His *Towards the Whites* (Fig. 204) shows a fertile inventiveness in the use of symbols, combined with a restless rhythm which is nevertheless refined and extends beyond the edges of the picture as if controlled from a distance.

In the works of Franz Kline, another American artist who came to the fore after the Second World War, expressionistic violence is even more noticeable; he also allows gestures to play their part and the resulting tangle becomes a symbol of vitality. This reminds us of that desire for action propounded not only by the Expressionists, but by pragmatic philosophers as well, who have many followers in America and lay great stress on action. As a result the symbols are vivacious and the rhythm is created by direct tension, by impulses. On the other hand, Pollock's *Cathedral* (Fig. 205) leads us straight to the so-called 'action painting' in which gestures, in accordance with the principles of Surrealist automatism, evoke the unconscious: 'The source of my painting is the unconscious... When I am painting, I do not realize what I am doing; only later do I see what I have done.' In his last years (he died in 1956) he created his most aggressive pictures by letting quantities of paint and varnish drip from above on to canvases lying on the floor, a system which had already been tried by Max Ernst and other Surrealists. But in this case, too, the material action was to a certain extent controlled by the painter, even if he could not possibly foresee the ultimate effects. Symbols and gestures, even when they seemed to be produced by the mechanics of automatism, were in reality the outcome of complete concentration, with the mind, the senses and intuition all taking part in the *action*, in the act of painting interpreted as being life, thanks to a new laical mysticism which owed its revival to Pragmatism.

Of course, all such works need to be viewed from the proper angle, and only the history of the development of symbols can tell what this angle is. And there must be no preconceptions like those of people who insist that art must have some resemblance to reality, and be a comprehensible representation or imitation of Nature – in other words, the old traditional procedure in painting. Art is continually discovering new methods, new ways of expressing its ideas and of communicating the living word.

207 Painting by a child.

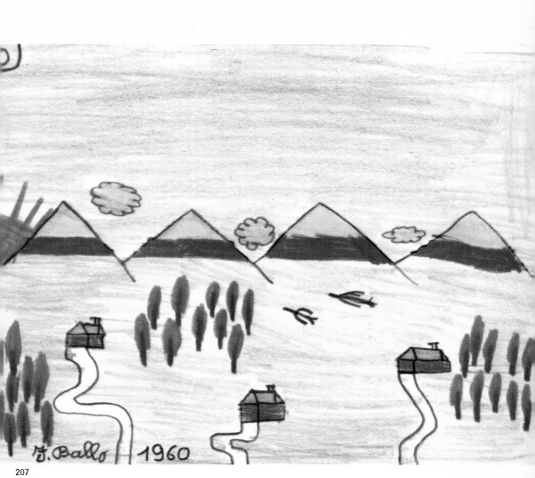

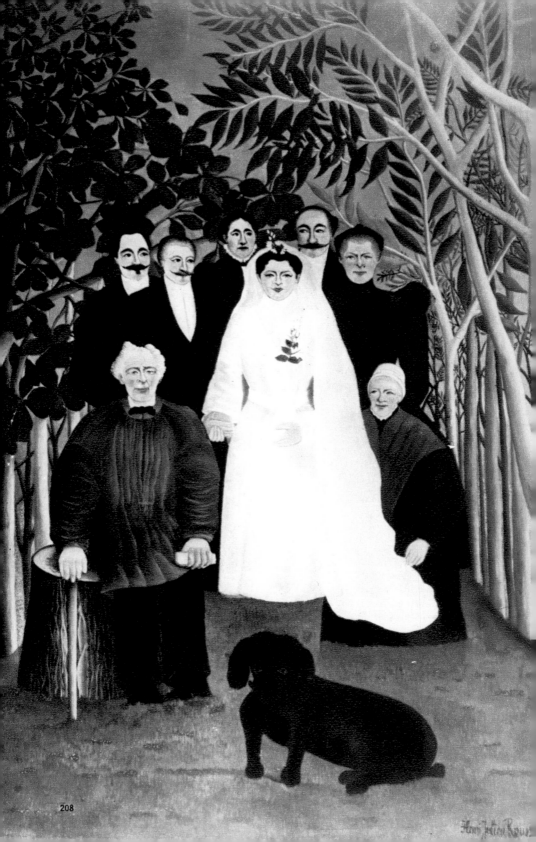

The Rôle of Expression and the Ugly in Art

AFTER all the talk about rhythm, proportion, style, harmony, modulation and restraint, how is it that art is so often ugly, or in certain cases even repulsive, instead of being beautiful? What sense is there in distorting everything and even exalting the grotesque? Are such things really art, or are they not a species of aberration, passing whims, a kind of exhibitionism? It is true that plenty of ugly and deformed figures can be seen in pictures dating from earlier times; we need only think of Brueghel's *Parable of the Blind Men*, or of the dwarfs in some of the paintings of Velazquez. But Brueghel's colours are beautiful and the restraint shown by Velazquez in his ensembles is admirable. Must we then force ourselves to like deformities just because they are deformities? And should we not talk of the ugliness of art rather than of its beauty?

These are questions that spring to the minds of all those who are shocked by the prevalence of ugliness in art. And in reality, if ugliness is a matter of taste and not a response to a need to achieve expressiveness, it has no sense and merely upsets us. But there are cogent reasons underlying the problem of non-beautiful art, and before we reject it, we must study it and examine every individual case, without prejudice and without condemning it *en bloc*, to do which is always a mistake.

The chief propagandists of the myth of beauty in art were the neo-classicists, who as a result of their passion for ancient Greek art identified all art as being 'ideal' or 'sublime' beauty, a well-proportioned abstraction. But what they really propagated was a taste for cold, insipid beauty, lacking in colour and character, even if it was academically harmonious in its well-balanced relationships. When Canova, during a visit to London, saw original works by Phidias for the first time in his life, he himself perceived that the neo-classicists were quite wrong and that 'sculpture means flesh', i.e. life and colour. In a letter he wrote in 1815 to his friend Quatremère de Quincy he maintained that this was what he had always thought; but then, Canova came from Venetia, and we can understand his attitude.

Beauty conceived as harmony and identified with art is a concept that goes back to the classical period. But in ancient Greece, side by side with the Apollonian element, there was also Dionysiac fury, and as a result the forms were endowed with vitality. In any case, Greek civilization produced an art in which geometry and proportion signified beauty and art, since beauty lay in the harmony of the proportions and no attention was paid to fortuitous circumstances. Thus the myth of an ideal beauty was born, abstractly synthetic, though in works of sculpture it had a concrete vitality. From

208 DOUANIER ROUSSEAU, *Country Wedding*, Grenoble, Museum.

Greece, as everyone knows, this idea spread to other countries and it influenced the whole development of classicism throughout the centuries. Nevertheless, it was only one of the many conceptions of art current in the various cultural climes. History teaches us that other civilizations, from prehistoric times down to our own and in every part of the world, developed other ideas about art, in which the concept of ideal beauty carried to the point of the sublime is never found at all.

In Etruria, in the absence of Greek influence, expressive distortion was an outstanding feature in works of art, from the canopic funerary vases shaped like human bodies down to the numerous sarcophagi, acroteria and other kinds of works. The Etruscans never felt the necessity of moderation, beauty or gracefulness, but concentrated on character, which they accentuated by making an expressive use of distortion. Roman portraiture, as soon as it became realistic (and therefore Etruscan in conception rather than Greek), was anti-classical and also paid more attention to character than it did to beauty. And we must also remember those other civilizations which never had any contacts with classicism: — for example, Pre-Columbian sculpture; the monsters and divinities of various Asian countries; the statues found in Sardinian *nuraghe*, which are full of expressive tension; and all the works produced by primitive peoples, such as African carvings, totem-poles, fetishes, the traditional arts of Mexico, Northern Europe and Canada, and countless other works. We are again reminded of the words of Wackenroder, which I have already quoted once: 'Had your soul budded thousands of miles away, in the East or on Indian soil, when you gazed on the queer little idols with their innumerable arms you would have felt that a mysterious spirit, unknown to our

209 Sicilian ex-voto, 1892, Catania.
Visionaries often distort things in the interests of expressiveness, and this is not always due to lack of technical skill. Children's paintings are the works of visionaries, because childish eyes are astonished by the reality they see and view everything emotionally; hence the bright colours they use and the imagination they reveal, without the assistance of the third dimension, in interpreting what they see as if in a dream. The so-called distortion is due to the fact that a child does not try to imitate objects, but only to repeat what he has seen in his imagination. Pictures by uneducated artists have many points in common with those produced by children, and these, too, can be classified as 'naïve' art. Their directness of communication is due to the desire to relate a story in a striking manner, and although certain elements may vary in accordance with the popular traditions current in the various countries they invariably reveal a certain degree of naïve expressiveness; the distortions are not deliberate, the settings are not governed by any laws of perspective and the mind of the artist plays only a minor role.
Douanier Rousseau was influenced by Gauguin's symbolical synthetism (hence the patches of colour and the heightening of harmonies), but although he was always a visionary story-teller, his paintings cannot be described as naïve, because they often reveal very shrewd observation and come near to being 'literary'. Amateur painters admire Douanier Rousseau because for them he was the man who made this kind of 'ingenuous' painting popular without sacrificing the fundamental aim of telling a story.

262

209

210

211

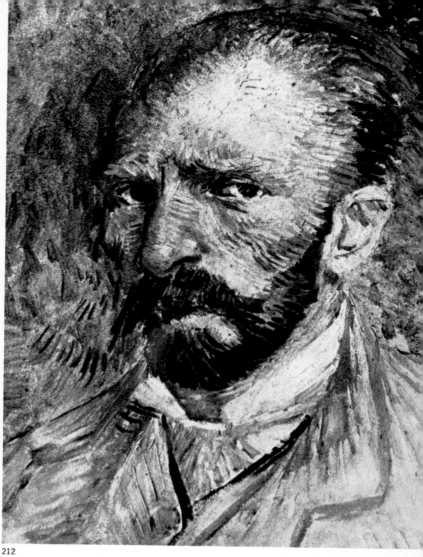

212

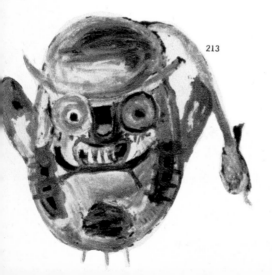

213

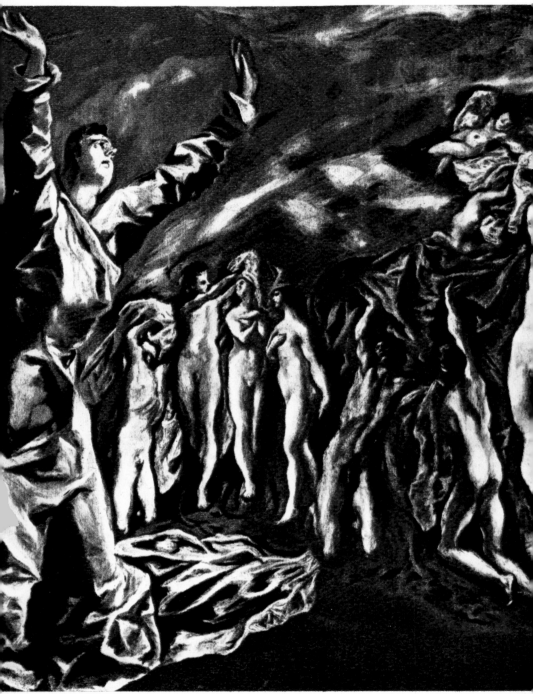

senses, was inspiring you; and this spirit would bring them to life before your eyes, and you would feel only indifference when confronted with the Medici Venus.'

We must, therefore, draw one fundamental distinction, which will serve as a guide to the formulation of a critical judgement—a distinction between art in which moderation and proportion, thanks to the aloofness of the artist's mind, produce harmonious beauty, and art in which the role of expression, an urge to convey a message, makes the artist ignore all canons, distort everything and concern himself primarily, not with the achievement of harmony and beauty, but with expressiveness. In the broader sense (though even this distinction should not be taken too literally, since it can so easily become generic

210 Vase in the shape of an animal, from the central plateau, pre-Columbian period, San José (Costa Rica), National Museum.
The hideous expressiveness of this pre-Columbian sculpture modelled in clay is due to the exaggerated stress laid on the grotesque element, without any regard for the harmony and beauty of our own classical tradition. Here the ugly becomes an essential element of expression and thus assumes the character of art.

211 EDVARD MUNCH, *Desire*, lithograph, 1898.

212 VINCENT VAN GOGH, *Self-portrait*, 1887, Amsterdam, Rijksmuseum Kroller-Mueller.

213 Painting by a mental patient.
The heightening of effects in the interests of expressiveness as practised by many modern artists has often been held to be a symptom of insanity, and this idea has been extended to all the ugly and deformed elements in art. And if, as in the case of Van Gogh, the painter really was mad at a certain stage in his career, this opinion is raised to the level of a dogma and may give rise to many misunderstandings of a pseudo-Romantic kind. But anyone who has ever been to an exhibition of paintings by the insane will have noticed that there are always a number of different trends representing different temperaments and states of mind, some revealing depression and others excitement. Such people are rarely able to give free rein to their imagination, for in most cases they cannot think clearly enough to enable them to exercise control over their works. In his bouts of mental illness Van Gogh composed works which were less vivacious and more laboured than those he painted when he was well, one of the reasons being that exaltation involves a tense lucidity of mind and complete concentration. The terrifying effect of this *Self-portrait* is due to deliberate effort and great concentration, and even when it may seem to be due to insanity, it invariably requires a measure of control over the mind. The painting by a mental patient here reproduced, on the other hand, has the visionary character found in pictures painted by children; the colouring is subdued and there is a desire for expressiveness, but there is no trace of control in the use of technical means. It should, however, be noted that even madmen have their lucid intervals and that painting serves to liberate and distract them; moreover, it will always show traces of their previous cultural training, in a more or less confused way.

The lithograph *Desire* by Munch, with its expressive lucidity, reveals the imaginative character of this Symbolist painter who had such a great influence on Expressionism. In his works the ugly and the deformed have a profound expressiveness, from the moral as well as from the aesthetic point of view.

214 EL GRECO, *The Apocalypse*, 1610–14, New York, Metropolitan Museum.

and create other misconceptions), this is the same distinction that we draw between classical and Romantic origins, between the tendency to concentrate on form and the preoccupation with colour, between essential synthesis and existential variety. In reality, however, these two conceptions are often found side by side. If we find no life or warmth but only adherence to academic rules in neo-classical sculpture, which tried to imitate Greek art (without ever having seen the originals), for example in the works of Thorwaldsen, who in his day was deemed to be a leading exponent of this trend, on the other hand, in genuinely classical Greek works we find life and a repressed fury such as no Romantic could ever have conceived – for example, the *Korai*, the archaic figures of girls now in the Acropolis museum in Athens, although they are motionless statues, emanate such vitality owing to their potentiality of movement and the concise rhythm of their compact forms that they leave the spectator speechless. Photographs cannot possibly reproduce this sensation of being alive, which is due to the concreteness of the marble, the colour and the barely perceptible transitions. The forms have character, and they are also beautiful, because Attic harmony was based on the relationship between proportions.

As we have already pointed out, this unquestionably admirable conception was in complete accord with Greek civilization, the climate and culture from the archaic period down to the fourth century B.C. After that everything changed and there was disintegration and multiplication. Hellenistic art is no longer Greek and it is absurd to maintain – as the neo-classicists did – that other civilizations must imitate Greek art or produce works of the same kind, since this implies ignoring the fact that Greek art was the product of a particular stage in the evolution of culture, history and life.

A great artist – for example, Goya – may adopt different styles, each of them corresponding to a certain phase in his maturity. When Goya painted his *Parasol*, he was still under the influence of Tiepolo

215 JAMES ENSOR, *Entry of Christ into Brussels*, 1888, Ostend, Casino.

216 PAUL CÉZANNE, *Portrait of the painter Achille Emperaire*, 1866–68, Paris.

217 EMIL NOLDE, *Pentecost*, 1909, H. Fahr collection.
In this painting and in Ensor's *Entry of Christ into Brussels*, the heightening of the colours and the visionary elements go far beyond any myth of beauty in the urge to achieve the maximum expressiveness. Ensor was the last great painter of the traditional Flemish school and he had a predilection for savage irony bordering on the grotesque, his favourite subject being the nakedness of mankind beneath the mask. Nolde, who was of Frisian-Danish descent, expressed the inner truths of man's existence without the slightest attempt to embellish them, and he depicted the primitive drama of mankind with deep religious feeling, and a truthfulness which is not just apparent, but has its own aesthetic coherence and is therefore complete. In such works, distortions are necessary in order to heighten the expressive tension of the images.

216

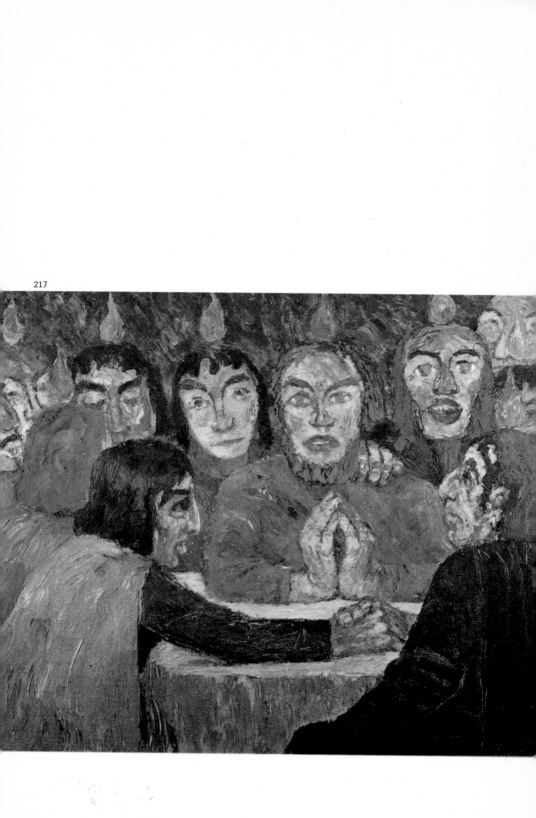

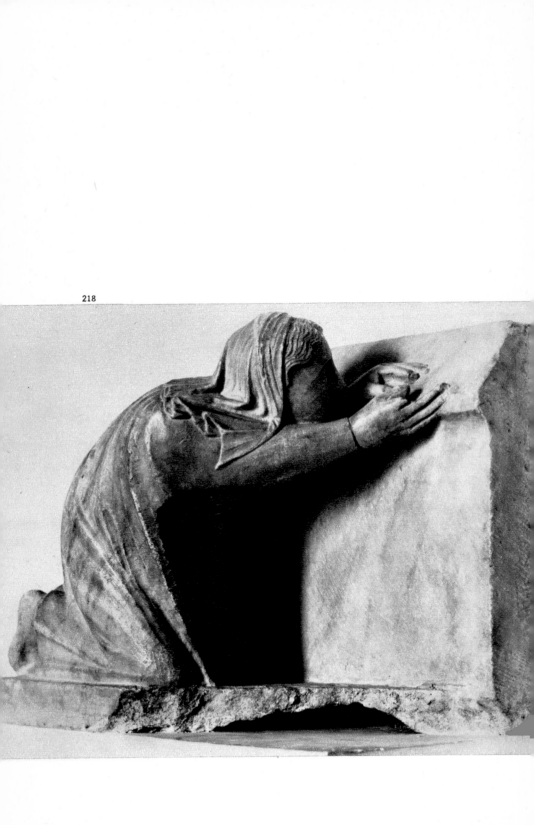

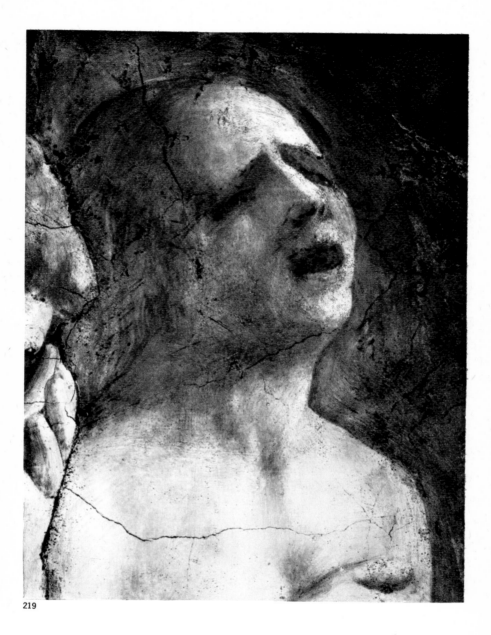

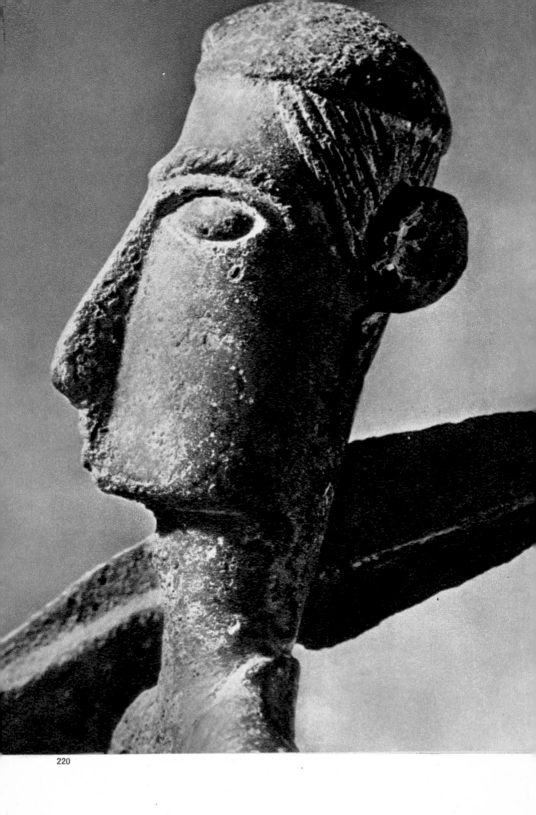

and tending towards an eighteenth-century type of beauty and gracefulness and a pleasing harmony; in his *Maja desnuda* and *Maja vestida* (the colouring of the latter is more vivid and penetrating) he exalted female beauty, the female body, and these works were greeted with approval by the public at large. But when this same Goya painted his *Witches' Coven* for the 'Quinta del Sordo' (Fig. 40), which today is also in the Prado, he had a presentiment of death and used darker colours; similarly, there is no longer any beauty and the figures are ugly and deformed. The public accepted these things as being due to the fact that by this time the painter was deaf and almost insane, but in reality he was achieving far more expressiveness and profundity than in the *Parasol* of his early years.

The fact of the matter is that if distortion is due to an imperative need for expression, then beauty, pleasing effects, harmonious proportions and gracefulness are replaced by the fundamental urge to express a truth which is not just an imitation of Nature, but the whole of life, and feeling plays a predominant role. By painting in this way an artist can go beyond the art of contemplative vision, and the result may even be a contamination of art by life, material objects being pieced together to form collages made up of ugly scraps and refuse, which have their own psychic and expressive significance. This is as true of the ritual and magical practices of primitive tribes as it is of certain disturbing trends in modern art derived from Expressionism. Schwitters (Fig. 94), whom we have already had occasion to mention, is a typical example.

Considered as an historical movement, Expressionism began in Germany in 1905, at Dresden, with the emergence of the group

218 ARNOLFO DI CAMBIO, *Thirsty Old Woman*, 13th century, Perugia, Galleria Nazionale.
Arnolfo was an architect as well as a sculptor, and he therefore understood the importance of strict adherence to the rules of proportion. In this carving, however, which shows an old woman kneeling before a fountain, he distorts the reality of Nature in order to make the figure more expressive; the plastic masses look like blocks and this makes the effect all the more expressive.

219 MASACCIO, *Expulsion of Adam and Eve from the Garden of Eden*, detail showing the face of Eve, *c.* 1426, Florence, church of the Carmine, Brancacci Chapel.
Even in Renaissance days when Florentine artists were tending towards restraint in the treatment of proportion and perspective, the desire to achieve expressive tension often violated all the rules of beauty. In this vigorous fresco Masaccio tried to depict the drama of mankind, and by distorting reality he achieved a great expressiveness. The Renaissance was not concerned solely with restraint and proportion; it also felt the appeal of the human drama and of man's unending struggle.

220 Bronze figure of a warrior from a Sardinian nuragh (detail).
Since the earliest days the aim of art has been expressive tension rather than the representation of beauty. The distortions visible in this bronze figure from a prehistoric Sardinian nuragh are there because the artist felt that they were necessary, and this is true of every epoch, if artists are deeply concerned with the rendering of expression and do not contemplate their works with detachment.

known as 'The Bridge' (*Die Brücke*), to which Fritz Bleyl, Kirchner, Heckel, Schmidt-Rottluff and, somewhat later, Nolde, Cuno Amiet and Pechstein all belonged. The movement had a moral aim and was a protest which at times became shrill. Its origins go back to the German 'Storm and Stress' (*Sturm und Drang*) movement towards the end of the eighteenth century and to German Romanticism, which brought about a change of attitude towards the Primitives and convinced people that art was a matter of inner feeling, and should not be conceived merely as pleasing harmony.

Nevertheless, a trend towards expressionism, or to be more precise, towards the exaltation of expression, involving deformation and a profound moral participation, had existed ever since prehistoric days, since there had always been a desire for direct and expressive communication, suggestion and persuasion with the aid of striking images. In such cases the concepts of dimensions and proportion played no part at all; the ugly, the deformed, the monstrous and everything else that goes to make up life, were charged with emotional feeling and became violently expressive. Since we are accustomed to the classical myth which defines art as being ideal beauty, we are inclined to exclaim, when we examine expressive works, that they are 'beautiful', which is almost equivalent to saying that an artist can make even ugly things look beautiful. In reality, however, the concept of beauty has nothing to do with it, because what is really important is vitality and expressive forcefulness, which strike us and convey an immediate message. In other words, it is something beyond the limits of the beautiful and the ugly.

When Masaccio was painting his *Expulsion of Adam and Eve from the Garden of Eden*, he did not worry about beauty. And yet, in the early days of the Renaissance the need for restraint and proportion was keenly felt in Florentine art circles, for Ghiberti and Brunelleschi were working in Florence, where architecture was based on the harmony of commensurate spaces. In other works, for example in his *Trinity* in Santa Maria Novella, Masaccio also felt this need for restraint. But in his *Expulsion* he shows himself to be more of a visionary, with a deeper feeling for expression, and so he distorts Eve's face (Fig. 219) to such an extent that he turns it into a mask, because for him the human drama was a matter of moral tension and not just an aesthetic theme. The inspiring rhythm created by this intensity of feeling dominates the whole work, eliminating all the classical conceptions of beauty.

Similarly, Arnolfo di Cambio's *Thirsty Old Woman* (Fig. 218), when viewed from the standpoint of classical beauty, may well appear to be a mediocre work owing to its lack of proportion and, in fact, since no one viewed it from the proper angle, it was for a long time deemed to be an unsuccessful attempt to produce a work of art, while for the neo-classicists who worshipped Greek art it was positively ugly, and for the realists it was not a skilful imitation of Nature. In reality, however, it is one of the most striking examples of mediaeval

sculpture. Arnolfo was also an architect and therefore aware of the importance of harmony in spatial relationships (the cathedral of Santa Maria del Fiore in Florence is an outstanding example of rhythm based on Gothic linearism, combined with the equilibrium of Florentine Romanesque with its classical origins) and in this carving he reminds us of the school of Nicola Pisano—compact sectors wedged in among the masses of the composition, which develop within a well-defined setting without any trace of Gothic linearism, despite the fact that the work dates from the Gothic period. There is also a peculiar, unmistakable expressive tension, which distorts reality and (as Giotto, who was influenced by Arnolfo, also did) makes it caustic and brusque, reminding us of the human drama, elementary and absolute, as it was originally. Since Arnolfo felt this urge for expression, beauty for him was a minor consideration; he was interested only in life and expressiveness.

Before Arnolfo, Romanesque sculptors, from Viligelmo and the Master of the Bronze Doors of San Zeno (Fig. 12) to Antelami (Fig. 133) and the anonymous sculptors who adorned the façades of basilicas (Fig. 75), did not worry about the problem of beauty, but tried to achieve effective expression by means of distorted rhythms, accentuated, in some cases, by the desire to bring their works into tune with the architecture. The driving force behind Romanesque art was an aggressive, barbaric tension and a sense of guilt and sinfulness, of the contrast between this world and Heaven— a feeling that was typically Christian. The ugly and the deformed (for centuries deemed to be real, and not just artistic, ugliness) signified an expressive vitality, a means of conveying a message to the congregation of the faithful, who had to be redeemed, and not taught to admire beauty.

For that matter a certain degree of distortion is inevitable when an artist does not start from the idea that he has got to imitate reality, but from a visionary standpoint, from a desire to reveal and convey a message; and distortion is always at the root of real, intense expressiveness. In fact, we ought not to use the word 'distortion' at all, since it implies some sort of relationship to Nature—a relationship which often does not exist. Instead of calling it distortion, it would be better to use some term like accentuation, exaltation, or exaggeration. (Here I have used 'distortion' merely because I am trying to explain the problem of the ugly in art, the aim of which is not always beauty.)

El Greco, for example, was a visionary painter and a forerunner of Expressionism in the way he exalted his images, by elongating the figures, giving them squinting eyes and making them look as if they were suffering from goitre, by using discordant colours and disregarding all the rules of proportion—things which certainly do not indicate any wish to achieve beauty and restrained classical harmony. El Greco was, as we have said, an anti-classicist, a Byzantine by origin, and the influence of Mannerism, which he absorbed in Italy, tended to make his figures even more strange. If, however, we judge them

277

from the proper standpoint, i.e. that of coherent expressive intensity, then they reveal a great artist who effectively conveyed a living message. We need only glance at his *Apocalypse* (Fig. 214) or at his striking *Portrait of Cardinal de Juvara* — a new version of the Pantocrator, wearing spectacles — in order to realize how great was El Greco's ability to express himself (and we must not consider as defects a certain repetitiveness in the figures, which show few variations and were generally painted by his numerous assistants, after he had reached the zenith of his fame in Spain and confined himself to adding a few strokes of the brush to the compositions and then signing them).

After Romanticism, after the accentuation of expression to the point of grotesqueness in the paintings of Daumier (who, however, in his drawings, turned this caricatural and anecdotical grotesqueness into caustic satire), after the symbolical synthetism of Gauguin, who campaigned against the bourgeois predilection for prettiness and tried to return to the origins, that is to say to intensive expression (despite the fact that he himself was too much of a lyric poet), the ugly and the deformed in modern art have become a normal source of inspiration. This has been mainly due to increasing contacts with primitive civilizations, with Negro, Polynesian, pre-Columbian, tribal and prehistoric painting and sculpture, while contributory factors have been the vogue of realistic naturalism and above all the search for new and more vigorous methods of achieving expression.

Cézanne himself, who was a lover of order and, after his early experiments with Impressionism, tried to express Nature in terms of 'cones and cylinders', when he painted the portrait of Achille Emperaire (Fig. 216), heightened the effect of expressiveness by changing the relationships and making use of foreshortening, thus achieving a deliberately grotesque effect which was a prelude to Expressionism.

To an even greater extent Van Gogh, after adhering to the neo-Impressionist movement, became a precursor of Expressionism with the visionary exaltation of his images (which have a rhythm of whirling strokes far removed from the constructive moderation of Seurat). His *Self-portrait* (Fig. 212), one of several that he painted, is a really terrifying work.

With his series of mask-personages and owing to the visionary feeling which he owed to his Flemish origin, Ensor exalted the ugly (Fig. 215) by using bright colours and giving his grotesque figures the values of expressive symbols.

With Emil Nolde we are in the full tide of Expressionism; his *Pentecost* (Fig. 217) is one of the most novel and impressive works produced by a modern painter. Nolde has the religious fervour of a Primitive; not only does he refrain from any attempt to achieve beauty, but he is also entirely absorbed in the search for fundamental truth, which involves moral participation. In his works there is no trace of any desire to please; he is rugged and harsh, and delights in jarring clashes of colours, which nevertheless give life to his pictures, while

the message he conveys is not an imitation of Nature, but a revelation. He is thus a visionary, in whose works reality is an expression of the artist's innermost soul which relegates the narrative content to the background.

Before Nolde's time, another great visionary was, as I have already said, Munch (Fig. 211), who by using expressiveness as a symbol, makes us feel that the human drama is something more than a myth of beauty.

Even the so-called naive artists, who paint what are almost dreams, can be called visionaries, and the same may be said of pictures made by children (Fig. 207), whose vision always has an emotional basis and is therefore a revelation of what is in their minds, provided they are not misled by the advice adults may think fit to give them; and children evolve a simple, elementary technique — so straightforward that it assumes a symbolic value. The works produced by the mentally deranged — many people think that all modern artists are mad — have points in common with those of children (Fig. 213), and we must remember that even madmen have their moments of lucidity, during which they recall the teachings they received in their childhood. When, however, madness takes the form of imaginative exaltation (more often it is merely an unreasoning crisis of depression), it may result in the production of more vivid works, like those of children.

Generally speaking, however, a work of art can be created only following a definite method and if the artist subjects himself to discipline, even if it may seem to have been the product of a visionary impulse. A work of art is the terminal point of a whole process of liberation which makes its meaning clearer; and if liberty is to be accompanied by coherence of style, this can only be done after a struggle. When Van Gogh was in the throes of a mental crisis, he produced inferior work (for example, the rather weary works he painted while he was in a mental home; the *Self-portrait* I mentioned above seems at first sight to be the work of a madman, but in reality the artist was in complete control of his senses and able to express himself clearly).

In conclusion, the figure of a warrior from a Sardinian nuragh (Fig. 220) is an example of consistent and expressive distortion; with its stringent, harsh rhythm it takes us back to prehistoric times.

After studying these works, not all of them modern, but representing various civilizations and some of them very old, we may conclude this attempt to initiate the reader to art criticism. If we want to find the most suitable angle of vision, we must always think of the civilization, culture and whole history of the peoples who produced the works. Our appreciation must always be entire, based on our own knowledge, and not on the opinions of others.

And above all we need a certain flair, a desire to understand and to form a critical judgement. No book can offer any help to people who are not willing to listen.

Bibliography

ALBERTI, L. B., *La pittura*, Lanciano 1911.

ARAGON, *L'exemple de Courbet*, Paris 1952.

ARGAN, G. C., *Walter Gropius e la Bauhaus*, Turin 1951.

BALDINUCCI, F., *Notizie dei professori del disegno da Cimabue in qua*, Florence 1681–1728.

BALLO, G., *Idea per una estetica dello spettatore*, Varese, La Lucciola, 1956.

BALLO, G., *Sulla interferenza delle arti e altri pretesti*, Varese 1956.

BALLO, G., *I miti delle poetiche*, Milan, Maestri, 1959.

BALLO, G., *Vero e falso nell'arte moderna*, Turin, La Bussola, 1962.

BALLO, G., *El Greco*, Milan, Mondadori, 1952.

BALLO, G., *Boccioni*, Il Saggiatore, 1964.

BALLO, G., *La linea dell'arte italiana—dal Simbolismo alle opere moltiplicate*, 2 vols., Rome, Edizioni Mediterranee, 1964.

BANFI, A., *I problemi di una estetica filosofica*, Milan, Parenti, 1961.

BARR, H. H., *Cubism and Abstract Art*, New York 1936.

BAUDELAIRE, C., *L'Art romantique, Curiosités esthétiques*, Paris 1868.

BELLORI, G. P., *Vite de' Pittori, Scultori ed Architetti moderni*, Rome 1672.

BERENSON, B., *The Italian Painters of the Renaissance*, Oxford, Clarendon Press, 1930.

BOSCHINI, M., *La carta del navegar pitoresco*, Venice 1660.

BOTTARI, S., *I miti della critica figurativa*, Messina, Principato, 1936.

BRETON, A., *Manifeste du Surréalisme*, Paris 1924.

BUCHHEIM, L. G., *Die Künstlergemeinschaft Brücke*, Tübingen 1956.

CENNINI, C., *Il libro dell'arte*, Florence 1859; English translation, *The Book of the Art*, London, 1922.

CROCE, B., *Estetica come scienza dell'Espressione e linguistica generale*, 5th edition, Bari, Laterza, 1922; English translation, *Aesthetic as Science of Expression and General Linguistic*, London, 1909.

Dada, Monograph of a Movement, Teufen (Switzerland) 1961.

D'ANCONA, P., and WITTGENS, F., *Antologia della moderna critica d'arte*, Milan 1927.

D'ARGENVILLE, *Abrégé de la vie des plus fameux peintres*, Paris 1745.

DE HOLLANDA, F., *Tractado de pintura antiqua*, 1539, ed. Pellizzari, Naples 1914.

DELACROIX, E., *Psychologie de l'Art*, Paris 1927.

DORFLES, G., *Discorso tecnico delle arti*, Pisa 1952.

FERRETTI, G., *Estetismo*, Palermo 1940.

FIEDLER, K., *Schriften über Kunst*, Leipzig, Hirzel, 1896.

FRESNOY, *De Arte Graphica Liber*, Paris 1637.

GAUGUIN, P., *Noa-Noa*, Paris 1924.

GHIKA, M. C., *Essai sur le Rythme*, Paris, Gallimard, 1938.

GIEDION, S., *Space, Time and Architecture*, Cambridge (Mass.), Harvard University Press, 1943.

GLEIZES, A., and METZINGER, J., *Cubism*, London, Fisher Unwin, 1913.

HAUSER, A., *The Social History of Art*, London, Routledge & Kegan Paul, 1951.

HUYGHE, R., *Dialogue avec le visible*, Paris 1955.

HUYSMANS, J. K., *L'Art Moderne*, 1883.

ITTEN, J., *Arte del colore*, Milan, Il Saggiatore, 1965.

KANDINSKY, W., *On the Spiritual in Art*, New York 1946.

KLEE, P., *The Diaries, 1898–1919*, London, Owen, 1965.

LANZI, L., *Storia pittorica dell'Italia*, Bassano 1789.

LEONARDO DA VINCI, *Trattato della pittura*, ed. Ludwig, Vienna 1882; English translation, *The Art of Painting*, New York, 1957.

LOMAZZO, P., *Idea del Tempio della pittura*, Milan 1590.

MALVASIA, C. C., *La Felsina Pittrice*, Bologna 1678.

MARANGONI, M., *Saper vedere*, Milan 1933; English translation, *The Art of seeing Art*, London 1951.

MENGS, A. R., *Opere*, Parma 1780; English translation, *The Works of A. R. Mengs*, London 1796.

MICHELANGELO, *Lettere*, ed. Milanesi, Florence 1875.

MILIZIA, F., *Dizionario delle belle arti del disegno*, Milan 1802.

NERVI, P. L., *Scienza e arte del costruire*, Rome 1944.

PACHECHO, F., *Arte de la pintura*, Seville 1649.

PACI, E., *Esistenza ed Immagine*, Milan 1947.

PEVSNER, N., *Pioneers of the Modern Movement from William Morris to Walter Gropius*, London, Faber & Faber, 1936.

PINO, P., *Dialogo di Pittura*, Venice 1548.

READ, H., *Art and Industry*, London, Faber & Faber, 1953.

RIEGL, A., *Die Spätrömische Kunstindustrie*, Vienna 1927.

RUSKIN, J., *Modern Painters*, London 1851–60.

SERUSIER, P., *ABC de la Peinture*, Paris 1950.

SEVERINI, G., *Ragionamento sulle arti figurative*, Milan, Hoepli, 1936.

SIGNAC, P., *D'Eugène Delacroix au Néo-impressionisme*, In 'Revue Blanche', 1899.

SIRONI, M., *Ragioni dell'artista*, in *Dodici tempere di Mario Sironi presentate da Massimo Bontempelli*, Milan, Edizioni del Milione, 1943.

THEOPHILUS PRESBYTER *Schedula diversarum artium*, in *Quellenschriften für Kunstgeschichte*, VII, Vienna 1874.

VAN GOGH, V., *The Letters of Vincent Van Gogh to his brother*, London, Constable, 1927–9.

VASARI, G., *The Lives of the Painters, Sculptors and Architects*, translated by A. B. Hinds, London, Everyman's Library, 1927.

VENTURI, L., *Il gusto dei primitivi*, Bologna 1926.

VENTURI, L., *Pretesti di critica*, Milan 1929.

VENTURI, L., *Stoira della Critica d'arte*, 2nd ed., Florence 1948; English translation, *History of Art Criticism*, New York 1936.

WACKENRODER, W. H., *Herzensergiessungen eines kunstliebenden Klosterbruders*, Berlin 1797.

WINCKELMANN, *Geschichte der Kunst des Altertums*, 1764 (in *Werke*, Stuttgart 1874); English translation by G. H. Lodge, *The History of Ancient Art among the Greeks*, London 1850.

WÖLFFLIN, H., *Renaissance und Barock*, Munich 1888.

ZERVOS, C., *Picasso*, Paris 1932–42.

ZEVI, B., *Saper vedere l'architettura*, Turin, Einaudi, 1948.

Index

284

285

286